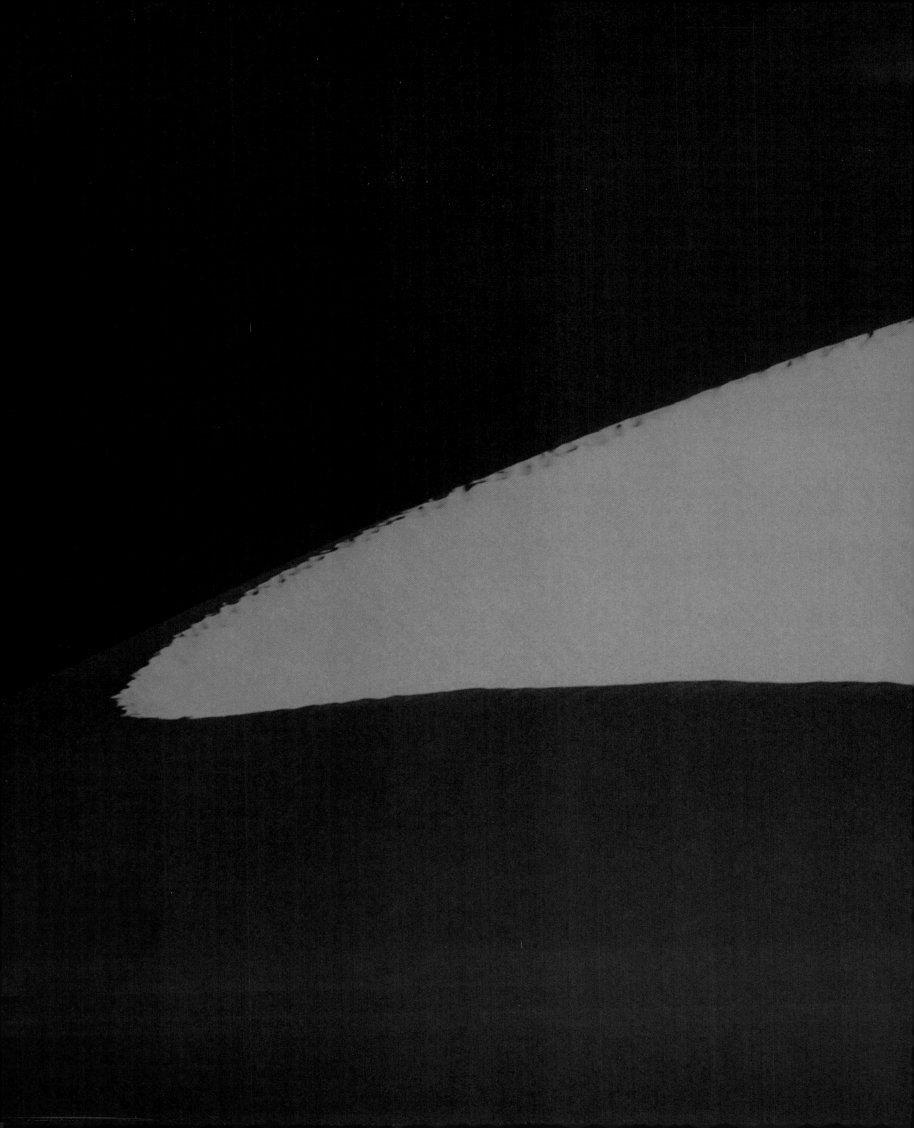

# SAHARA

## LA PASSION DU DESERT

Jean-Marc Durou
préface de Mano Dayak

Théodore Monod
Bruno Lamarche
Jean-Francis Held
Louis Gardel
Hervé Derain
Mohamed Aoutchiki Criska
Ibrahim Litny
Edmond Bernus

Harry N. Abrams, Inc., Publishers

The Sahara leaves no one cold, as the volumes that have been written about it prove. The purpose of this work, therefore, is not to reiterate the hard facts about the world's largest desert but to invite others to share in the passion of a few of the great Sahara travelers.

I wish to thank them for revealing here some of the private emotions they experienced upon encountering this land and the men, women, and children who live there.

I dedicate this book to the Tuareg, in the hope that one of the noblest of the desert civilizations will never die.

JEAN-MARC DUROU

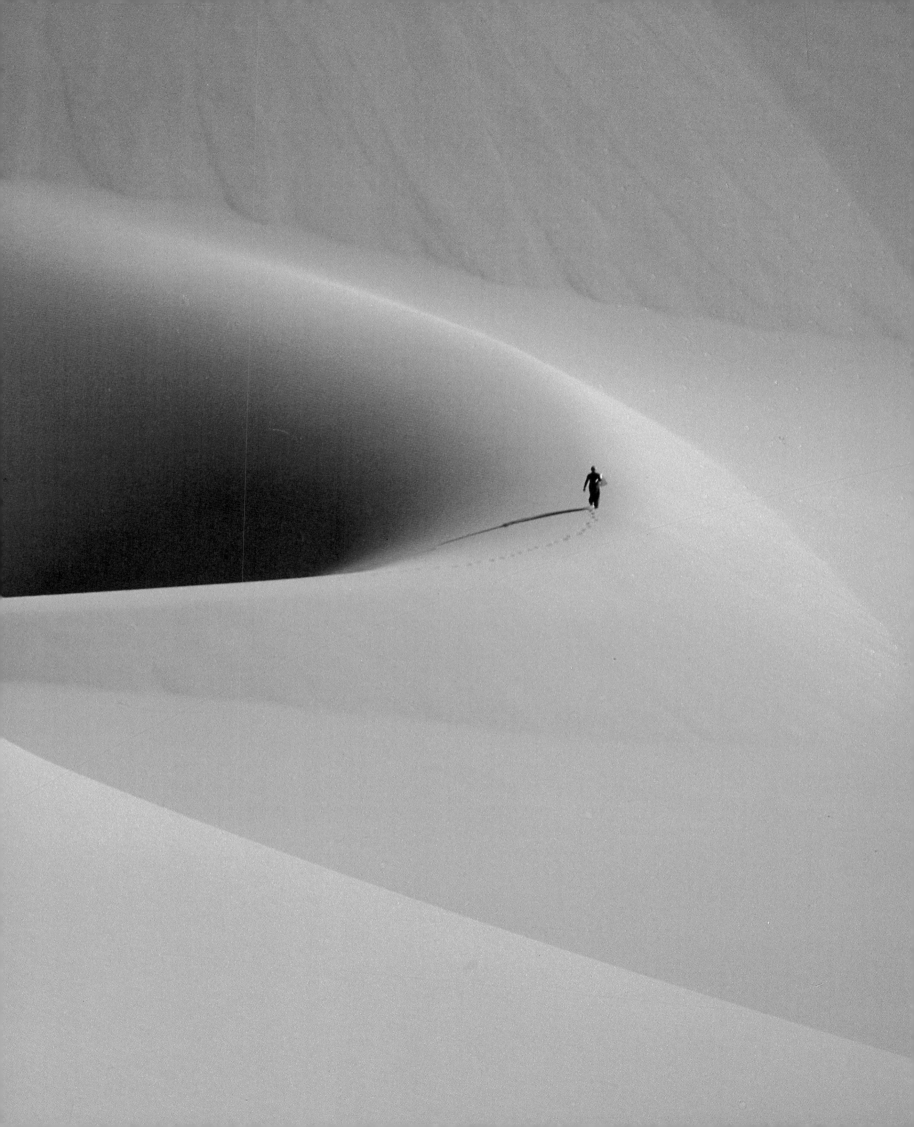

The desert cannot be described; it must be lived. What words, then, can translate the passion that the nomads feel for the desert? To those who haven't lived there, the desert looks like nothing more than a big empty space, while for us it is infinitely alive. How can I explain our love for so arid and so arduous an environment?

A culture's people are always deeply marked by the land in which they live; their personalities are shaped into the image of that land. In this respect, the desert remains the perfect example of human adaptation to, even integration into, one's surroundings.

Reflecting the land they inhabit, the Tuareg have learned not only humility in order to survive but also austerity and strength in order to protect themselves. They know that if they are to survive, they must adapt to the desert, understand it, and listen to it. Since the desert will always be more powerful than humans, living there requires simplicity as well as courage.

To me, the desert is extremely beautiful and pure, both overwhelming and magical. Every time I look out at the desert, it draws me into an emotional inner journey in which nostalgia collides with the anxieties and hopes of the present. The desert has taught me to commune with the mysteries of infinity. It is the mystery of the wind chasing the sand dunes, giving them the strangest shapes, the purest lines. It is the mystery of the acacia, lost in the expanse of sand like something left behind from another time. It is the mystery of a tuft of grass that seemingly grows out of nowhere, in the hot sand, both fragile and hardy. It is these blades of grass scratching cabalistic signs in the sand that, in my imagination, become the djins' pens, drawing messages like so many traces of destiny.

The desert is also the mystery of storms rising suddenly to pour out floods of water, like so much volatile life. And it is the mystery of the delicate, graceful gazelle, that fleeting vision, and the mystery of the addax, the powerful beast of these parts, the only living creature that can go years without a drop of water, making it the only creature that needn't observe our law, the law of those who live in the desert: *Aman iman*—"Water is life."

The desert is all these miracles at once, all reasons for wonder, and it is these miracles that nourish the passion the Tuareg feel for the desert. For us nomads, nothing in the world is more thrilling than a caravan winding through the sands; nothing more moving than the poetry of a nomad encampment at nightfall, when the fires are lit and the herds brought in. This is the holy hour, when dunes and sky merge in the flaming colors of the setting sun.

What more could we desire, we who are privileged to fall asleep each night beneath the sheltering sky, a sky spangled with millions and millions of stars, ignited to illuminate our dreams?

For us nomads, the desert is a deep, absolute passion, full of abiding images that not even death has the right to one day take from us. The desert seems eternal to those who live in it, and it offers that eternity to those who can love it.

MANO DAYAK

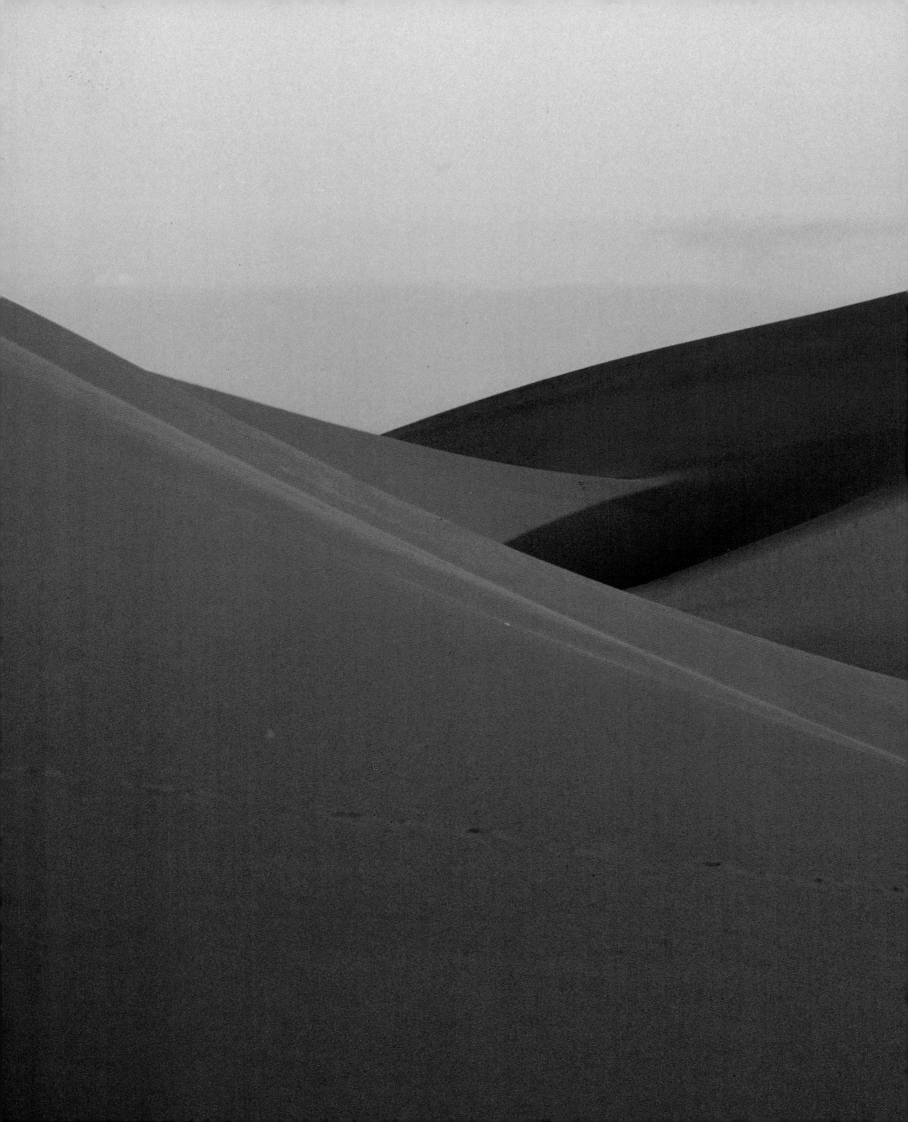

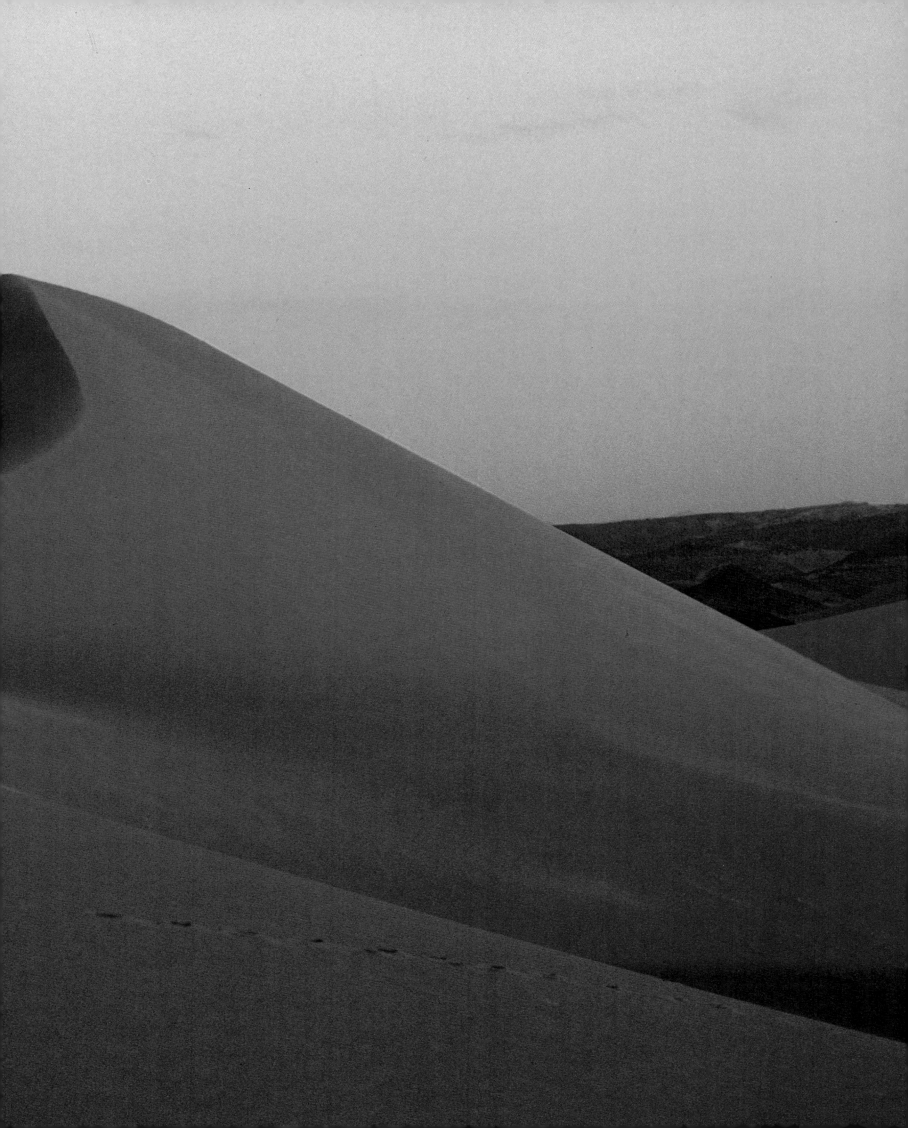

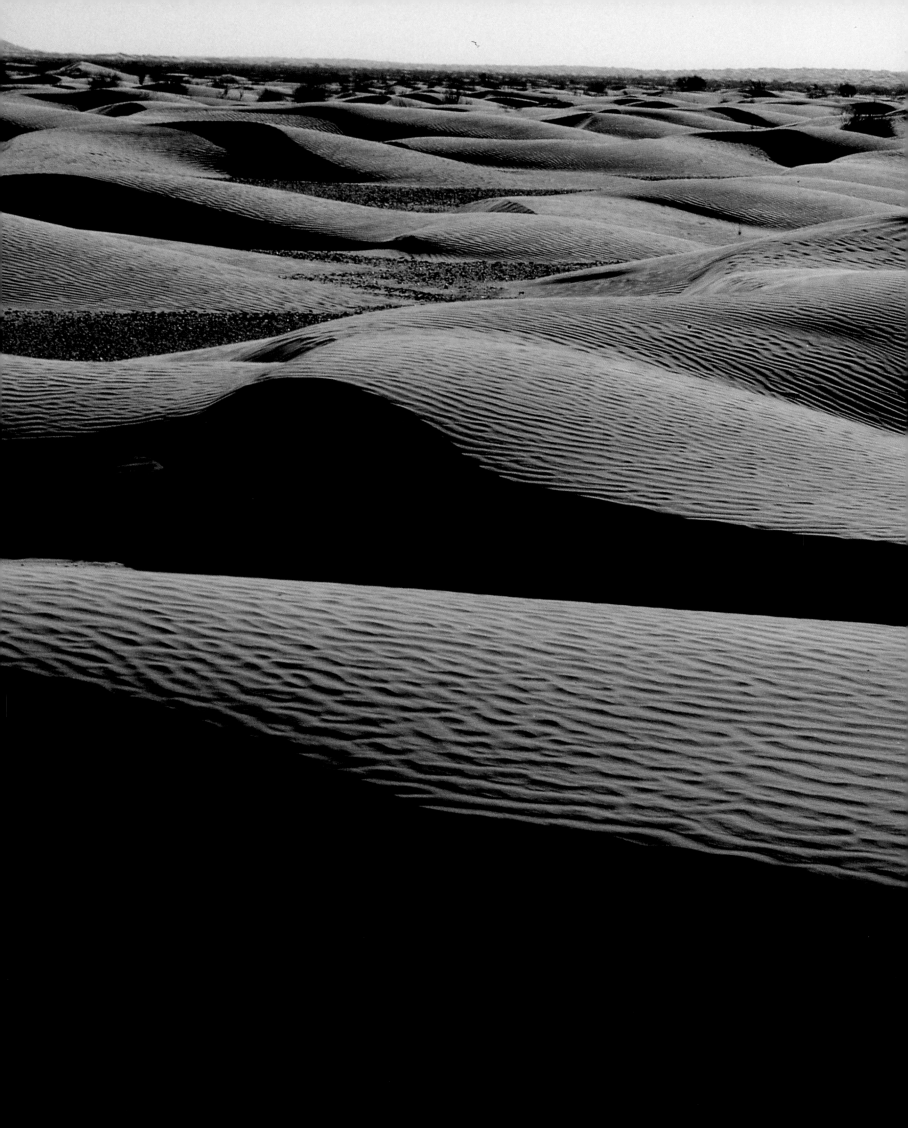

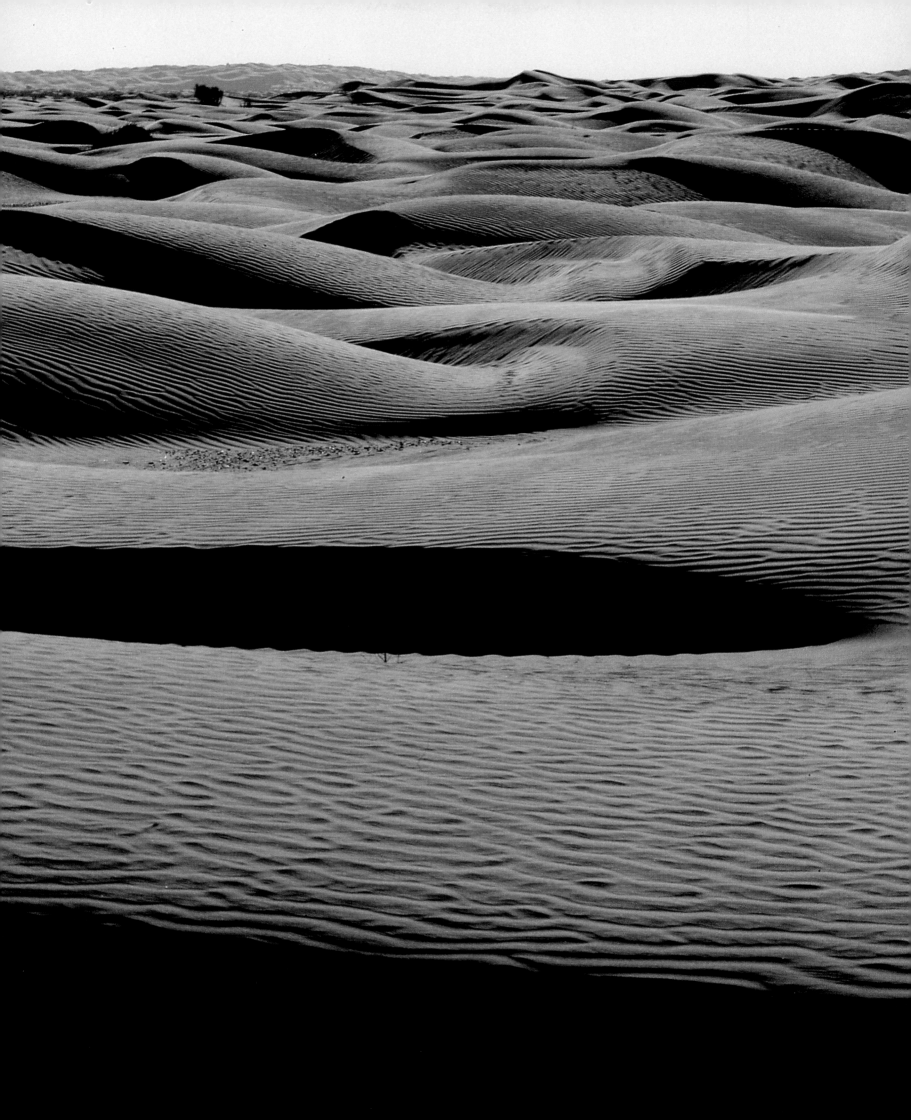

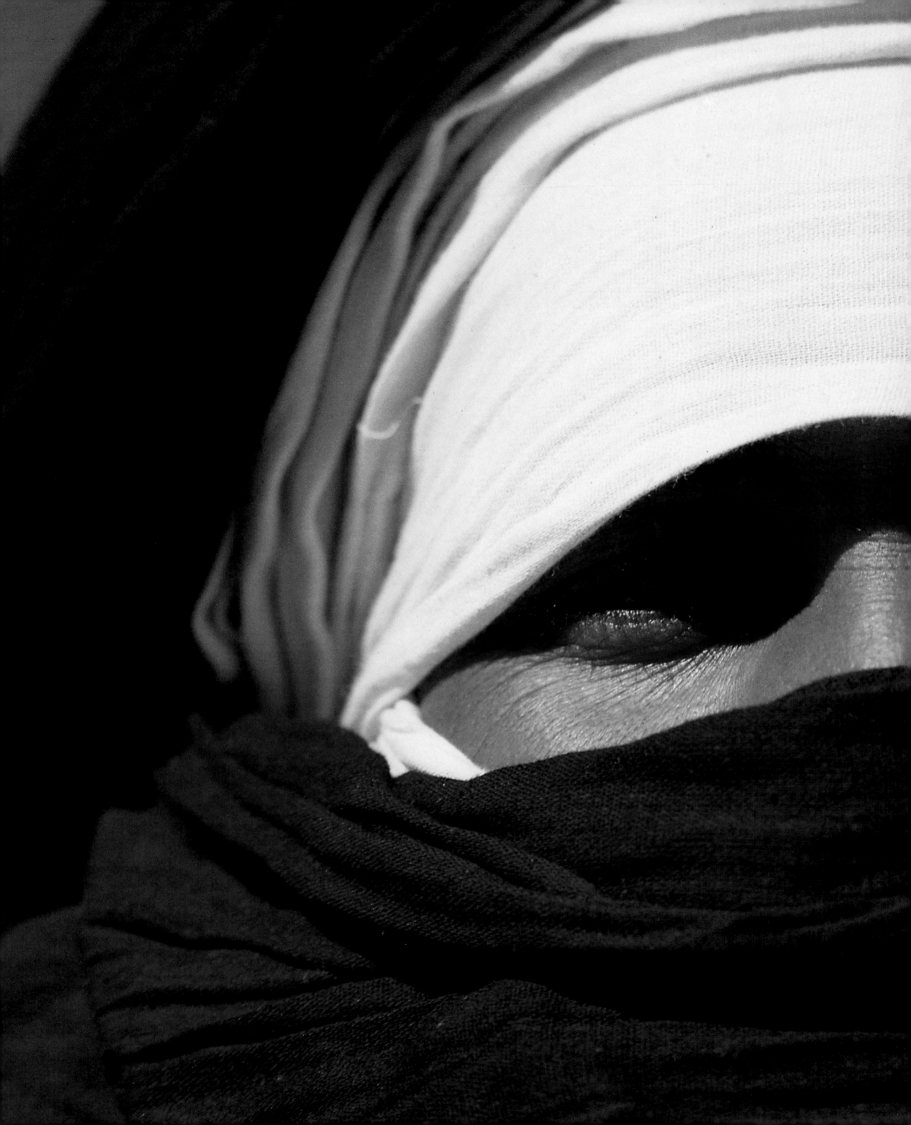

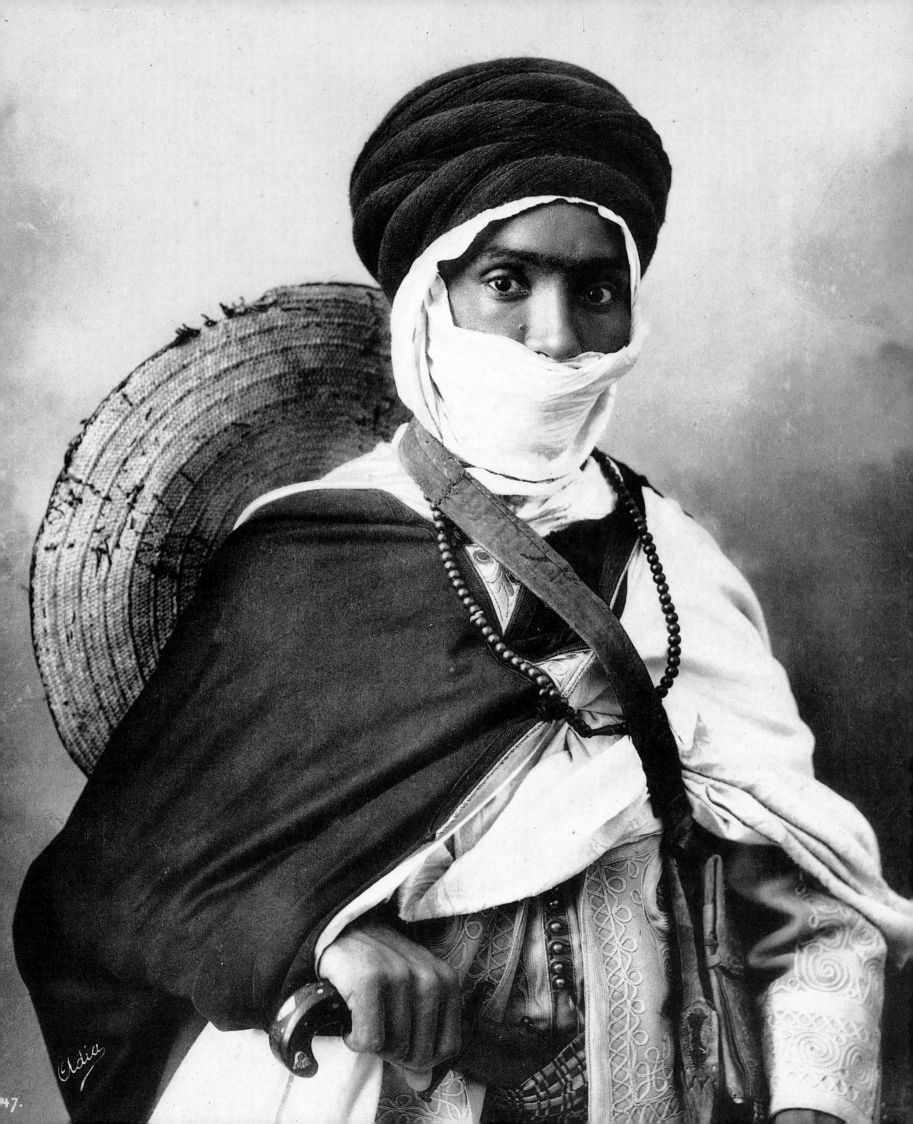

# THE SAGA OF SAHARAN EXPLORATION

Nowadays, when travelers look at a map of Africa, they expect to find every river, mountain, and massif precisely identified. Everything is listed: distances, altitudes, localities—seemingly nothing is left out. It is impossible to imagine that just a century and a half ago the interior of this continent was unknown to Europe, its neighbor.

This ignorance was due in part to the barrier of Islam, which, beginning in the seventh century, with the arrival of the Arabs in North Africa, forbade Christians from entering. Other factors include the impenetrable, dangerous bush south of the Sahara, where rivers slashed with innumerable rapids made navigation difficult and access nearly impossible. In Africa's immensity, the Sahara defied even the most intrepid Western adventurers for centuries.

With interests primarily in the slave trade, Europe had had settlements on the African coasts since the sixteenth century. As Théodore Monod puts it, "All we knew of Africa in the nineteenth century was its coasts—a sailors' Africa." Around this time the Americas and Asia were becoming well known, whereas Africa remained a mysterious continent about which the greatest mapmakers of the period could contribute nothing new. Their knowledge was limited to a few antiquated facts and to the tales of Arab and Jewish travelers who happened to reach the West during the Middle Ages.

Exploration made great strides in the latter half of the eighteenth century, a time when Africa was beginning to fascinate many Europeans, who were finally challenging the hitherto uncompromising institution of slavery. The image of the "noble savage"—within a society that claimed to be the modern bearer of civilization—spurred the early abolitionist movements. Scientific discovery and the struggle against slavery were not the only motivations behind European exploration, however. This great epic was also inspired by the immense, untouched territories that were ripe for commercial expansion.

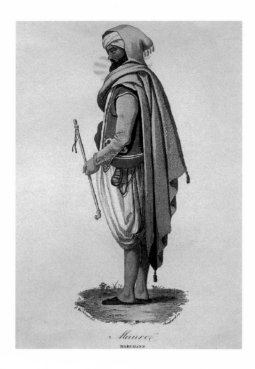

Maure
MARCHAND

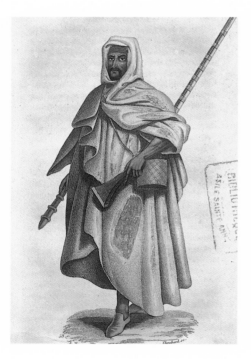

BIBLIOTHEQUE
AFRE SAINT GENEVIEVE

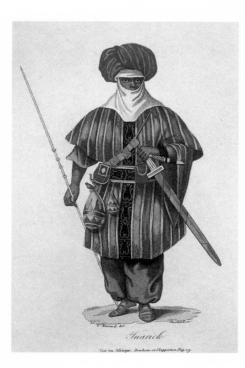

Tuarick

Vue en Afrique. Denham et Clapperton Pag. 59.

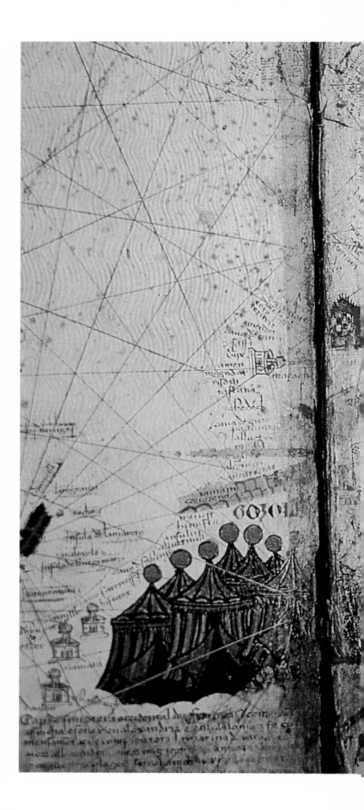

## A Belated Exploration: The Great Adventure at the Dawn of the Nineteenth-Century

In 1788, two associations were founded in Europe: The Society of Friends of the Negroes, which demanded an end to the slave trade, and the African Association, intended to promote exploration in the interior of the continent, abolish slavery, and develop commercial contacts. The area south of the Sahara was the first to arouse the curiosity and cupidity of the English. The Arabs called it Bilad es Sudan, "the black peoples' country," as opposed to Bilad el Bedane, "the white peoples' country," to the north of the great desert.

The ancient peoples of the Mediterranean knew this area was rich in gold; medieval documents also mentioned the region's wealth. Later, the Arabs, the first true foreign explorers of the Sudan, were attracted by the fabulous empires—known as Ghana and the empire of Mali—that were supposedly streaming with the famous yellow metal. The writings of Al-Bakri, Ibn Battutah, and Leo Africanus, famous medieval and Renaissance writers, also affirmed the area's immense riches.

Although Europeans were acquainted with some of these early writings, the wealth and decadence of these empires was only legend. Ghana, for example, the linchpin of the gold trade and the inspiration of so many fabulous tales, was no longer in existence past the sixth century. The Berber historian Ibn Khaldun had vividly related the opulence of King Kan Kan Moussa of the empire of Mali, but that empire, too, had ceased to be. The Songhai Empire was destroyed in the Moroccan conquest. The Europeans of the late eighteenth century did still believe in the legends of gold in the mysterious city of Timbuktu, which became the stuff of dreams.

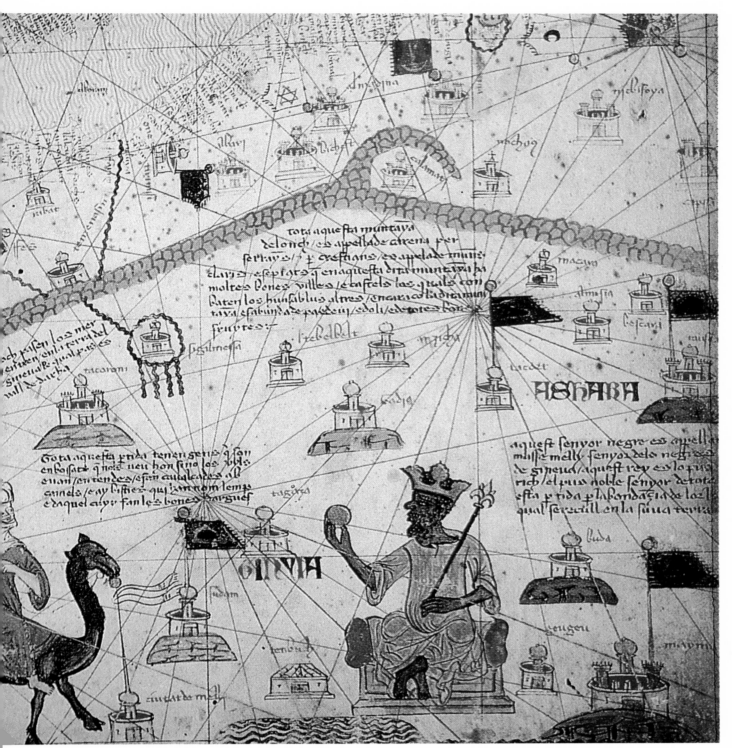

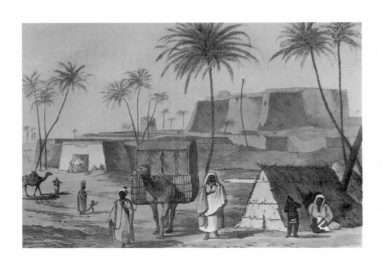

19

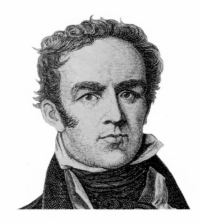

## The First European Explorers of the Sahara

In 1790 the two-year-old African Association sent a young officer, Major Houghton, to find the Niger River. Reckoning that the river was most accessible from the Gambian coast, where England had trading posts, the expedition plunged into the bush, where it disappeared. Four years later, Mungo Park, a Scottish doctor, took up the challenge. Fresh from the Sumatran jungle, he displayed all the best qualities of a potential explorer to Africa. In Gambia he assembled a small escort made up of two interpreters, a horse, and two donkeys, with whom he crossed Senegal and entered the kingdom of the Bambara. For two months he wandered around the bush, handing out gifts to buy his way through. On June 20, 1796, he discovered the Niger River, the first European to do so. Eight years later, during a second expedition, Mungo Park would drown in the river he had made known to Europe.

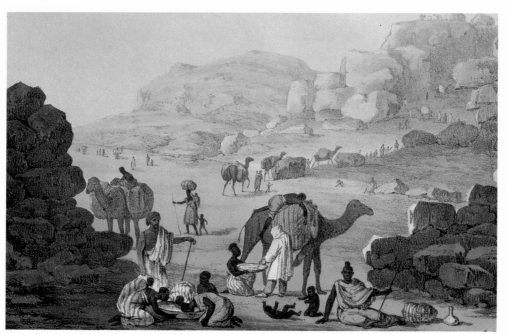

Recognizing the obstacles that explorers continuously encountered in a tropical region whose people had been rendered extremely aggressive by three centuries of slave trade kidnappings, the African Association decided to approach the Sudan by way of North Africa.

In 1798 the association sent a young German, Friedrich Hornemann, to Cairo with a mandate to reach the Niger. After several months in the Egyptian capital, he blended in with the Muslims, joining a caravan leaving for Marzuq. The young German, who spoke fluent Arabic, took the name Yusuf, and so impeccable was his familiarity with Muslim culture that his Christian identity went undetected throughout the journey. After passing through Siwa, a famous oasis in the Libyan desert where, twenty-one centuries earlier, Alexander the Great had come to consult the oracle, Hornemann reached Fezzan safe and sound.

In Marzuq he secretly prepared his first set of notes for the African Association, attaching a

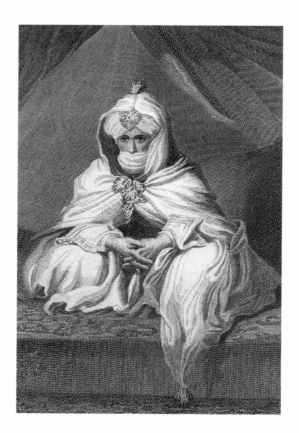

letter requesting that they not look for him for three years. The association respected his wish; three years passed, but Hornemann was never seen again. He died without having reached his goal, the Niger.

Undeterred, the British sent an expedition from Tripoli in 1822. The mission's itinerary followed the notorious slave route to the Bornu region by way of the Kawar, along the edge of a torrid desert called the Ténéré. There were three explorers: Dixon Denham, Hugh Clapperton, and Walter Oudney; their guard was a troop of Arab warriors sent by the pasha of Tripoli. The caravan was soon deep in the heart of the Sahara. At each well along the way, the explorers were horrified by the sight of dozens of skeletons bleached by the sun, an ugly reminder of the violence of the slave trade. After crossing Fezzan and the Kawar, the expedition came upon a sea of sand: the southern Ténéré. In the late afternoon of February 4, 1823, after another tiring day's march, they spotted an immense expanse of water glistening in the sun. This was no mirage, but rather the great Lake Chad, whose geographical location and name were still unknown in Europe.

When they arrived in Bornu, the first Europeans to reach the region, they were received by the sultan, upon whom they lavished gifts. After a few months' exploration in the surrounding regions—where they were surprised to find a number of European products in the markets—one of the three explorers, Dr. Oudney, began to show signs of exhaustion. One day in the bush, Clapperton begged his comrade to rest, but Oudney, in his unwavering fervor, replied that, just as the duty of a Roman emperor was to die standing, that of an explorer was to die walking. Oudney died two days later.

Denham and Clapperton managed to make it back to Europe in 1825. The account of their discovery aroused exultation, enthusiasm—and hopes of reaching the legendary city of Timbuktu.

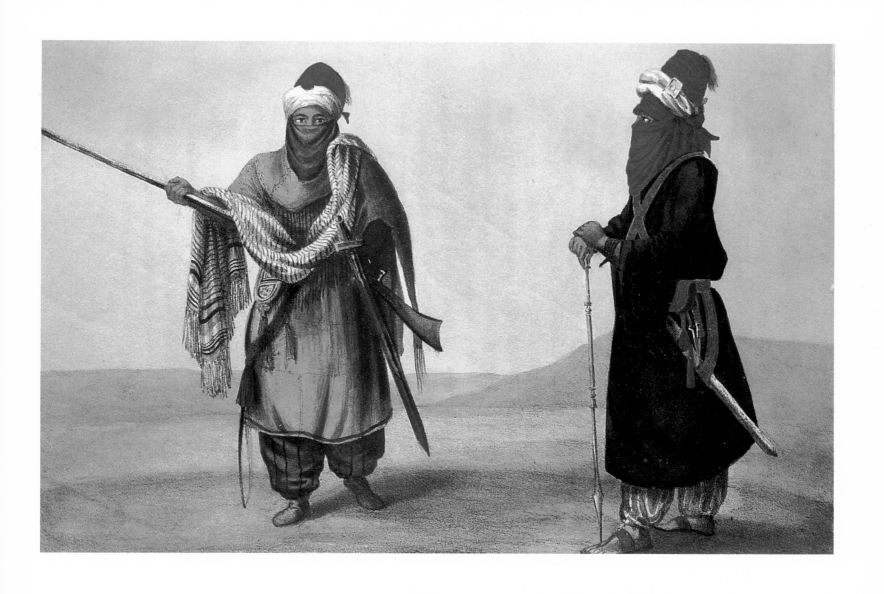

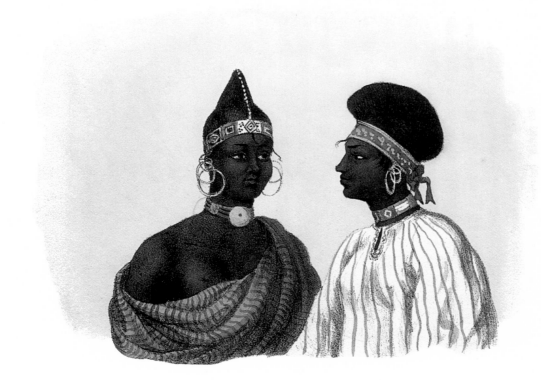

## Timbuktu: History of a Legend

Driven by the desire to be the first European nation to establish commercial networks in the interior African continent and aware of the tremendous task of exploration still ahead, the British sent one of His Majesty's young officers to Tripoli in 1825. On July 16, Major Alexander Gordon Laing left the Mediterranean coast for the Sahara with a small caravan. His goal: Timbuktu.

Far from concealing his identity, the bold captain traveled in his British army uniform. He easily reached the hitherto unknown oasis of In Salah, north of the Ahaggar Mountains. Unfortunately, farther south, at

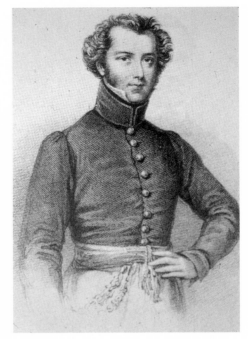

Left
*A caravan halts at a water hole.*
Above
*Major Alexander Gordon Laing (1793–1826), officer of His British Majesty.*
Below
*A Moorish nobleman of the western Sahara.*

the In Ziza well, on the edge of the Tanezrouft Mountains, he received twenty-four saber cuts when he was attacked by a band of Tuaregs. Though robbed and left for dead, Laing did not give up. He continued to make his way south, and on August 13, 1826, fifteen months after starting out, he reached Timbuktu. Was Europe about to learn the secret of the legendary city? Not this time. Major Laing was murdered on his return trip a few weeks later, and his notes were never found. Once again, Timbuktu kept its secret. In England the news of his death was greeted with great sorrow, followed two years later by a wave of anger when the British learned that a Frenchman had ultimately discovered Timbuktu. The English, believing they had a monopoly on African exploration, could not fathom how a Frenchman, alone and without resources, was able to succeed where one of His Majesty's officers had failed.

René Caillié, born in 1799 in Mauzé, in Deux-Sèvres, France, had thrilled to the stories of the great African travelers from the time he was a teenager. At seventeen he embarked for Saint-Louis in Senegal. Successively a cobbler, peddler, and street vendor, the young Caillié dreamed only of exploring the bush, and in the end he convinced himself that he had to be the first European to discover Timbuktu. He was uneducated and penniless, and no one took his project seriously. He quickly realized that if he wanted his dream to come true, he must rely only upon himself.

Caillié lived with a Moorish tribe in northern Senegal for several months to learn the customs of the Sahara and of Islam. The harshness of the nomads' life

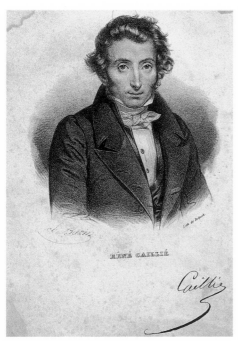

RENÉ CAILLIÉ

CAMEL CONVEYING A BRIDE TO HER HUSBAND

London, Publish'd by I. Murray Albemarle St. 1821.

Above

*The famous French explorer René Caillié (1799–1838) was the second European to enter Timbuktu, after Major Laing.*

Below

*Black peoples of the Sudan. An engraving from Lyon and Ritchie's mission, 1821.*

*A dromedary carrying a* bassour, *a kind of tent made to allow women to travel. An engraving from Lyon and Ritchie's mission, 1821.*

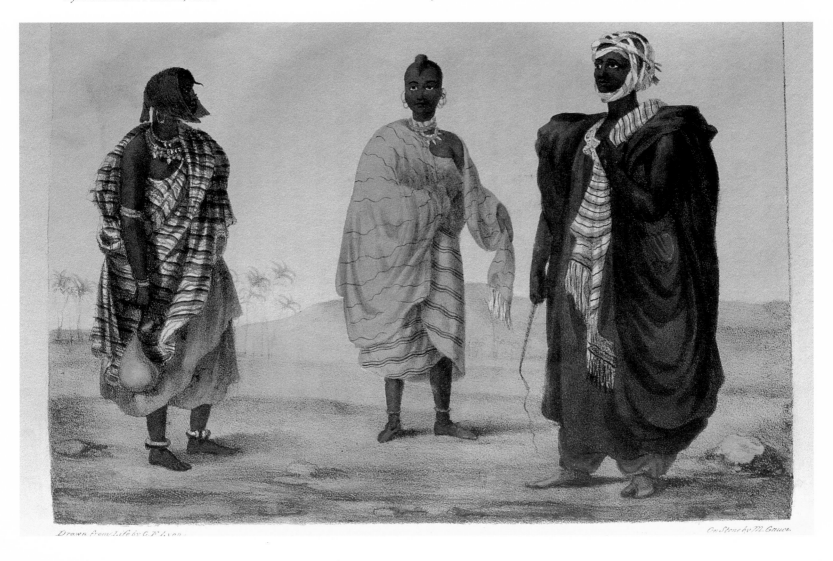

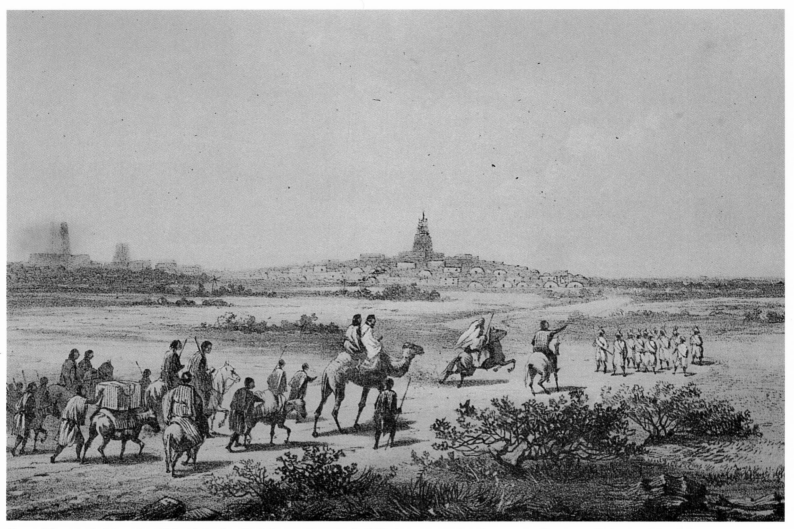

Above: *The arrival of the explorer Heinrich Barth to Timbuktu, on September 7, 1853. An engraving from his account of his journey,* Reisen und Entdeckungen in Nord und Zentralafrika in den Jahren 1849 bis 1855.
Below: *The explorer Camille Douls (1864–1889). Disguised as a warrior named Ouled Delim, Douls lived among the nomads of the western Sahara for five months.*

Opposite:
Top
*Henri Duveyrier (1841–1892) was the first European to form friendships with the Tuareg.*
Bottom
*The German geographer Heinrich Barth (1821–1865) was one of the great African explorers.*
Right
*A Tuareg warrior. After courageously fighting the French colonial troops out to conquer the Sahara, many Tuareg became faithful friends of France.*

seems not to have frightened him—it was not so different from the daily misery that had been his lot for many years. Soon, Caillié, with his new name, Abd Allahi (God's slave), felt ready, and one April day in 1827 no one noticed when he disappeared into the bush. For months he traveled the trails to Timbuktu as a beggar. He passed himself off as a young Egyptian who had been taken prisoner by the French and then released; touched by his story, many Muslims helped him. Nevertheless, ill with scurvy, malnourished, oppressed by the torrid climate, he wrote in his notebooks that there were days when he wanted to die and asked God to take him, in hopes of another, happier life.

On April 20, 1828, he finally reached the gates of the mysterious city. His face was burned by the sun, his teeth were lost to scurvy, his body was covered in rags—no one paid any attention to just another poor wretch. René Caillié had triumphed. As he wandered around the city of his and so

many Europeans' dreams, he was sorely disappointed. Timbuktu was no longer a city streaming with gold but, at best, a sorry agglomeration of mud houses baking in the sun.

His keenest desire at that point was to tell Europe of his discovery. Joining a caravan leaving for Morocco, he crossed the Sahara—more than 1,000 miles (1,610 km)—in the middle of summer. After his arduous journey and unmerciful suffering, he managed to get to France, where he received the honors due his magnificent exploit. While the French expressed no doubt whatsoever about Caillié's journey—which no one else could substantiate—the English, still shocked by the loss of Major Laing, attacked him in the press, calling him an impostor. It would be twenty-five years, long after Caillié's death, before another explorer, Heinrich Barth, returned from Timbuktu and proclaimed his admiration for the Frenchman, whose account he endorsed.

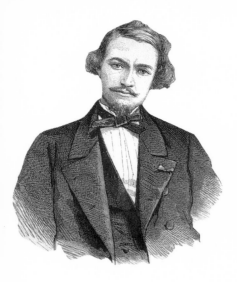

## Two Great Princes of Saharan Exploration: Heinrich Barth and Henri Duveyrier

No sooner did France begin colonizing Algeria in 1830 than it immediately pressed its conquests southward. England, no longer alone in Africa, would now have to contend with this formidable rival; fierce competition arose between the two nations.

In 1850 the English sent another expedition out from Tripoli. Buoyed by considerable financial support, the mission was directed to quickly establish economic relationships with the various Sudanese rulers. Heading the mission was an Englishman, James Richardson, who had established contacts with the Tuareg when he explored the area around Ghat five years earlier. With him were two young German scientists, doctors Adolf Overweg and Heinrich Barth. The expedition—which, thanks to Heinrich Barth, became one of the most famous in Africa—followed an entirely uncharted itinerary out of Ghat, north of the Tassili N'Ajjer. After crossing the barren northern Ténéré, the explorers came upon the astonishing mountain mass of the Aïr, which no European had ever seen. In the dead of August, frequent rainfall gave rise to a luxuriant vegetation that surprised and thrilled them; they humorously christened the region "the Switzerland of

the Sahara." Leaving his two companions north of the Aïr, where the caravan would rest for a few days, Barth took the opportunity to visit Agadez. There, in the principal city of the Aïr, he paid his respects to the sultan, showering him with gifts in the name of the queen of England. The sultan, who was flattered but somewhat taken aback, thanked both him and the queen of a country of which he was unaware until that moment. Barth rejoined the caravan, and the

explorers continued southward, electing to split up and cover different regions for greater travel efficiency.

Overweg went off to explore Lake Chad with the collapsible boat he had brought—a technological marvel for the time. Barth went in the direction of Kano, and Richardson to Zinder. Only a few weeks later, Overweg and Barth learned of the death of Richardson, the expedition's leader. In 1852, two years after

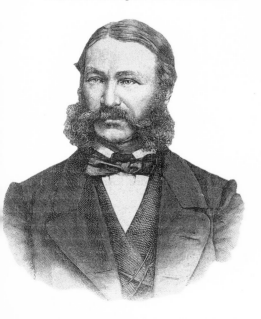

*In 1902, at General Laperrine's urging, France established camel companies in the Sahara (here, Captain Charlet of the Tidikelt company).*

*French soldiers of the Foureau-Lamy mission, which between 1898 and 1900 crossed the Sahara from north to south.*

*The French explorer Victor Largeau.*

setting out, Overweg was the next to die at thirty-one after suffering greatly from fevers.

Barth was left to face the immensity of Africa alone. For him there was no question of returning to Europe. He was armed with an exceptional will, and nothing could dissuade him from his goal. In the face of yet unnamed dangers, he drew courage from his passion for science and exploration and headed for Timbuktu—a modest jaunt of 2,440 miles (4,000 km) on foot, across a totally unknown part of the world.

On November 25, 1852, Barth left Bornu, a region near Lake Chad, and headed west. Even knowing that his journey would take at least two years, he felt, in his words, "as strong as a giant." For safety's sake, in Massina, a region within the bend of the Niger River, Barth passed himself off as a Muslim for the first time. Disguised as a Syrian sharif named Abd el Karim, he had a startling experience: awed by this religious personage who had come all the way from faraway Syria, a tribe asked him to lead them in prayer for rain, after many months of drought. Fortunately for Barth, there were showers two days later, arousing the admiration of the tribe. On September 7, 1853, he finally entered Timbuktu and confirmed the descriptions of René Caillié, to whom he paid tribute on his return.

Barth's sojourn in the mysterious city was not without peril. Natives soon recognized him as an impostor, and during his six-month stay he was protected by a wealthy sheikh named el Bakay, who saved Barth's life on several occasions by fearlessly facing down his attackers. The sheikh proved his fondness for the German explorer when he warned a band of warriors who had come to murder Barth, "The foreigner is in my hand; you'll have to cut it off if you want to take him."

When he considered his mission accomplished, Barth made his way back to Bornu in 1854, thence to Tripoli across the Sahara once more, along the Kawar route. This journey took five years, during which time he covered some 10,000 miles (16,100 km) on foot, bringing back invaluable historical and scientific information about the territories he had traveled, hitherto unknown to Europeans. Considered one of the great African explorers, on a par with Livingstone, Burton, and Speke, Barth died in 1865. The heir to his passion was a young Frenchman, Henri Duveyrier, who in turn contributed greatly to a better understanding of the region.

In 1857 seventeen-year-old Henri Duveyrier discovered the fascination of the south on a trip to Algeria. In Laghouat, an oasis on the edge of the desert just con-

quered by the French, Duveyrier became friends with a Tuareg from Tassili N'Ajjer; the young Frenchman promised to return and visit this man's country. Three years later, in 1860, the young explorer initiated an expedition to the central Sahara, attracted by these nomads whom few Europeans had frequented. For the first time, the purpose was not to explore the Sudan, but rather a specific area of the great desert: Tassili N'Ajjer.

His trip was not without its dangers, but Duveyrier's youth, sweetness, and naiveté made an impression on a Tuareg chief named Ikenouken. As soon as Duveyrier arrived in Tassili, Ikenouken took him under his wing and introduced him to the region. Duveyrier carefully observed the life and customs of its inhabitants and the flora and fauna among which they lived; he returned home with an impressive collection of notes that formed the basis of a magnificent book, *Les Touaregs du Nord*, published in 1864. Through him, Europe first learned about a people previously unknown.

Unfortunately, a number of experts harshly criticized Duveyrier for his fascination with these great nomads, whom many Europeans considered savages. They attributed his admiration to immaturity. These nineteenth-century critics were unaware that Duveyrier was ahead of his time in realizing that, if one wishes to understand a culture or society, one must study it within its natural environment; the laws of the nature have a direct impact on a specific culture's customs and traditions.

Many explorers would follow Major Laing, René Caillié, Heinrich Barth, and Henri Duveyrier. Some came back alive, many others added their names to the long list of those who vanished. Some deserve special mention. Gerhard Rohlfs became the first European to cross the Sahara from east to west and north to south in 1864, a veritable marathon traveler of the sands. In 1869 Gustav Nachtigal, a German doctor with no predisposition for exploration, discovered the Tibesti, the largest mountain mass in the Sahara. Traveling alone for five years, Nachtigal was robbed, subject to extortion, and in danger of losing his life many times over, yet nothing deterred him from his incredible journey.

The names of other explorers—Vogel, Panet, Camille Douls, Alexandrine Tinné, and Victor Largeau, among others—entered the history of Saharan exploration, which, in the late nineteenth century, turned from discovery into conquest. Most explorers were inspired purely by the desire to discover, but an international contest was under way between France and England for possession of the African continent. The French authorities established in Algeria insisted that they must be masters everywhere if they were to be secure anywhere. Now nothing could stop what would henceforth become the penetration of the Sahara.

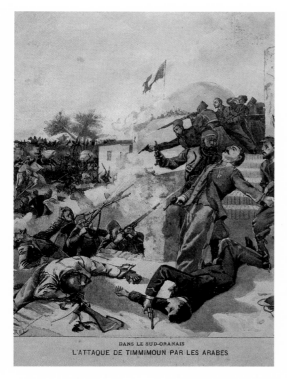

DANS LE SUD-ORANAIS
L'ATTAQUE DE TIMMIMOUN PAR LES ARABES

## From the Trans-Saharan to Conquest

In 1876 the idea of a railway across the Sahara, connecting the French colonies of Algeria and Senegal, was conceived in France. Everything seemed possible at the end of a century during which mechanical progress had intoxicated the West. Hadn't the Americans completed their first railway between the Atlantic and the Pacific oceans in 1869? Why shouldn't France achieve the Trans-Saharan? There were obstacles, of course: much of the Sahara was still uncharted, much was far from pacified, and the French failed to consider the potentially disastrous eco-

nomic effects of the Trans-Saharan on the caravans. This recklessness soon proved catastrophic: In February 1881 the Tuaregs, well aware of the risks to their culture posed by the railway, massacred the Flatters mission, which had come to survey the route north of the Ahaggar. The massacre delayed the penetration of the Sahara for twenty years, but it did not stop it.

In 1890 England and France signed an agreement dividing up a part of Africa the two nations had not yet conquered. The Sahara went to France, causing a British minister with a sense of humor to remark, "We have given the Gallic rooster no end of sand; let's let him scratch it as much as he likes."

Top, left
*France, which had occupied Algeria since 1830, began its conquest in the direction of the Sahara in 1840.*
Top, right
*French penetration into the Sahara.*
Bottom, left
*A reconnaissance mission commanded by Colonel Flatters.*
Bottom, right
*On December 29, 1899, the French conquered the oasis of In Salah.*
Left
*Father Charles de Foucauld in his hermitage in the heart of the Ahaggar.*

The cover of L'Atlantide, *a novel by the writer Pierre Benoît, showing Antinea.*

On October 23, 1898, the Foureau-Lamy French mission, made up of three hundred heavily armed men and one thousand camels, left Sedrata, north of the Algerian Sahara. It took them a year to traverse the Sahara from north to south, but they arrived in the Sudan safe and sound; the French army took the oasis of In Salah that same year. In the south, the French flag had already been over the ramparts of the legendary city of Timbuktu in 1894.

In 1902, following the battle of Tit, the Tuaregs of the Ahaggar surrendered to the newcomers, and over the next several years the bastions of the Tassili N'Ajjer, the Aïr, Tibesti, and Mauritanian Adrar fell one by one to the colonial troops. These victories were made possible by the camel corps that General Laperrine organized in southern Algeria in 1902, establishing a model for colonial troops in the south, which quickly assembled nomad units along the same lines.

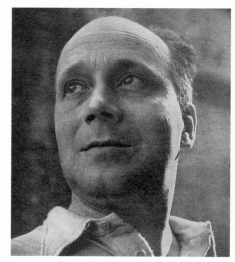

*The geologist Conrad Kilian.*

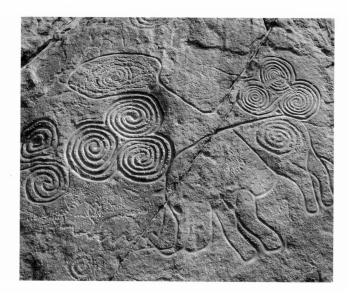

*Rock carvings in the form of spirals and a rhinoceros from the wadi of Djerat. They were discovered by a camelry officer named Brenans in 1933 and studied a few years later by Henri Lhote.*

*A camelry officer. Here, the young lieutenant Toubeau de Maisonneuve, of the Tassili N'Ajjer company, who in 1928 achieved one of the first explorations of the Ténéré.*

### Secrets of the Sahara

In 1920 the Sahara seemed to hold no further secrets for the Western world. Timbuktu, the city of mystery, had been conquered. Only novelists still cared about the legend of Atlantis, and only scientists were making significant new discoveries. There was nothing mythical about what they found, though there were plenty of surprises: no one knew that the Tassili N'Ajjer was not only rich in oil but was the world's largest open-air museum, the home of thousands of prehistoric paintings.

The oil was discovered by Conrad Kilian, a brilliant geologist, who in 1922 intuited the presence of the "black gold" on his return from an expedition to the Ahaggar. Some of the rock carvings and paintings had been discovered by nineteenth-century explorers, but no one antici-

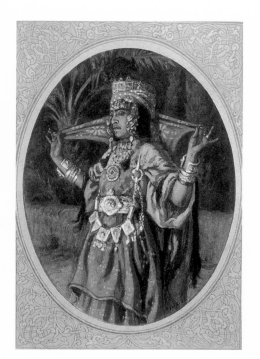

Left

*Beginning in 1930, the Sahara seemed to have been pacified by French forces. It would be the turn of poets and artists to discover the most beautiful desert in the world.*

Above and right

*Women of the Ouled Naïls tribe of southern Algeria. The paintings are by Étienne Dinet, an Orientalist who spent much of his life at the Bou Saâda oasis.*

Below

*The northern Sahara. Painting by Paul-Élie Dubois.*

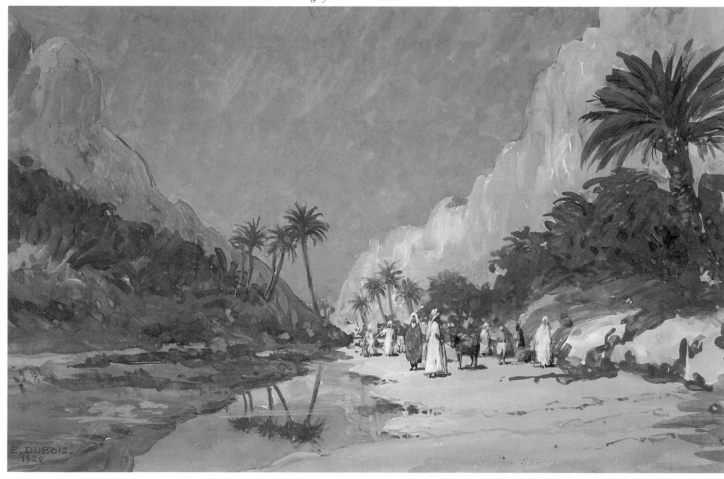

pated the large cache found in the Tassili N'Ajjer. It was a fluke that in the course of a survey in the 1930s, a young lieutenant in the camel corps named Brenans chanced upon the Wadi Djeraf, a vast prehistoric sanctuary. Everywhere he looked, the ground and walls were covered with hundreds of rock carvings representing animals of the savanna. In 1955 Henri Lhote and his crew revealed to the world these magnificent Neolithic rock paintings and carvings.

### The Citroën Long-Distance Rally

Beginning in 1920, exploration took different forms. The nineteenth-century explorers were followed by the military, which in turn left the field to scientists. The introduction of cars also accelerated the rate of discovery—the first automotive crossing of the Sahara was organized by Citroën in 1922. Five half-track vehicles carrying ten explorers left Touggourt on December 17, covering some 2,135 miles (3,500 km) of desert at an average speed of 27.45 miles per hour (45 kph). Twenty-two days later, on January 7, 1923, the Citroën long-distance rally triumphantly entered Timbuktu. The automobile had just conquered the desert—though the dromedary was still the surest way to travel.

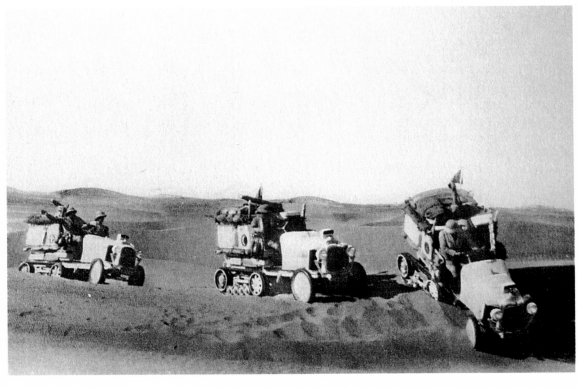

*The Citroën company organized the first crossing of the Sahara by motor vehicle in 1922.*
Below, left
*The poster for the film of the first crossing of the Sahara, carried out by the Citroën mission.*
Below
*Haardt and Audouin Dubreuil, leaders of the first Citroën mission across the Sahara (1922–23). After the success of this first Sahara crossing, two other missions would follow: the Black Expedition and the Yellow Expedition.*

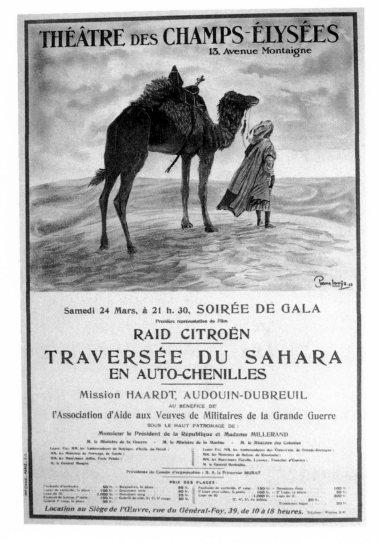

## Théodore Monod, a Traveler Across Infinity

In 1922 there occurred a unique case of love at first sight, that of a young oceanographer for the desert to which he would devote his life. Working with a sea of water, Théodore Monod discovered behind him an ocean of sand. When the job was finished, he surrendered to his curiosity; by the time he had returned from Port-Étienne to Saint-Louis by camelback, Théodore Monod the Saharan was born. Dromedary to dromedary, caravan to caravan, this naturalist and traveler covered the Sahara from end to end, propelled by an irrepressible urge to know everything. A combination naturalist, prehistorian, geologist, botanist, and explorer, Monod undertook his first crossing of the Tanezrouft in 1935. Two years later, he published *Méharées*, a book whose avant-garde style surprised readers, while drawing them into a realistic vision of the great desert. In 1953 he made several "ocean crossings." One of these is still famous: a 1,000-mile (1,700-km) "stroll" across Majabat-al-Koubra (the great solitude), which included a stage of 550 miles (900 km) between wells. It was during this period that the nomads nicknamed *Monod el Mehoun*—Possessed.

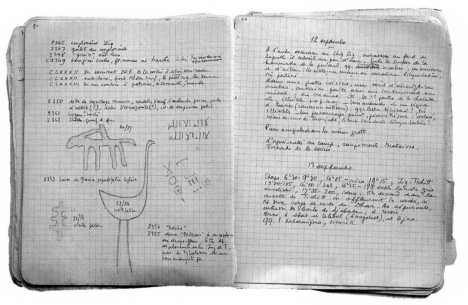

*Drawings and notations from one of Théodore Monod's many notebooks.*

At ninety-two years old, Théodore Monod still walks in the desert, even though, as he acknowledges, "The age of great Saharan exploration is over; today, it is done with a microscope. . . . It is just a question of scale and vocabulary."

If today the word "exploration" belongs to the past, "discovery" is still current. We wish all those who will discover the Sahara tomorrow—and return mesmerized—the passion that Barth, Caillié, Duveyrier, and Monod experienced, for, as Wilfred Thesinger wrote:

*No one, after living this life, can remain what he was before. He will henceforth be marked by the desert, bearing within the sign of the nomad's life. He cannot escape the desire to go back, a desire that will be quiet or violent, according to his nature. For this cruel country has, as no temperate land does, the power to enchant.*

Right
*Professor Théodore Monod in 1967, during a mission in the Mauritanian Adrar (which he likes to call his "diocese").*
Below
*For seventy years, the insatiably curious Théodore Monod noted his discoveries with the same precision as the eighteenth-century Encyclopedists, and studied them passionately.*

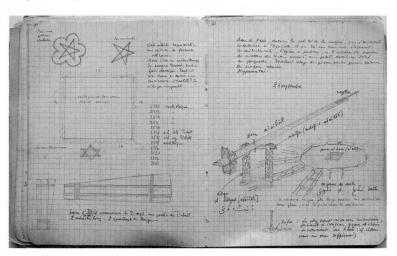

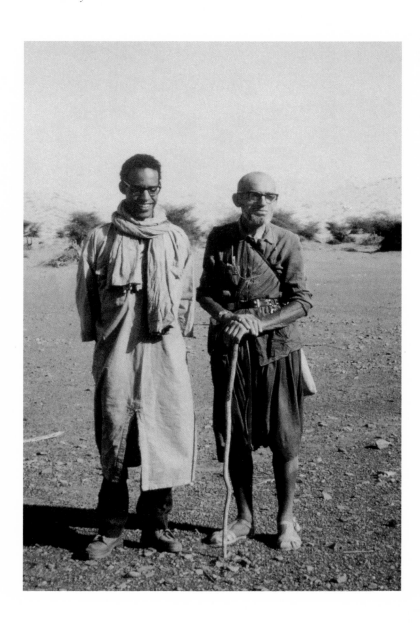

*He who loses himself in his passion*
*has lost less than he who loses his passion.*

Saint Augustine

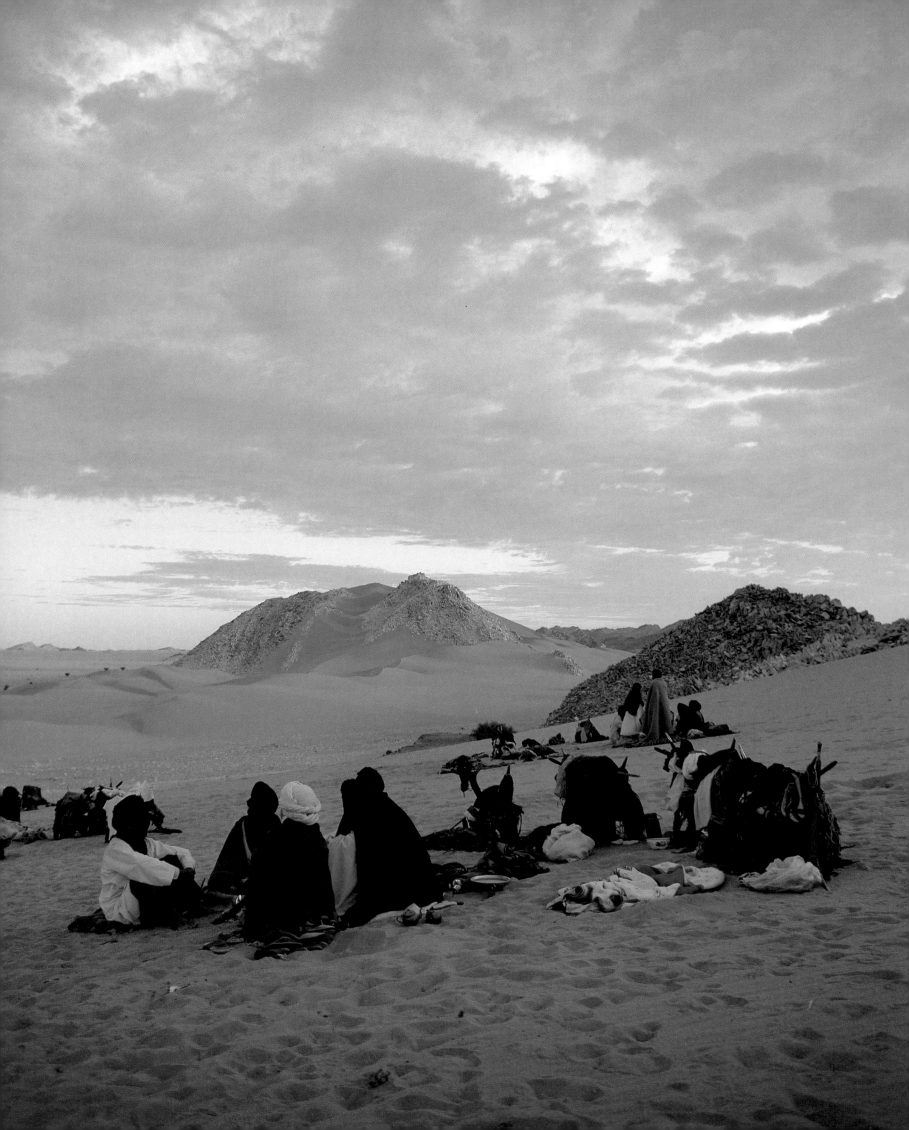

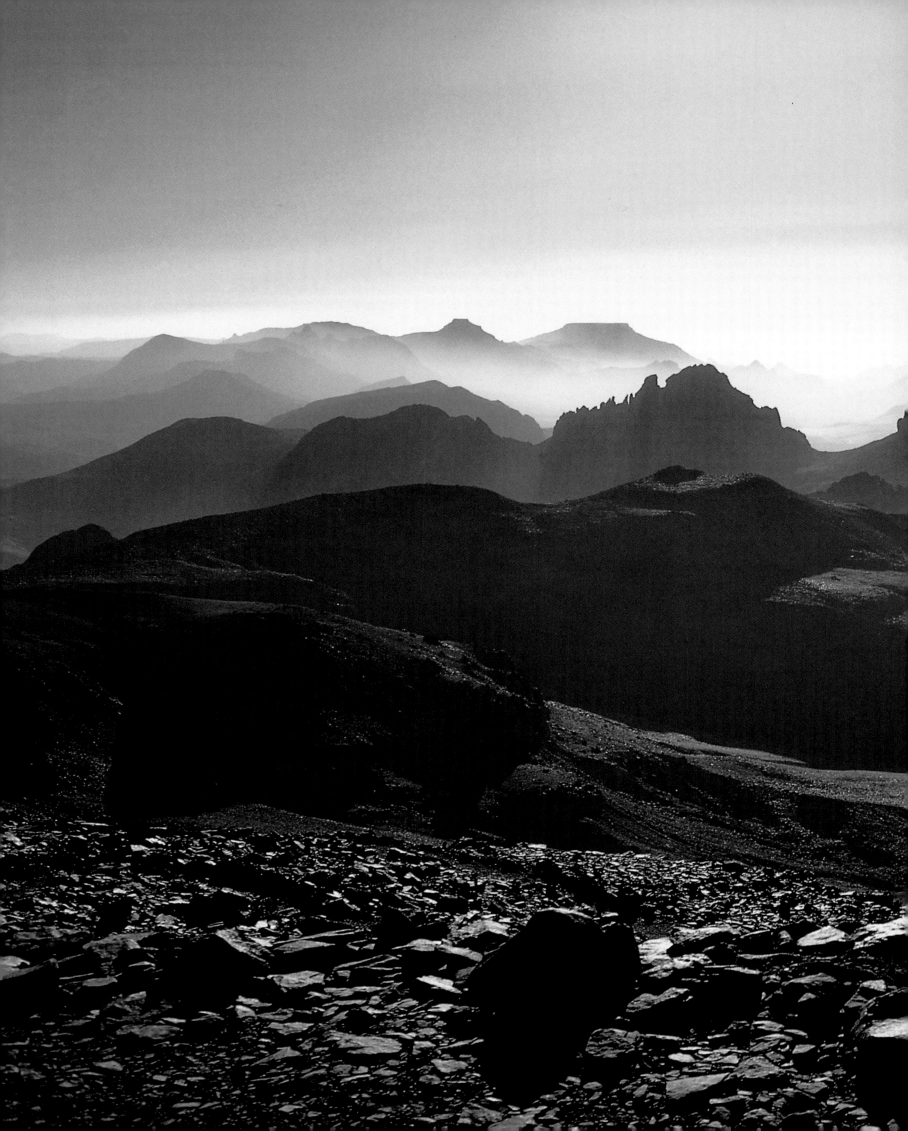

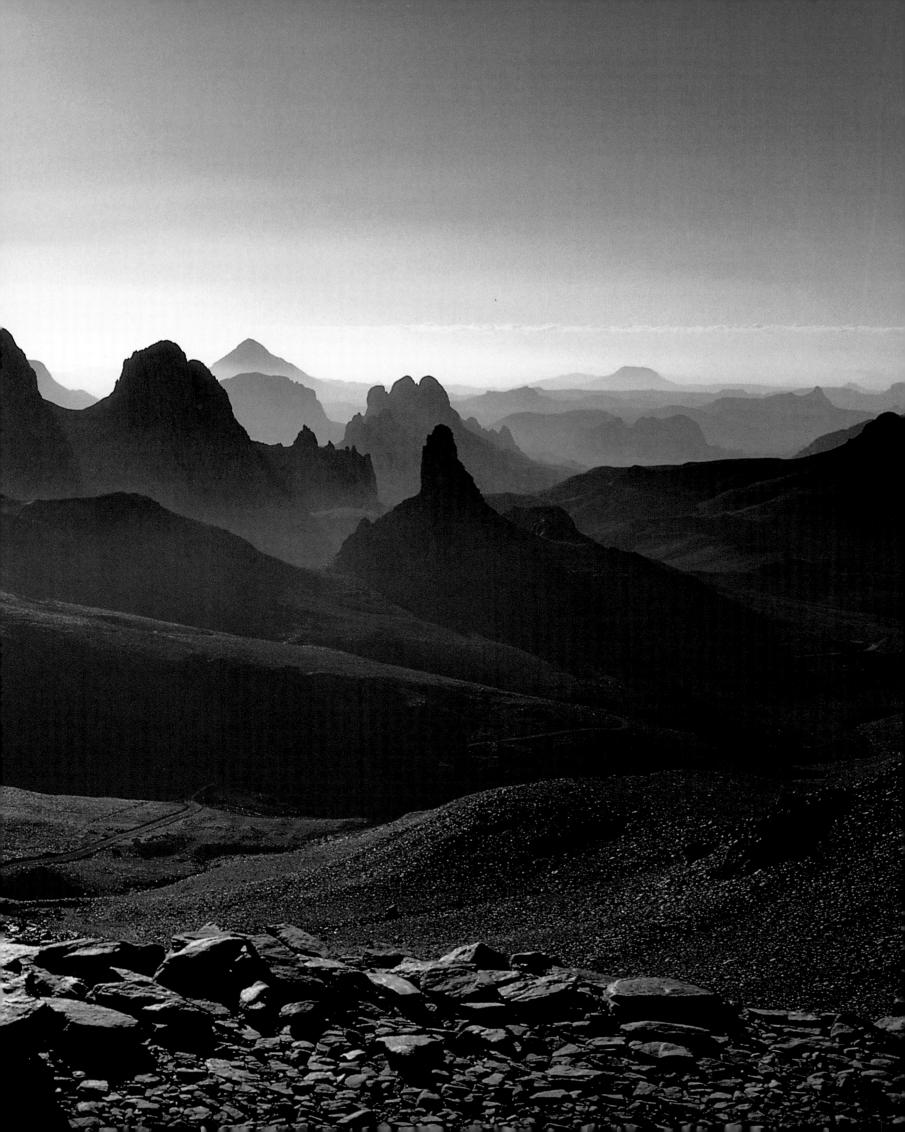

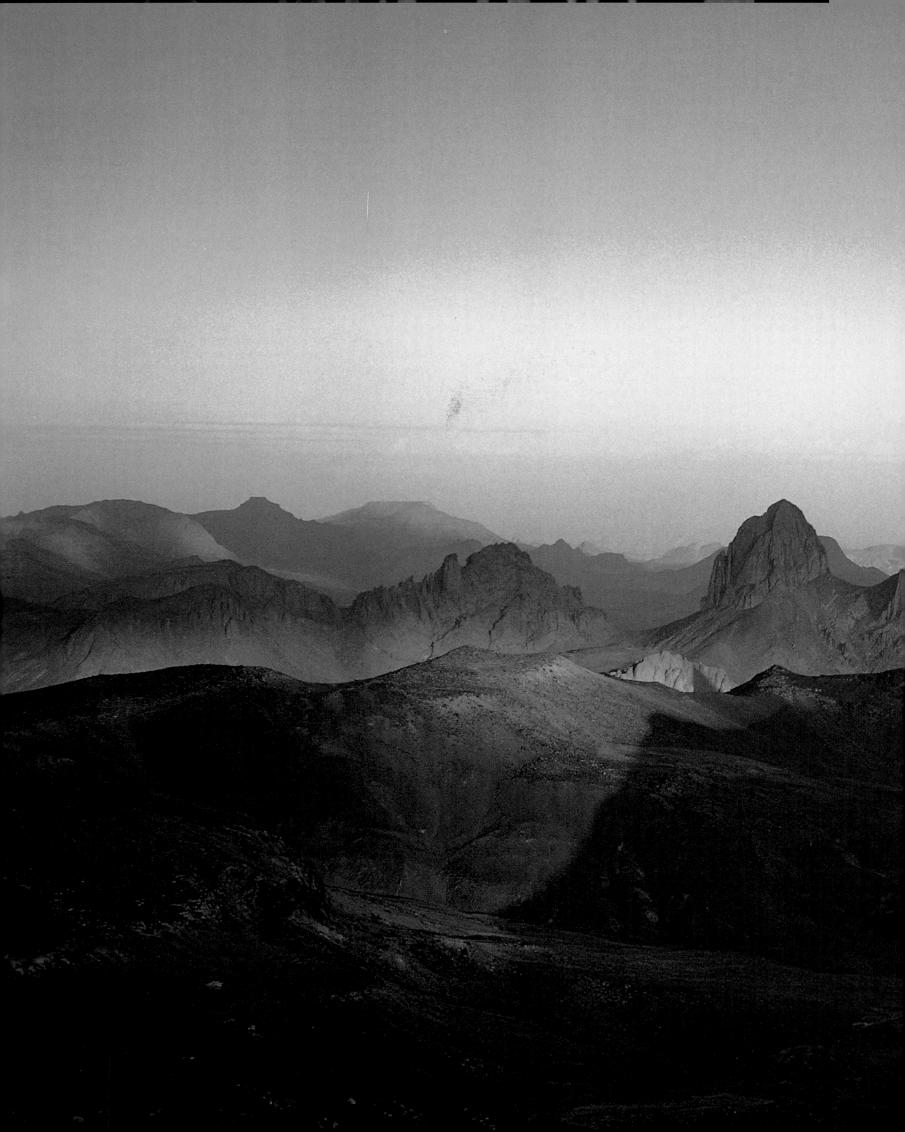

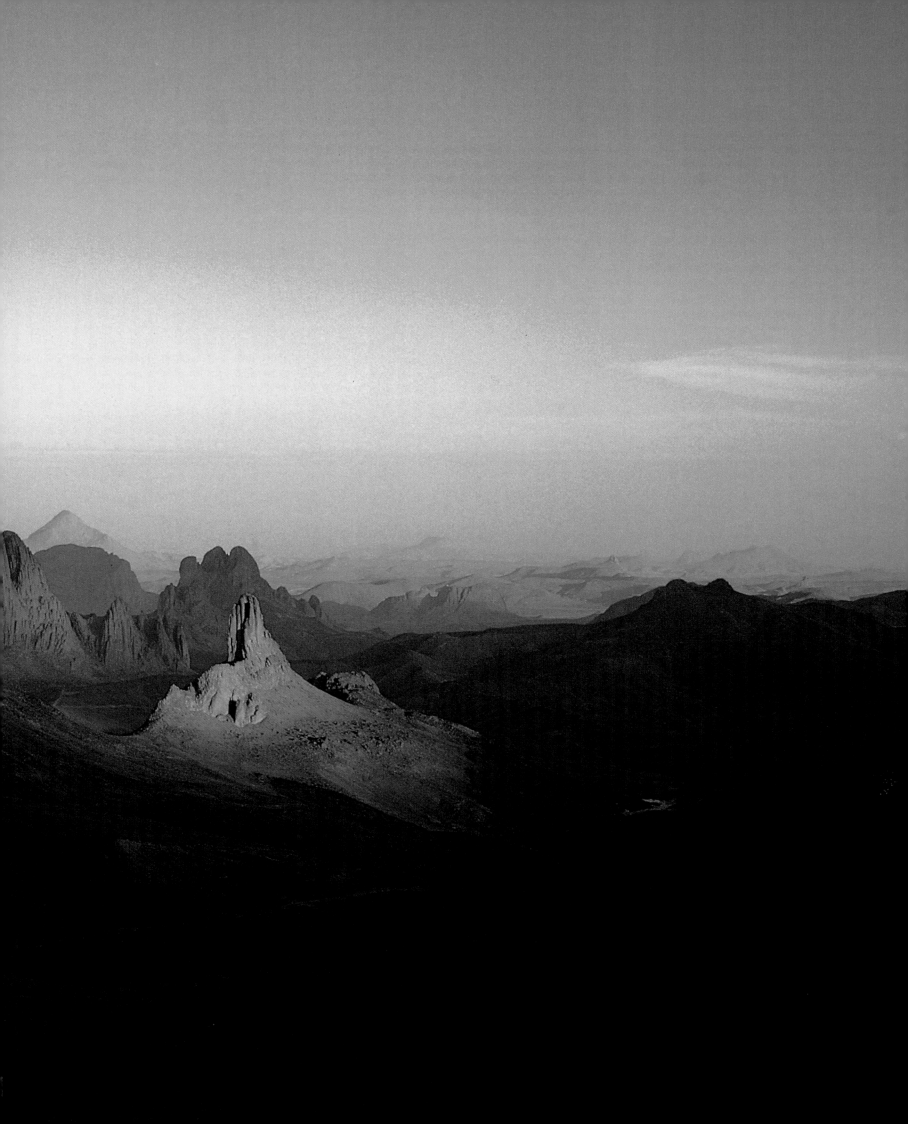

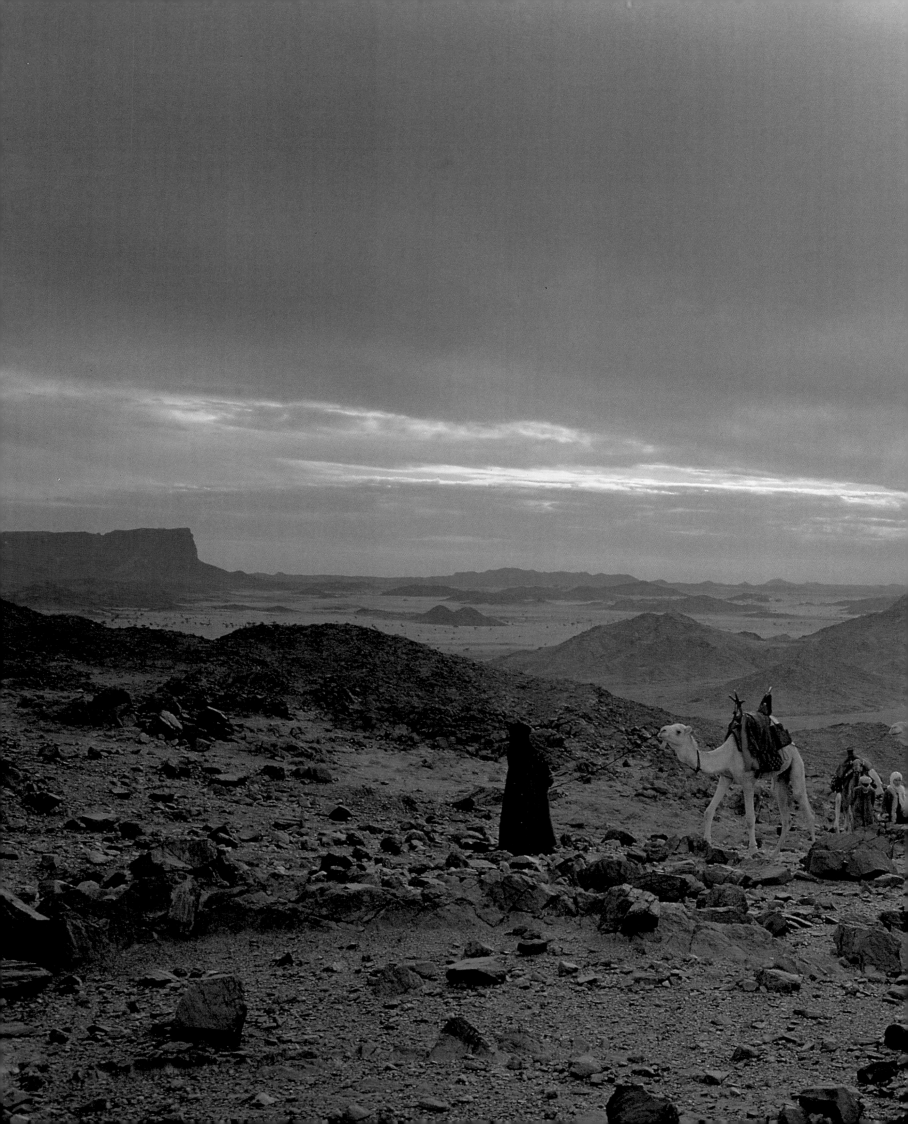

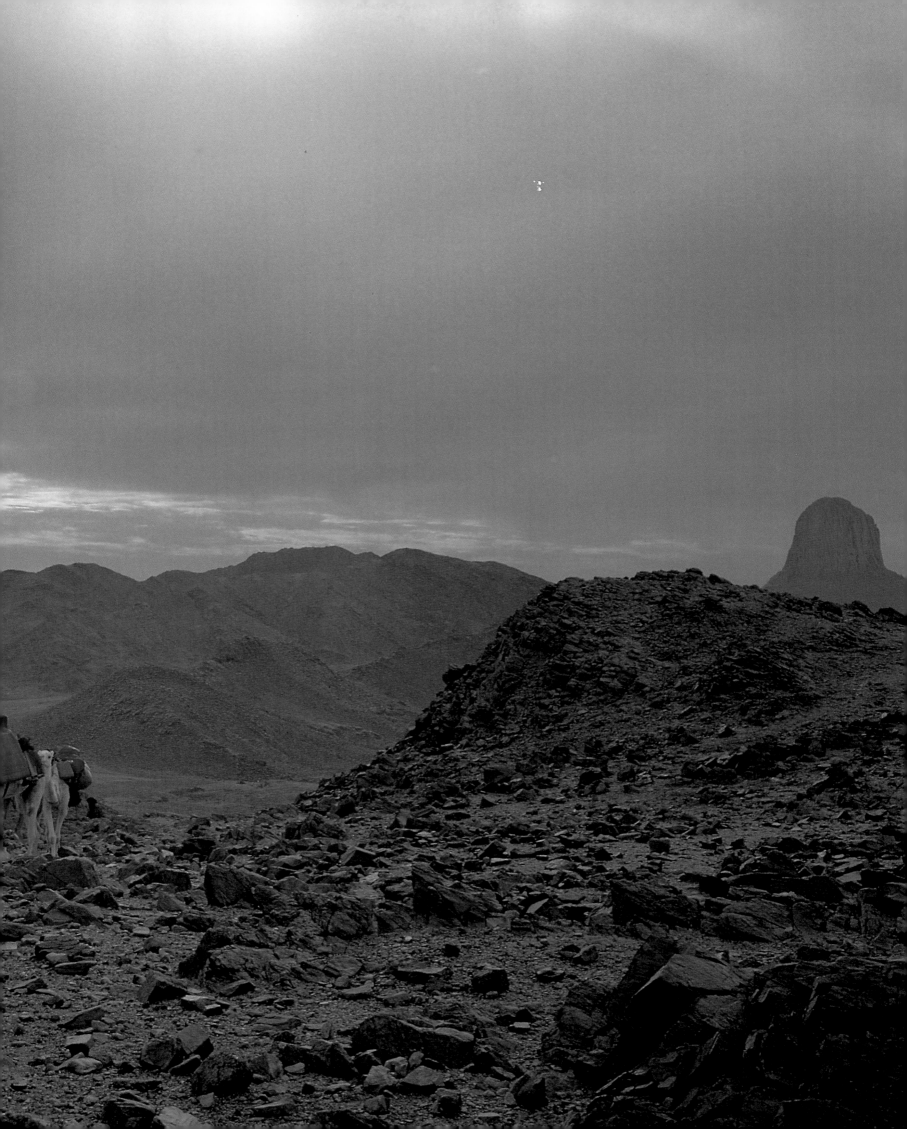

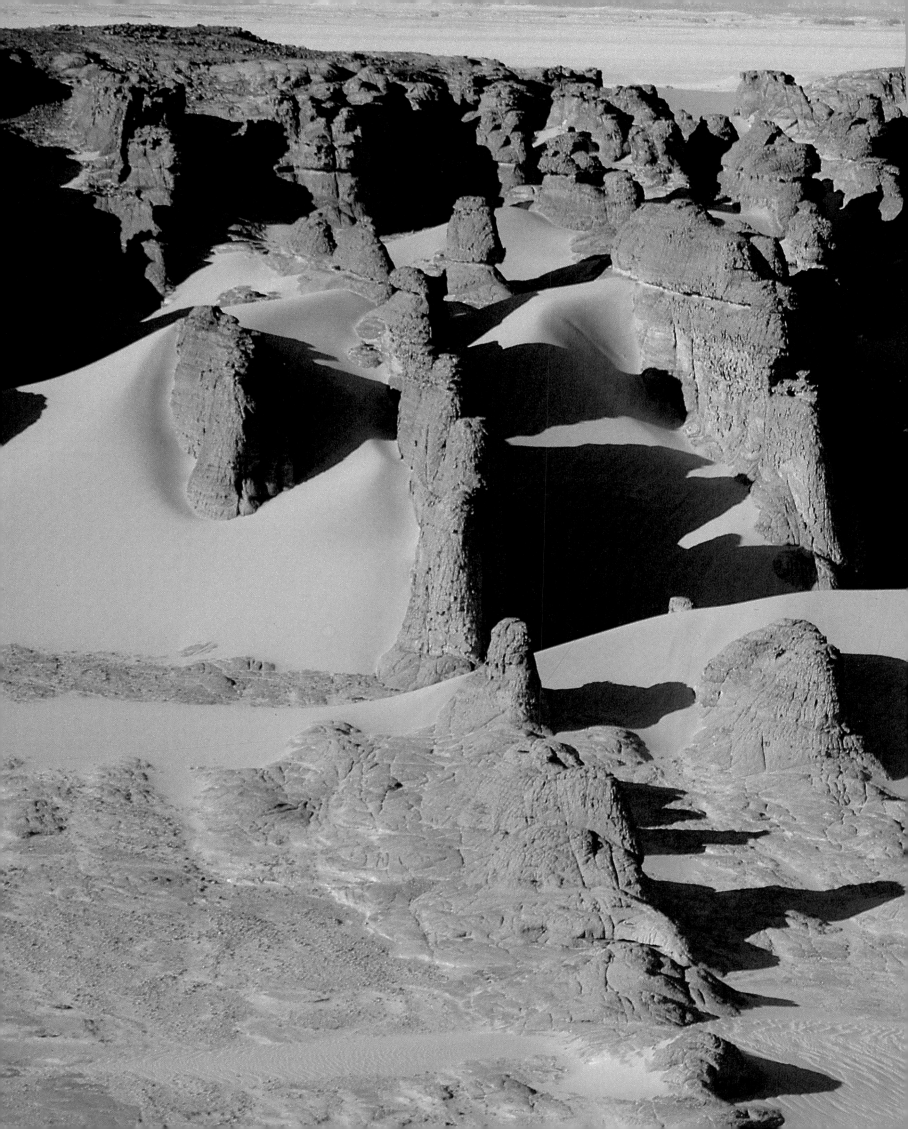

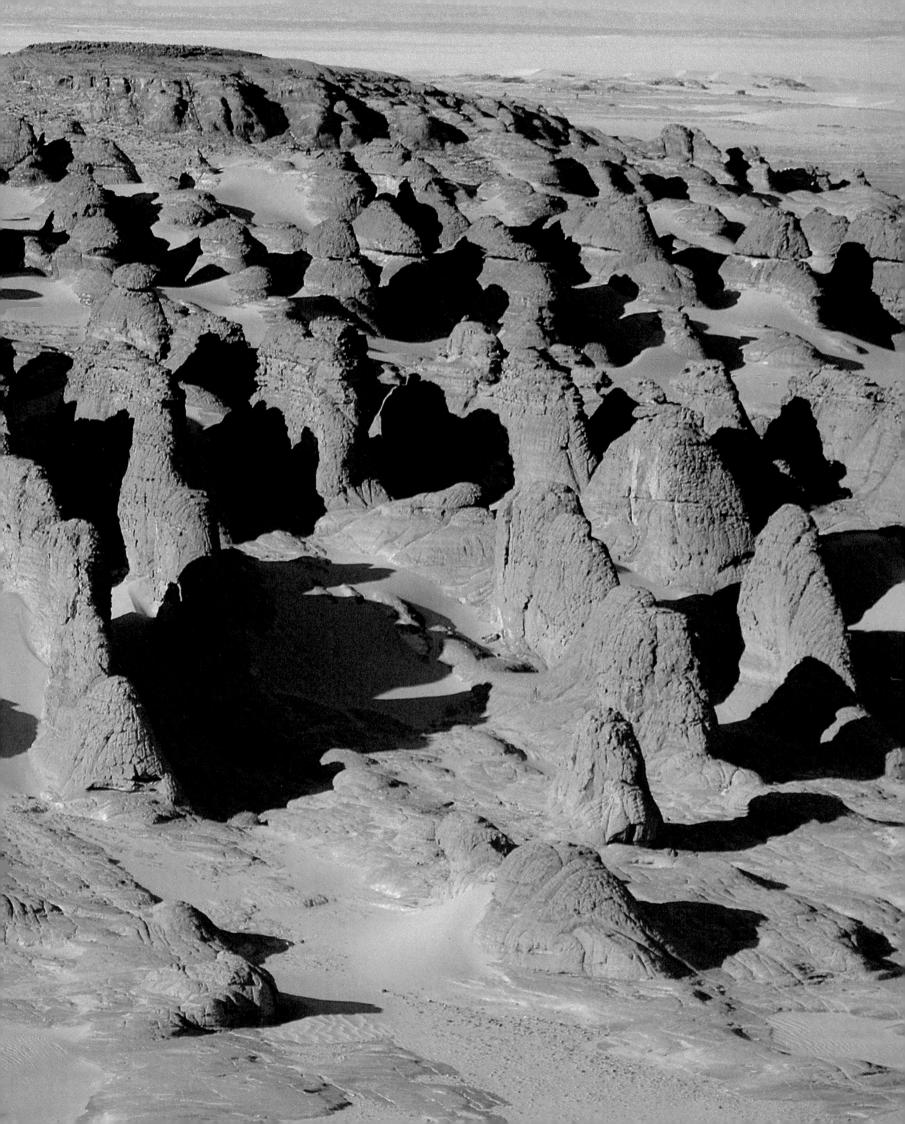

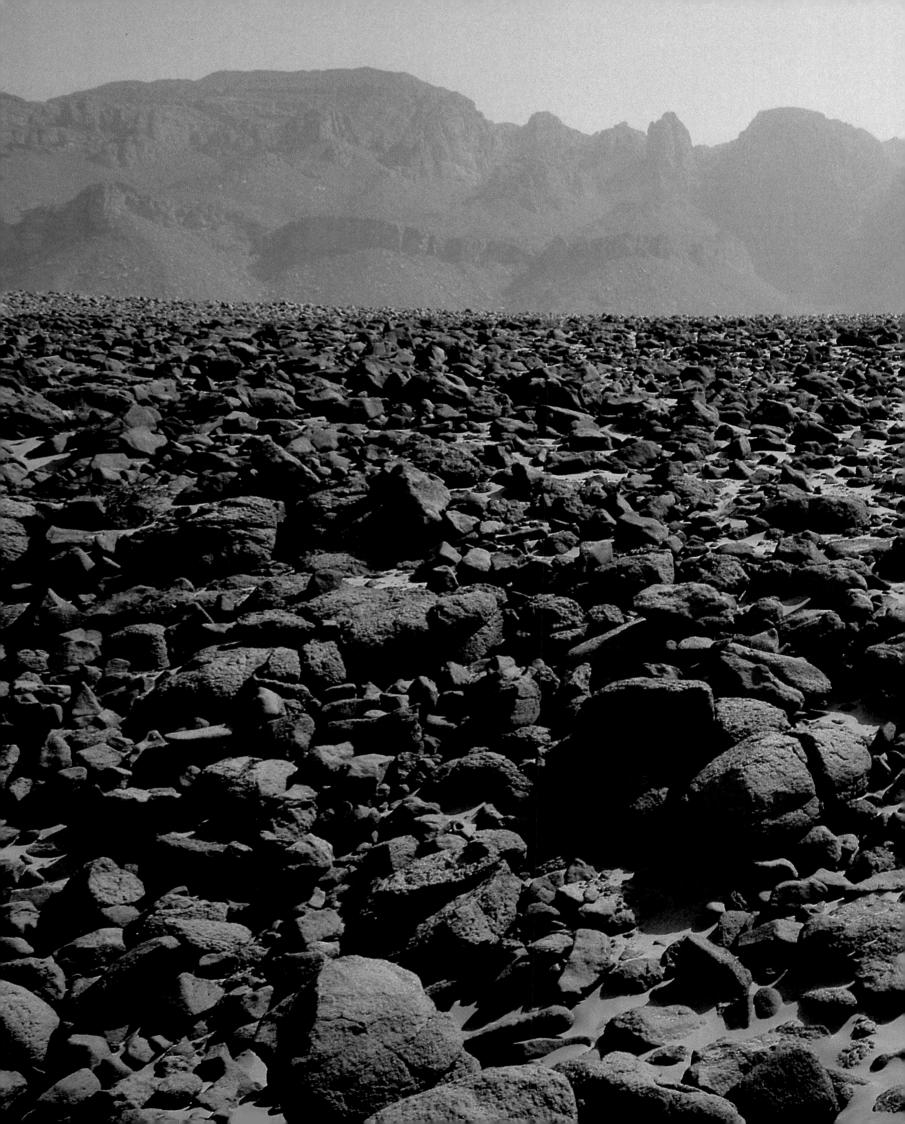

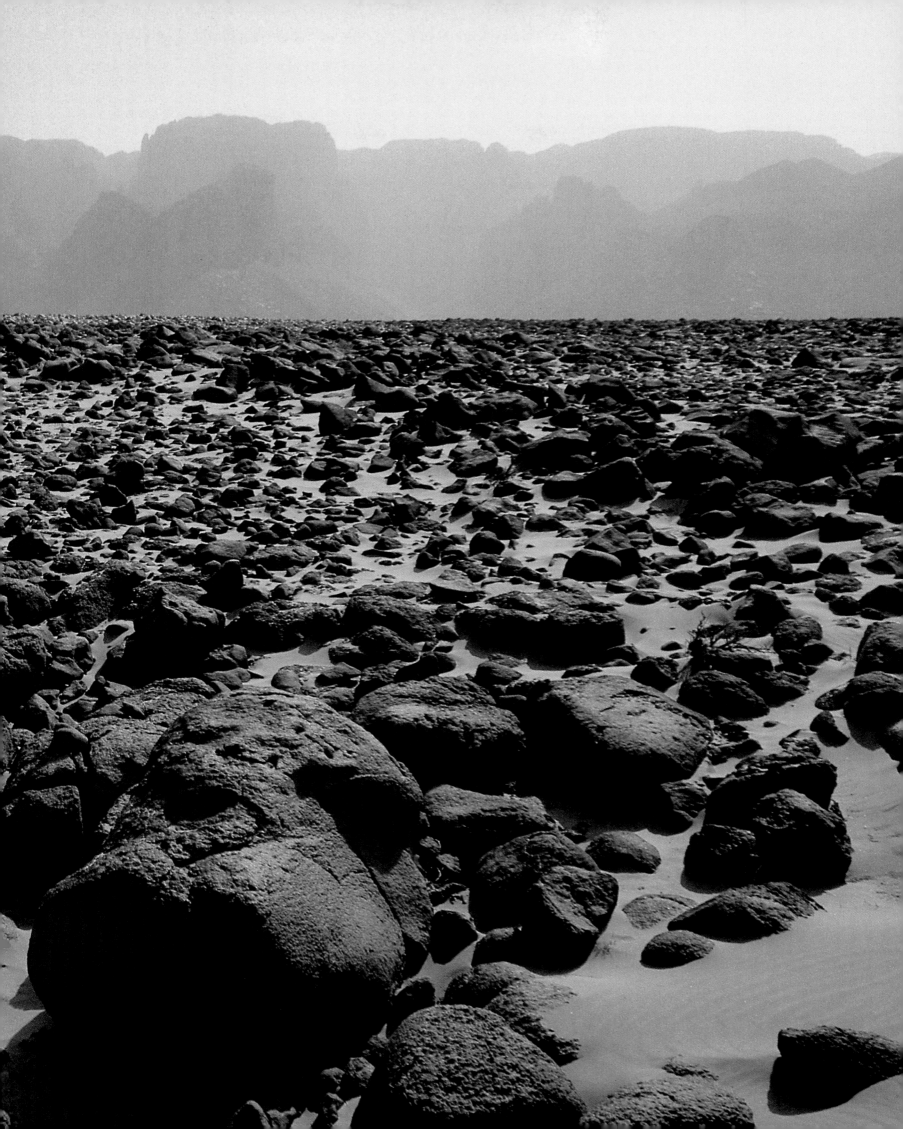

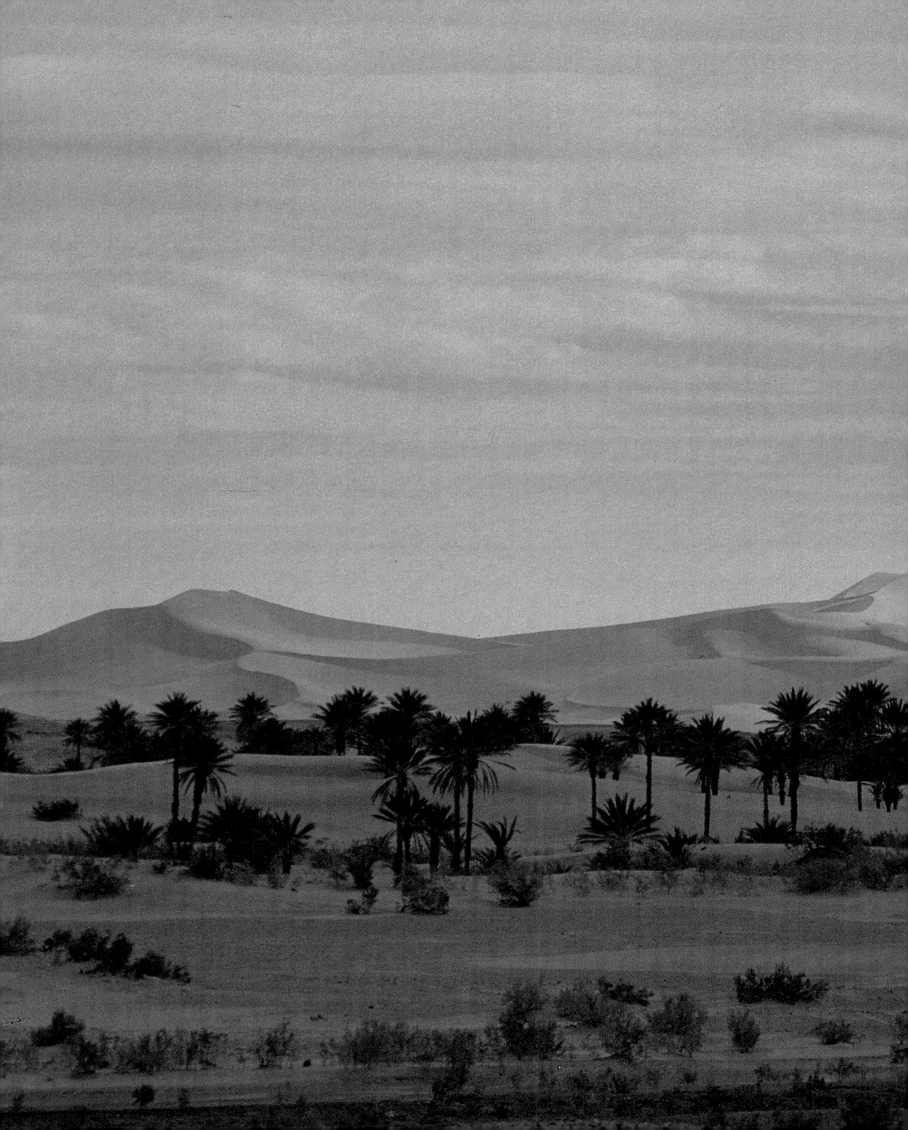

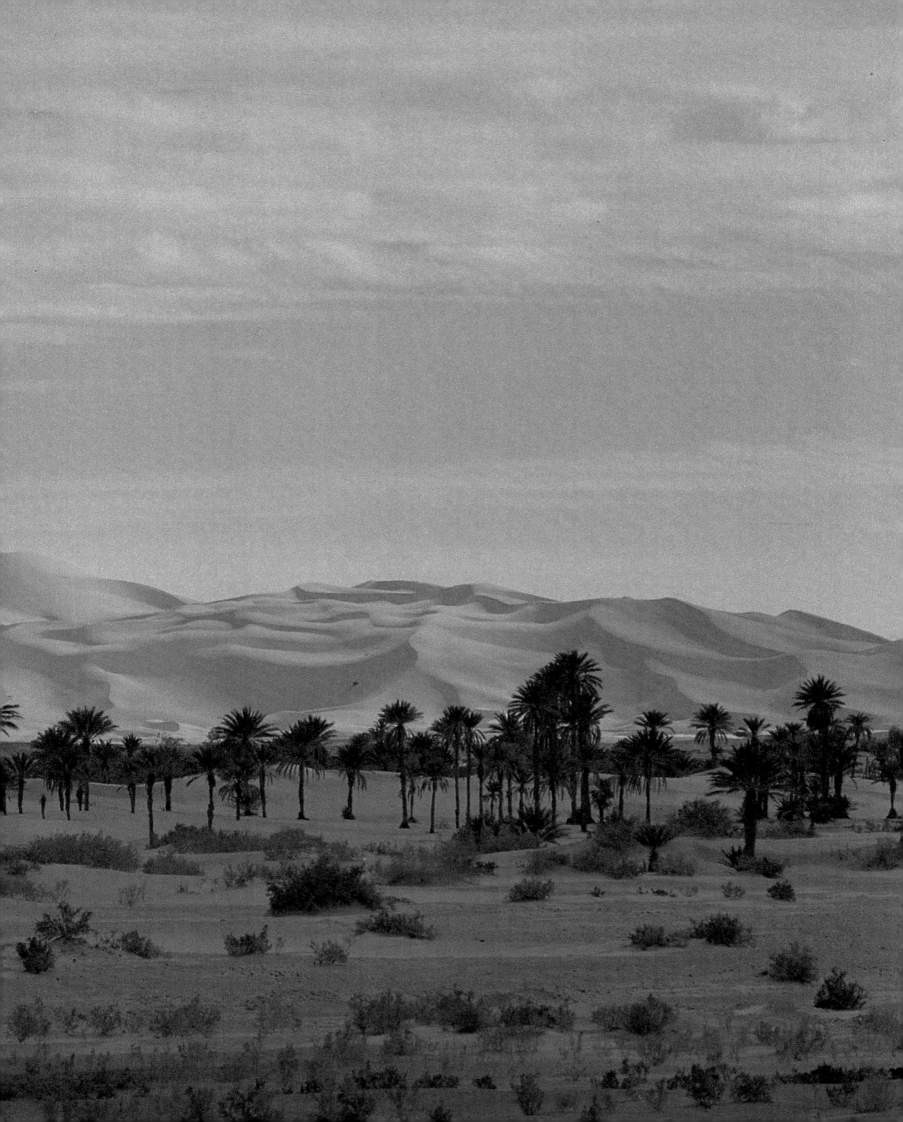

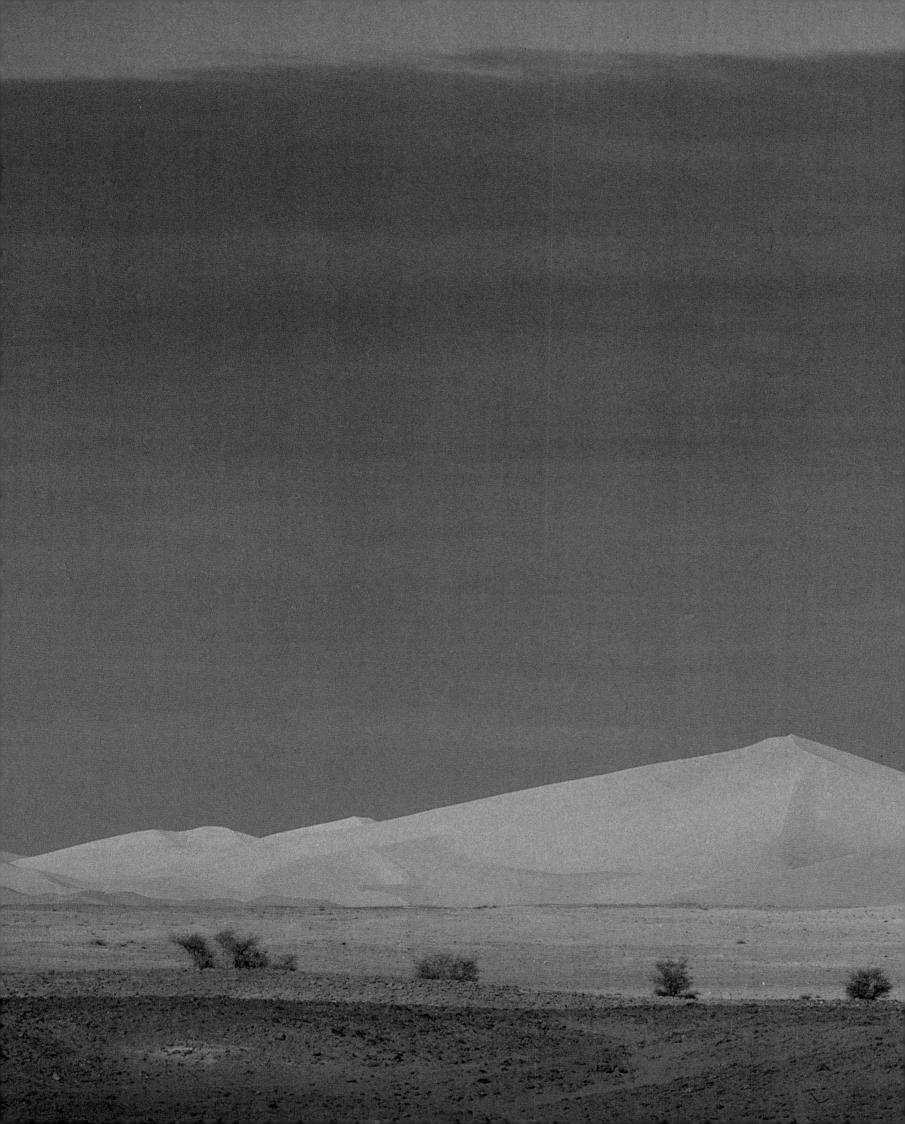

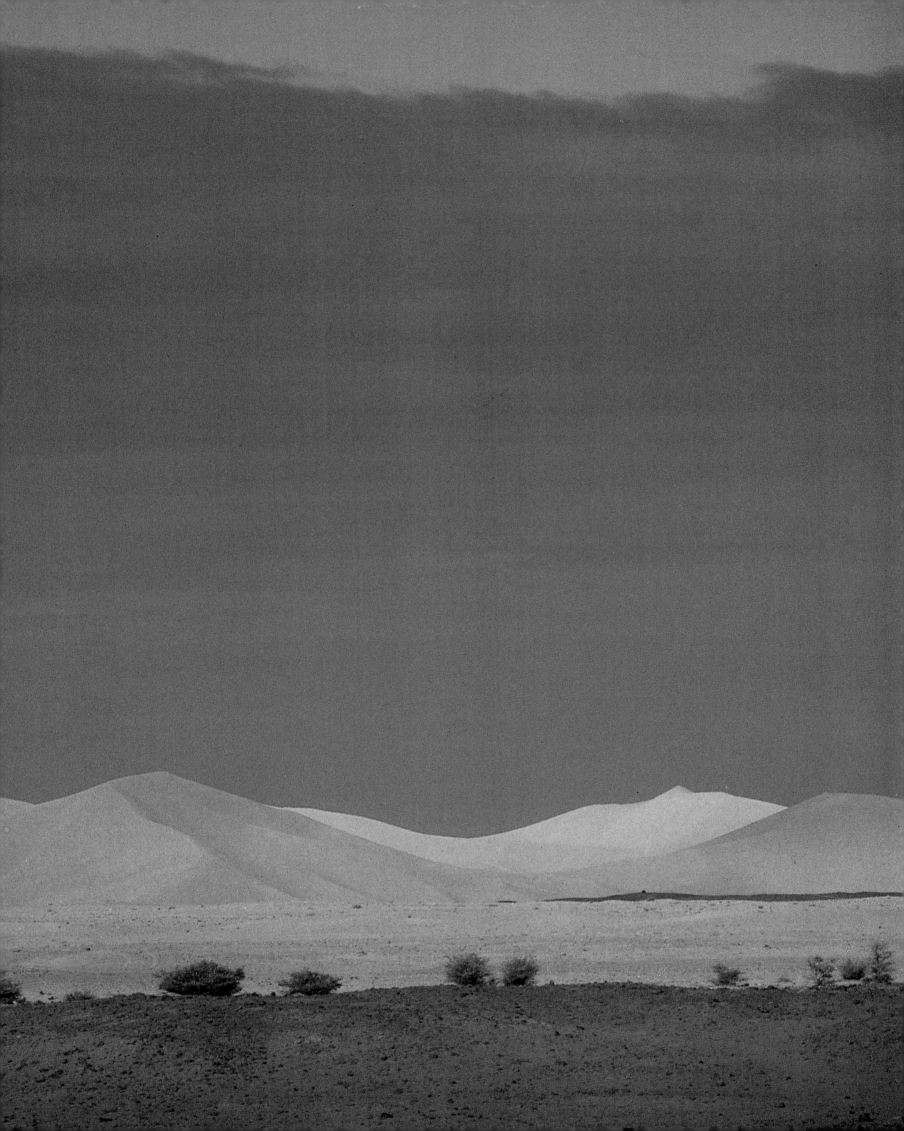

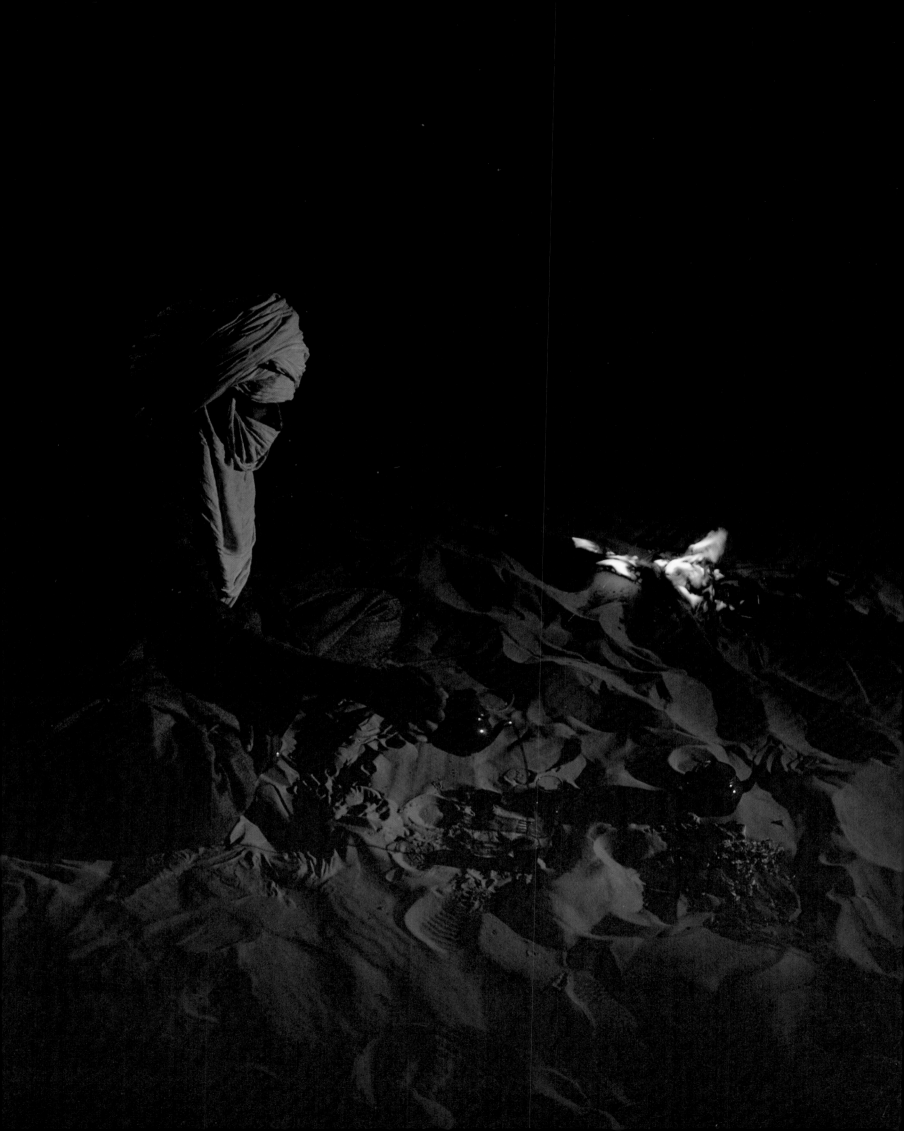

# VISITING THE DESERT

THÉODORE MONOD

At 12:10 p.m. on January 9, 1994, having reached a certain age limit (ninety-one years old), I dismounted from a camel for the last time. The parenthesis was closed: granted, it had opened on October 13, 1923, with my first trip by camel. It has been a long interlude, and these seventy-one years have been employed honorably enough to endow me with some authority on the subject of desert life.

Here, then, are a few thoughts about the Sahara desert.

## WHY?

This first question is easy. For those who live in the Jura or Aveyron regions, there are many natural environments on our planet that are totally foreign to traditional experience and that are singular and distinct: barrier ice, tundra, taiga, high mountains, dense forests, and oceans are each a world apart, strongly marked by their climate, fauna, flora, and the customs of the people who live there. In the *real* desert—I emphasize the adjective, because all too often what is called a desert is only an arid region with regular but light rainfall—more than a year can pass between downpours. Everything follows from these climatic characteristics: the structure and thus the landscape, the gradual decrease in the number of living things, and the amazing adaptive abilities of plants, animals, and human beings that enable them to survive the assaults of a climate that is by turns torrid and freezing. How do certain crucifers manage to germinate, grow, flower, bear fruit, and scatter their seed on sand that is only slightly damp? How does a small rodent, a gerbil, for example, which exposure to the noon-day sun could kill, manage to find shelter from the blistering midday temperatures? In response to a climate's harsh dangers, every species discovers the secret of survival—admittedly a fragile one at times—often through surprising adaptations.

The desert offers us a thousand more secrets to unravel, about both the living and inanimate worlds. Even just sand, for example, which is ubiquitous in the desert, raises countless questions about its origin, the conditions of its movement, how the mountain masses of an area—so beautiful to look at and so difficult to understand—came about. Compared with the forests of the Jura and the countryside of the Aveyron, the desert is an entirely different world, which can easily disorient visitors or arouse in them an endless wonder in the face of daily visions of grandeur. The sheer height of a cliff; the depth of a canyon; the sparkling white of a *sebkha*, a smooth, flat plain; the oceanic immensity of an *erg*, a region with shifting sands; the beauty of a dune, in light of the cruelly ingenious obstacle it poses to a tiny

caravan's progress; the wondrous water holes, sometimes edged with reeds and teeming with aquatic life—all this, and a thousand other sights that are fresh every day, soon persuade travelers that they have come upon a land that demands not only an aesthetic appreciation of the glory to behold but, perhaps even more, the respect due an environment that actually represents, in its naked perfection, what the world might have been like before the appearance of humans, as well as what it may one day become again.

## HOW?

Nowadays we understand that a woodcutter from the Jura or a shepherd from the Aveyron might want to explore the desert. The question is: How will they get from their forest or rocky terrain to the Sahara that they want to explore?

Obviously, some preparation is still required, albeit mainly of a psychological nature. There are several kinds of tourism. Of the agencies that organize tours to the Sahara, a number understand that they cannot take a group just anywhere, because of the risk of reckless plunder of paleontological and prehistoric sites. This kind of damage can happen quite easily. I will never forget what Professor H.-J. Hugot told us one day at Adrar Bous, an excavated Neolithic site on the eastern edge of the Aïr: "Twenty years ago, there was enough material here to fill a train. Today there isn't enough to fill a basket."

Many tourists have a kind of instinctive need to pick things up and take them away. This desire to appropriate is often harmless; for example, picking up an ordinary pebble because of its shape or color. Other times, taking away such a seemingly small token is a detriment to scientific study. It is hoped that most tour organizers and tourists recognize and respect the difference.

This respect for archaeological material should of course extend to anything written or depicted on a rock wall, carvings and paintings alike. Unfortunately, there is a great deal of vandalism, especially in cases of rock drawings being mutilated by a desire to take a piece away. Those who wish to photograph prehistoric carvings and paintings must also follow some rules: outlining areas in chalk to make them more visible is truly damaging and should never be allowed. Tourists generally don't cause much harm to flora and fauna, but they should be careful to respect the aquatic species in particular, especially those that live in permanent water holes. There have been cases of careless travelers making away with more than one hundred fish of a certain species from a site of great biological interest.

The well-mannered tourist should do everything possible not to disturb the natural surroundings or to leave behind a mess; groups on the move should take care to bury the day's trash carefully. If garbage and wrappings are not buried deep enough, the wind is guaranteed to unearth and disperse them. A respectful tourist agency leader truly concerned about keeping the areas where he takes his clients clean should pack the refuse from food preparation in garbage bags and then take them back to the base camp, where he/she can see to it that they are properly destroyed. Unfortunately, in some areas garbage trucks have become necessary on the more traveled routes to remove the trash left by travelers insufficiently aware of their responsibility.

I have often maintained that well-mannered tourists believe that what they wouldn't do in a church, mosque, or synagogue is equally out of bounds at the heart of a desert. Overall, however, we have not yet achieved that respectful consciousness. There is still a consid-

erable educational effort to be made, and tour operators have a great deal of responsibility in this area.

There are many types of expeditions, depending on the nature of the terrain and the means of transportation. And each has its advantages and disadvantages. Certain systems permit travelers to enjoy the pleasures of walking, riding dromedaries, and even traveling some stretches by car, to cover the less interesting areas quickly. For example, to achieve the discovery of Mauritanian Adrar, one must face 300 miles (500 km) of dishearteningly flat, monotonous open country and ergs.

Needless to say, not only plants and animals live in the desert, but also human beings, who especially deserve our fellow feeling rather than our curiosity. Travelers should know and apply certain rules of polite behavior: respect boundaries and avoid being intrusive, particularly by brandishing a camera where it is inappropriate to do so and dressing in clothing that may be deemed inappropriate and even scandalous by native peoples.

What a perfect world this would be if all of these behavioral guidelines were obvious; unfortunately, that is not the case. I can only hope that my appeal reaches the ears of those who have yet to discover the desert. First-time visitors to the Saharan desert will experience deeper joy than they could ever imagine, from landscapes crushed by the sun and heat of the day to the glorious splendor of star-spangled nights.

Traveling friends, I wish you a good journey with all my heart, because I know that after your initiation, we will surely see you again, beneath the scented acacias of the wadis or at the foot of a high dune that the evening will soon drown in shadow.

THÉODORE MONOD
*Naturalist and explorer*
*Member of the Institute (French Academy of Sciences),*
*the French Marine Academy,*
*the Academy of Sciences of the French Overseas Territories,*
*the Lisbon Marine Academy,*
*the Belgian Royal Academy of Sciences of the Overseas Territories,*
*Laureate (gold medal) of the French Geographical Society,*
*the Royal Geographical Society,*
*the American Geographical Society*

# THE DESERT, MY CHOSEN ENVIRONMENT

Bruno Lamarche

Why do I love the desert? Well, it's a very complex thing. Here, in no particular order, are notes, anecdotes, reflections, and scattered thoughts. They were like bubbles rising up and popping at the surface as I rode absentmindedly (or at least so it seemed) on a cranky, stubborn camel.

Our planet exhibits a few broad types of environments—forests, mountains, deserts, and oceans—each of which, moreover, exists in cold and hot versions. What these various vast ecosystems have in common are immensity, their vast impressions of space, their ability to inspire feelings of solitude and fragility, and the impression of how difficult it must be to live, survive even, in them, so variable are the climatic conditions.

To keep from disappearing, plants and animals adapt (sometimes rapidly and in surprising ways); humanity, which lacks the same adaptability of plants and certain animals, but at the same time has a highly developed mind, creates specific survival techniques instead. Sometimes, however, carelessness or ignorance in this regard can have fatal consequences.

Water comes to mind first, because to forget to fill your keg or *guerba* in a preventative fashion is, on certain routes, certain death. This has been known to happen to overly confident nomads; they inevitably "dry up," sometimes at the very lip of the well they were striving to reach, either because they had no rope or they tried to reach the life-saving water down in the well, but, ironically, were so exhausted that they slipped, fell, and drowned!

One must also know and recognize as much as possible the best route to take; not just anyone can be a guide. Experience with the terrain is not always enough, even for the nomads. A case in point is that of three old Taoudenni hands who, after quarreling with their guide at the Bir Ounane well, decided to proceed south on their own, with their salt-bar-laden camels. They lived to tell the tale only because we happened to cross their path as they were about to go into the Awana. There, in early May, they would surely have disappeared, since they were low on water and completely disoriented.

When people speak of the desert, and especially of the Sahara, they most often cite the heat as the greatest discomfort. As far as I am concerned—and though I have on occasion experienced extreme temperatures, (over 122° F [50° C])—my worst memories are of the cold. There is no question of riding a camel in the cold, for up there in the saddle you immediately turn into an ice cube. So you walk, wrapped up in every layer you can find (the resulting getups are often hilarious. We'd laugh heartily, if our lips weren't cracked!

These small miseries await travelers not only in the mountains (Ahaggar, Tibesti . . .), where the altitude naturally results in low temperatures, but also in regions at lower elevations. Even on ordinary plains you can find yourself in areas where the mercury cuddles up to zero and where even the lightest wind painfully numbs your toes. (And there's always wind; sometimes a little, sometimes a lot!) That's when you wish your leather or plastic sandals were slippers and when you long to be by the fireside; instead, you singe the soles of one another's feet with torches of dry straw before starting off once more. The day's walk requires a more or less steady pace.

It is no doubt because of these minor annoyances that walking, camel-riding, and expeditions in general provide such effective lessons in foresight, organization, endurance, patience, and objectivity, lessons that allow plenty of time to ponder—a rarity these days, at least under certain skies!

If I am able to write so readily about the desert and the ocean (which I enjoy just as much), it is because these two environments have much in common. They both require long journeys to cross, with no chance to replenish either food or water, as well as varying degrees of navigational techniques. Also, the resulting social mingling aboard a ship and in a caravan can't be beat. Until very recently, the great desert crossings—just like those at sea—necessarily meant traveling with many others; you had to board a vessel or take a place in a caravan.

Travel wasn't always about exploration; sometimes it was all business. With money to be made, it was time to get serious. So much so that until very recently, significant expanses of the Sahara (and of the ocean) were known only to a few addax, seal, or whale hunters who tended to be rather closemouthed about their hunting grounds.

But mindsets have changed gradually, and techniques have evolved; there is more openly acknowledged psychological training, and smaller group outings have multiplied. People have begun to talk more about what they feel at sea and in the desert.

When one contemplates the desert, especially the Sahara, one sees a remarkable entity, one whose people cheerfully cultivate duality, even paradox. The corollaries of emotions often straddle suffering, struggle, and resignation, a game of "splendor and misery"—of the mountainous dunes (the rapturous appreciation of their feminine curves and the softness of the sands), and of the oases (palm trees swaying in the wind, the palette of tender shades of green, the fragrance of mint, and shadows can mask the gardener's stubborn perseverance as he strains to keep bending the well's counterweight, ceaselessly raising the streaming baskets of quicksand . . . a Sisyphus, but with liquids).

The struggle of life versus death in the face of intense aridity is continuous. Threatened by the climate, life, in its many forms, takes refuge in the shelter of a rock, or is driven into a fold in the ground.

Some animals are fascinating. It is amazing enough that there are certain little mice (jerboas, gerbils, and others) that manage to more or less survive on dry food. These lovable little critters spend the deadly hot hours of the day in the shelter of their comfortable burrows, where the temperature and humidity are ideal. No torrid midday or sandstorms for these rodents; they come out in the cool dusk, the best time of the day—if nothing else, it saves water!

It is less obvious how comfort and economy come into play with the addaxes, which, given their size, must stay aboveground. How do they do it? Of course, I know something about how their kidneys work and about relative homeothermy and other physiological marvels, but it is still a mystery. I have followed these herbivores step by step for weeks on end, in var-

ious seasons and equally various temperatures, and I am still filled with wonder at this animal, compared to which the camel's legendary sobriety looks like a waste of water.

Sometimes I am amazed when I meet an animal in a spot that may be livable, at least in desert terms, but am faced with the question of how that animal came to be in that spot. For example, how did that snake (without feet, of course) or that hedgehog (with feet, yes, but very small ones) get to this patch of pasture, some ninety miles (150 km) at least from the relatively comfortable zone in which their closest kin live? How did they know there was vegetation here? Were they parachuted in? Is there such a thing as spontaneous generation? I lose myself in speculation.

In reality, everybody's search for food is limited to regions where it has rained and there is pasturage. This quest requires mobility, which makes it easy for birds, less so for mammals, and seemingly very difficult, if not impossible, for reptiles, since in these zones feeding oneself is also the struggle of Life against Time and Space.

Nomadism is the attempt to negotiate between transience and distance.

Gazelles and camel drivers live under the same sign, pasturage is ephemeral and unpredictably sited, nothing to do but move—and fast!—if you want to live, or simply survive.

Gazelles, camels, and Bedouins, among others, are miracles of adaptation and of survival techniques. Politicians would sweep away these products of centuries-long, even millennia-long, efforts with a single controversial stroke of the pen, "settling the nomads," as if there were alternatives to the peoples of these cultures: it's not nomadism or something else, it's nomadism or nothing at all!

And yet, sometimes it rains, and then it's Byzantium!

Much has been said about the wadis in a spate of raging torrents that wash away huge boulders and tree trunks—a natural, truly impressive sight. All the more so because this fury is utterly fleeting. Soon after, nothing remains except a few scattered puddles, a waterfall that becomes a trickle then dies out . . . yet the water is there; soaked down to the sand's very heart, hidden in the deep crevices of the rocks. It is the life of future years.

Elsewhere, the effects of the rains endure more visibly when the substratum is clayey and extensive. Under those conditions, a torrential downpour can sometimes give rise to huge frozen pools; you go from awe to marvel to delight to annoyance, because you then must go around these shallow lakes that are uncrossable, since camels dislike skating and slipping on ice.

As for plants, they enjoy water in all its forms: abrupt storms (even hail; water in all its forms counts!); classic downpours like those of temperate lands; fine, long-lasting drizzles; and even damp fog (observe along the Mauritanian coast, where the dew can often be very heavy). All is washed, everything is clean, colors are refreshed, visibility is astounding; suddenly you can spot very distant mountains. What beauty!

The seeds respond instantly, each plant more swiftly than the next. Soon prairies are rippling in the wind; the *girgir* carpets the floors and hollows of the dunes with its tender green; trees flower, everything is fragrant. Otherwise, scents are so very rare in the desert.

The fauna are lively then, especially the insects. The *buprestis* (living jewels) beetles cling to the acacias' golden catkins; the horned caterpillars known as "sphinxes" happily devour the tender spurge; and the bright red velvet pompoms of *Thrombidium* roam awkwardly across the sand. As for the camels, you can no longer see their feet; gorged on flora, their bellies distended, they look like large, amiable, green-lipped barrels. The dunes no longer "smoke" in the wind: they, too, are gorged, but with water.

There is life there.

Then the plants dry out, but the perpetuation of the species is assured; the wind can heap the dried purple *girgir* flowers in the hollows of the dunes, creating delicately sumptuous mauve coverlets.

The desert's morphology, its flora and fauna, often reduced in the extreme, gives an impression of newness, of purity. It is a world without human beings; it could also resemble the world before human beings . . . before the invention of concrete and highways, before the mass media, before many unfortunate advances.

Our impressions of the relatively pristine Sahara and of the passing of time are further reinforced when we find ourselves contemplating the traces of the Paleolithic and Neolithic periods. Whether in the hollow of a dune or on a reg, at the foot of a cliff or on the shores of a dry lake, the emotions we feel are always powerful, so recent do these relics sometimes seem, as if the workshop was abandoned only yesterday—the day before yesterday, at the most. The grindstones and mills are there at the camp; so are the pottery works and the stone-carving tools. Everything was suddenly left half-finished. Why?

Sometimes the traces of human beings and animals—antelope, horse, hippopotamus—are captured in the clay, which gives a striking "snapshot" feeling: that hippopotamus looks as if it slipped on the edge of the marigot last night; instinctively, we look for the silhouettes of adult and calf on the shore of the dried pool.

These paintings and carvings, in all their variety, reinforce these impressions. The animal life of the Sahel—in fact, of the Sudan—is there, sketched perfectly in their habitats: amid herds, grazing, running. The livestock, too, is in place: herds of what look like the majestic-horned Fulani cattle with their loose-limbed herders . . . a cozy Sahel of grass, thornbushes, marigots—and sand flies!

A green Sahara; a Sahara of pools and lakes (thriving with turtles and enormous Nile perch); a Sahara of fisherfolk, and of great masses of reeds within which watch many crocodiles; a Sahara of graziers and travel by wagon.

You can't help but reflect that this arrow shaft and that flint have been there—untouched—for thousands, perhaps even tens of thousands of years. You are gripped by vertigo, a feeling of insignificance.

The sensation of time flowing by is very strong, and a little frightening. As it says in the Scriptures: "the fashion of this world passeth away" (Corinthians 7:31).

No doubt it is these different aspects of the Sahara—a feeling of purity, and of almost absolute calm, an awareness of the passage of time, the extreme sobriety that it requires—that made the desert a school of detachment, and hence of thought. Though certain factions may choose to emphasize their differences rather than their points of contact, we should recall that the world's great religions—Judaism, Christianity, and Islam—share a common origin: the desert.

The value of the hermit's or anchorite's way of life is no longer argued. A period spent in the desert is an initiation, and the day will come when "water will spring up in the untilled plain, where the earth shall become a pool, where the land of thirst shall turn into springs" (Isaiah 35:6–7). A descent and prolonged sojourn into our "interior desert" are necessary, but to attain the cosmic dimension we must not only love life but love the living world with tender equanimity, as practiced by certain fathers of the desert.

This means retaining our sensitivity and sensuality. The sounds of the desert, for example,

tend to elude those whose ears, saturated with noises of the modern world, have become completely deaf, or at least indifferent to Nature's multiple voices. These people are equally unaffected by all the different smells, the various (albeit rare) scents wafted by the breeze. In the desert regions, our noses become hypersensitive: we can smell fire (straw or wood) from dozens of miles away, rain from one hundred miles. The same phenomenon occurs at sea: we can sometimes smell an island before we see it.

The Sahara is by turns harsh and tender, perilously fatal and full of life, a source of joy and affliction and suffering; it is a site of reflection that leaves no one indifferent.

These are the reasons why I love this environment, where love and knowledge are intertwined, and where detachment and renunciation blossom into experience. It is called *desert*.

BRUNO LAMARCHE
*Naturalist*
*Professor at the Écoles normales supérieures*
*of Bamako and Nouakchott*

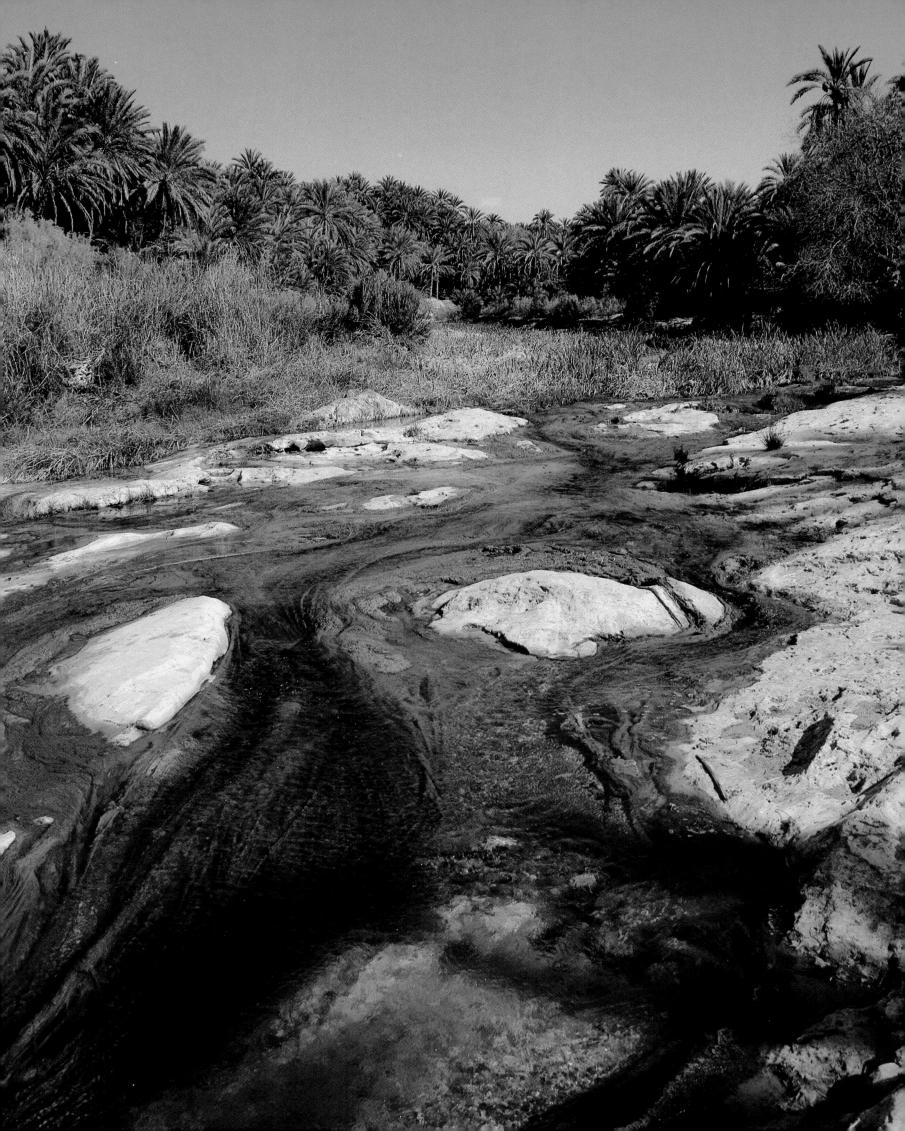

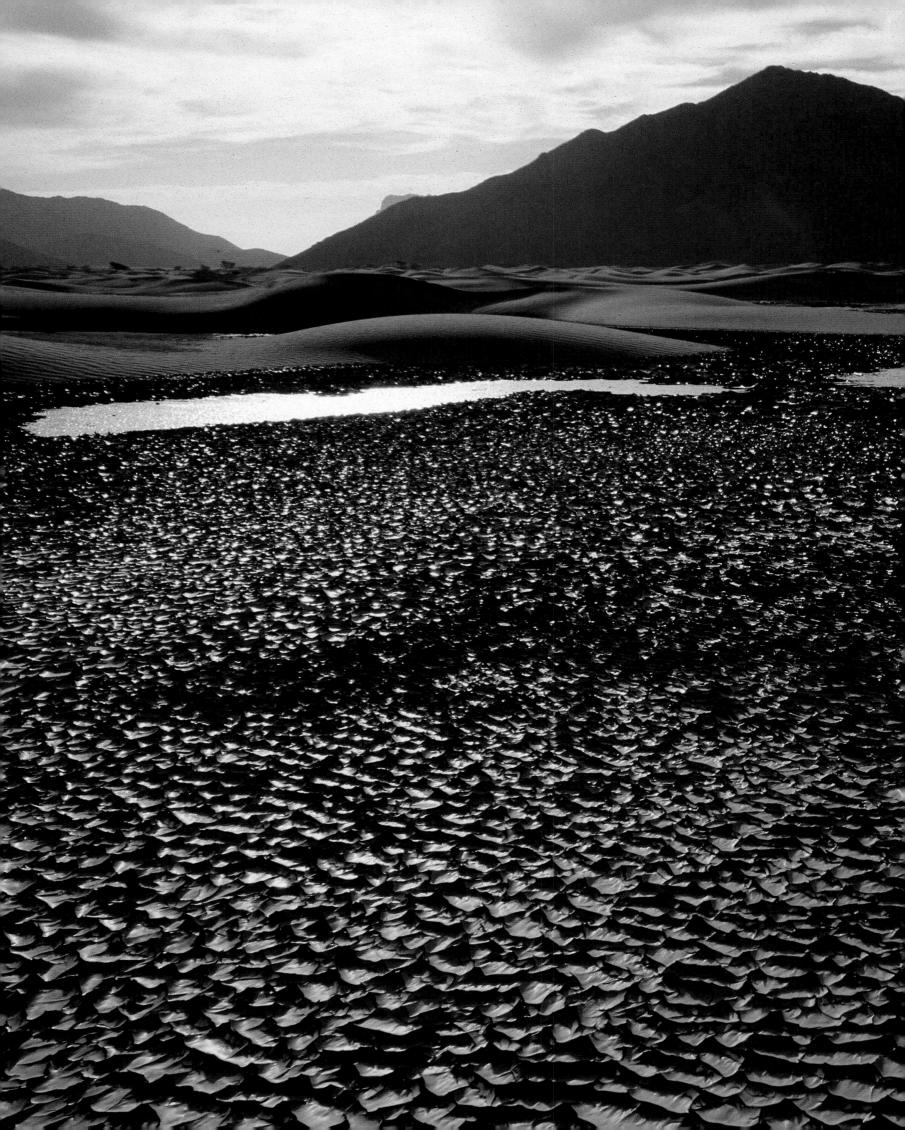

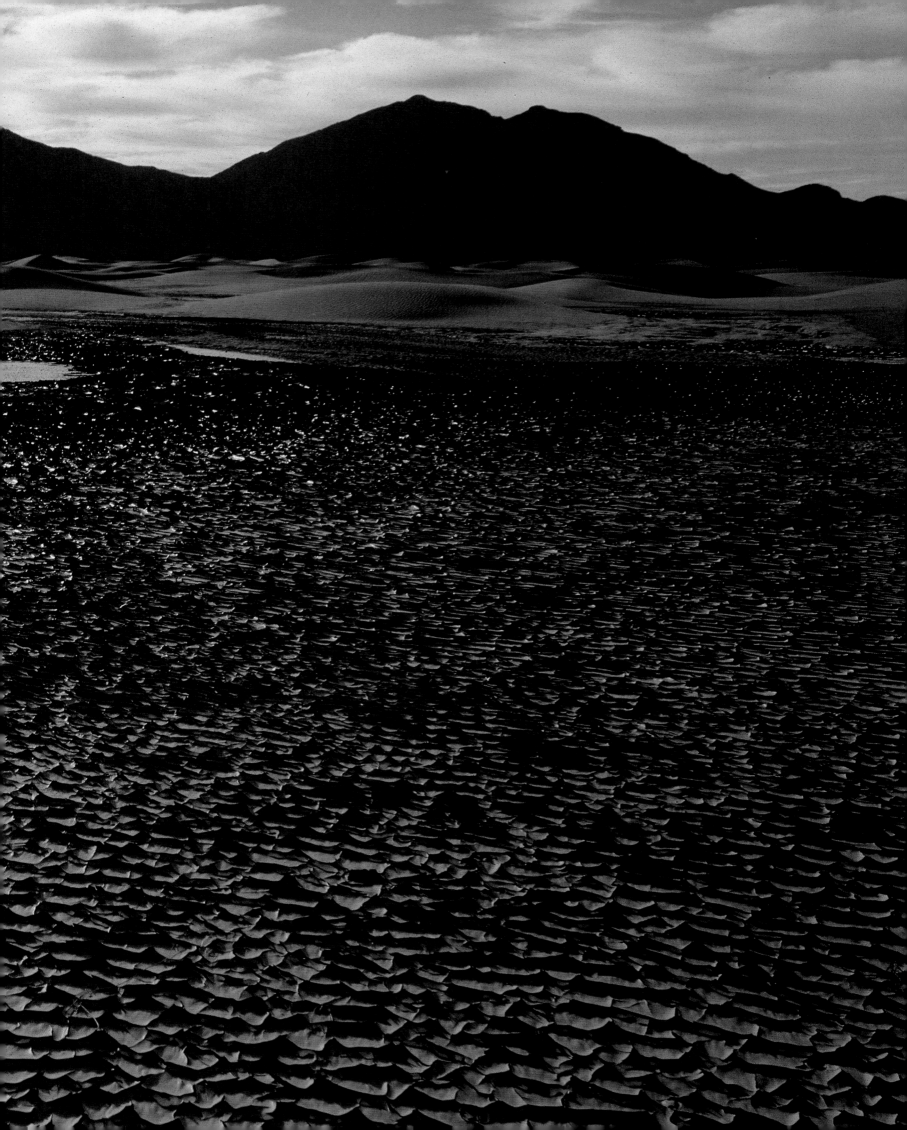

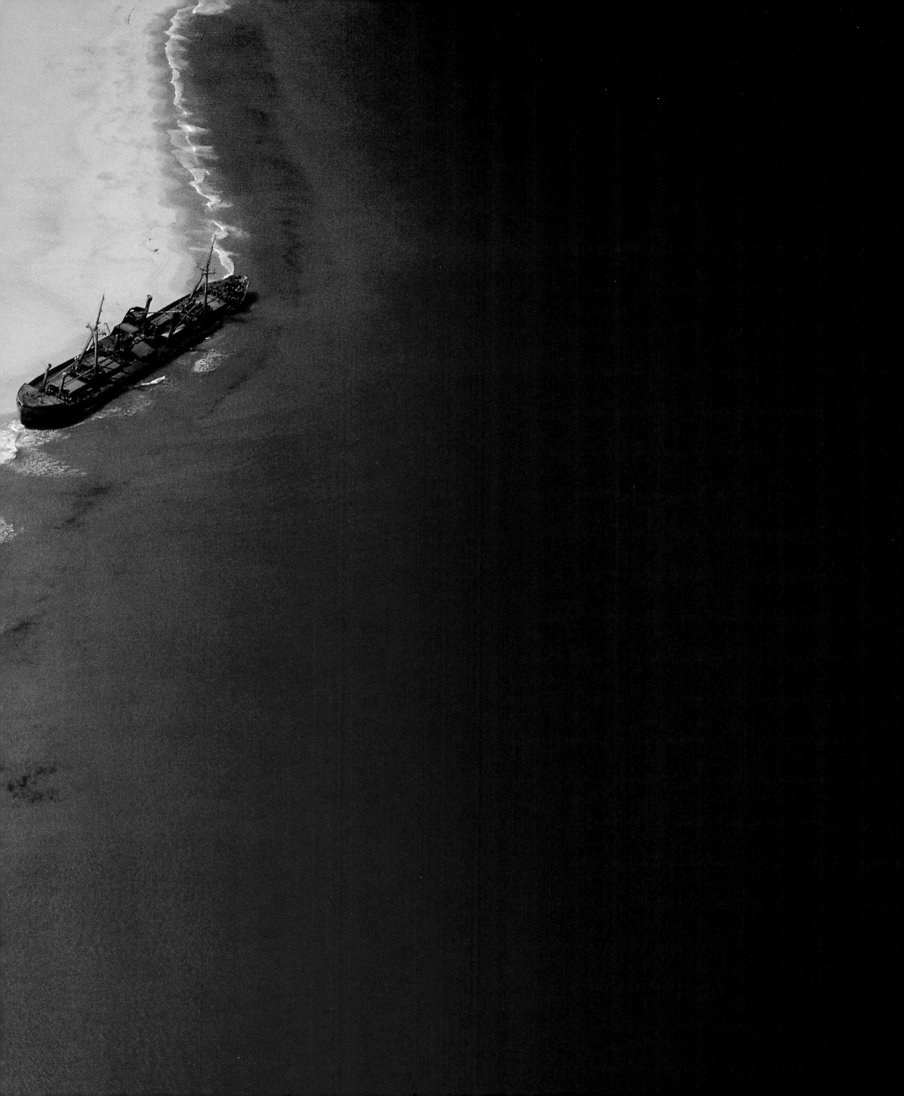

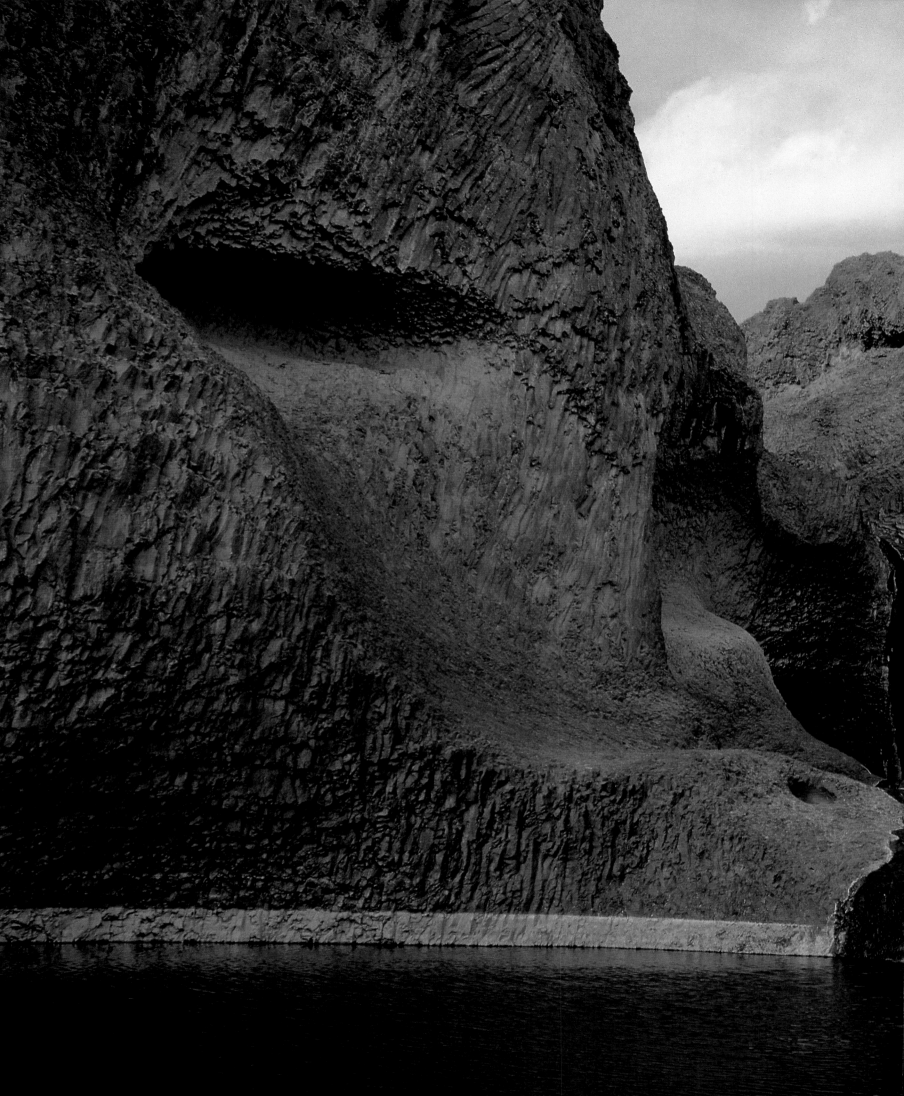

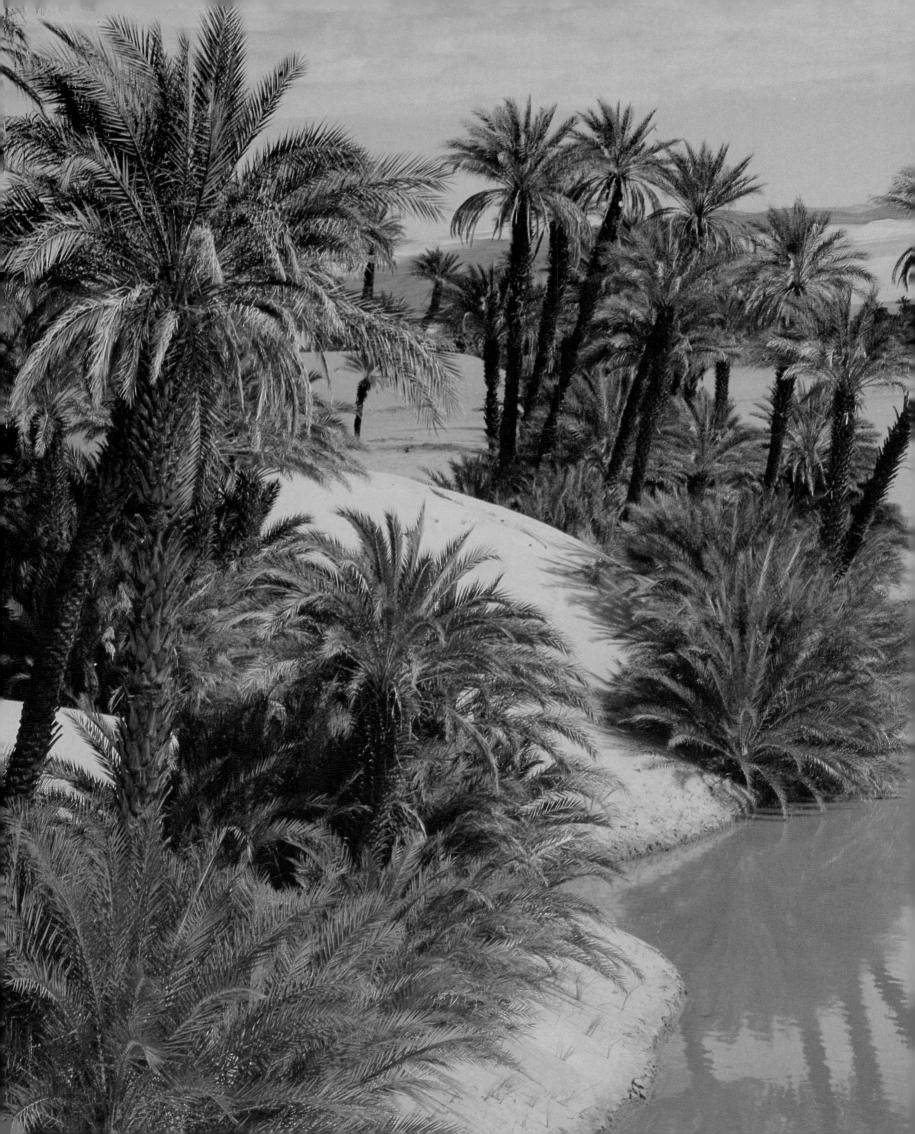

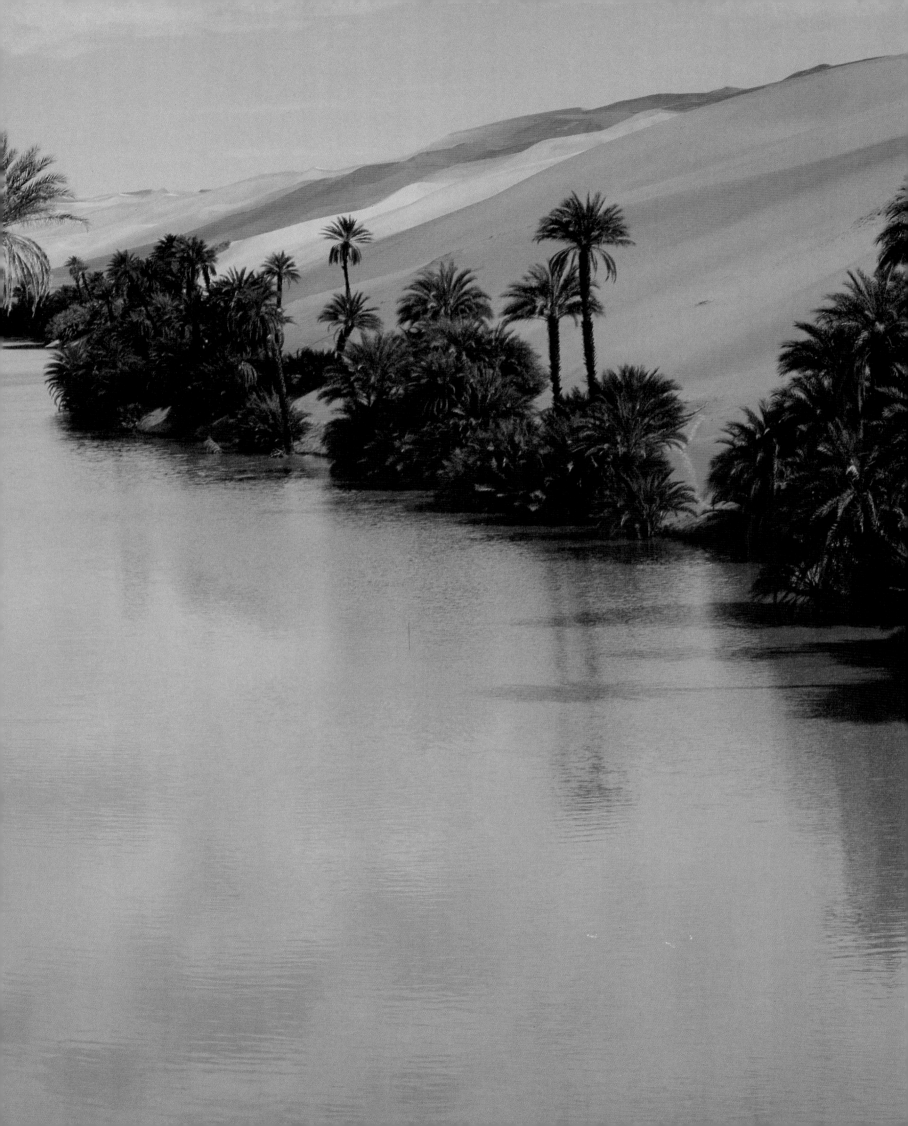

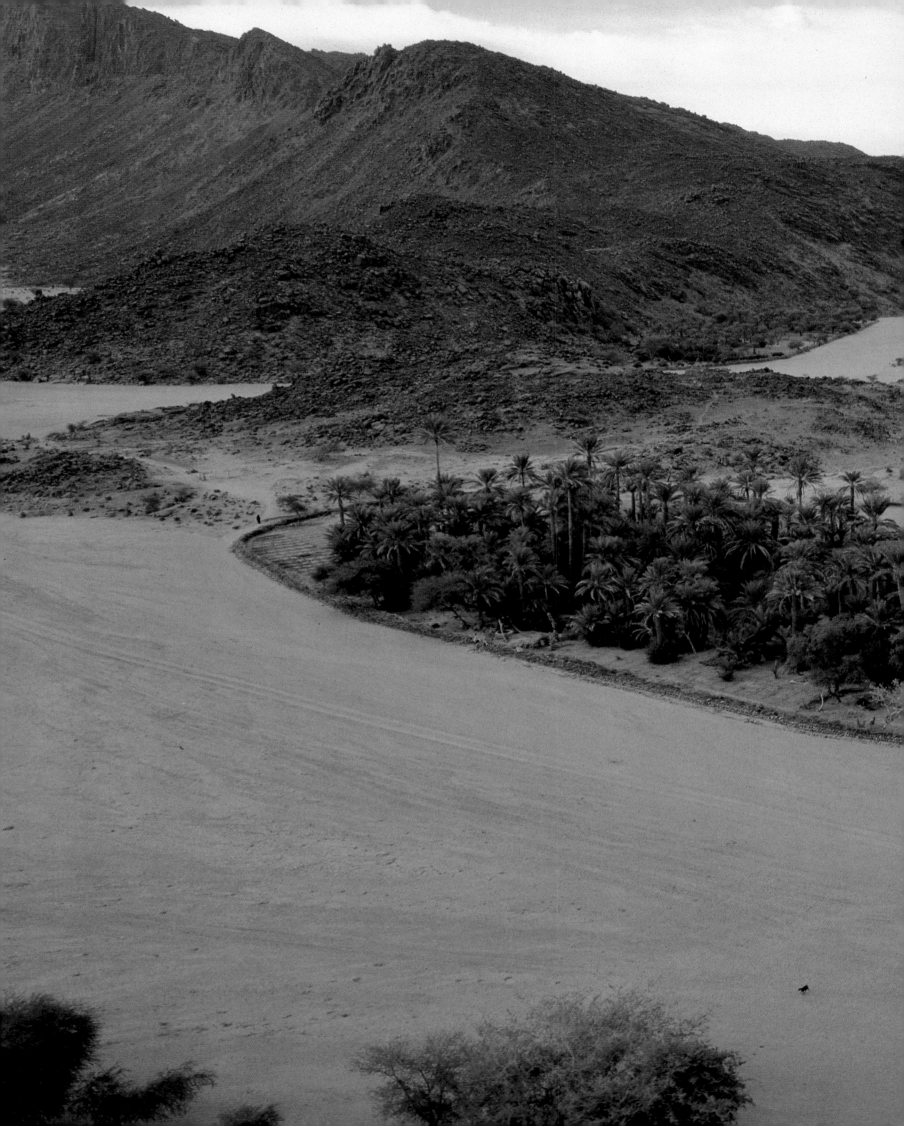

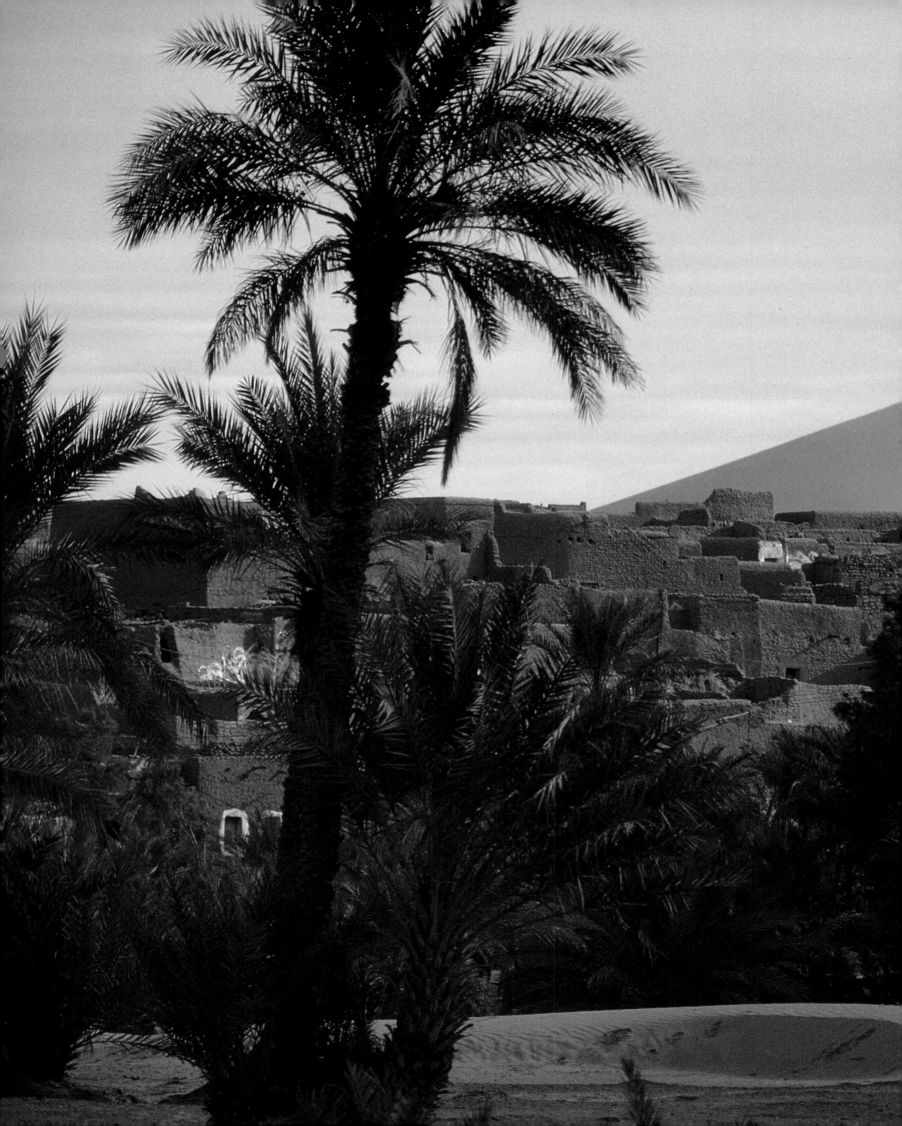

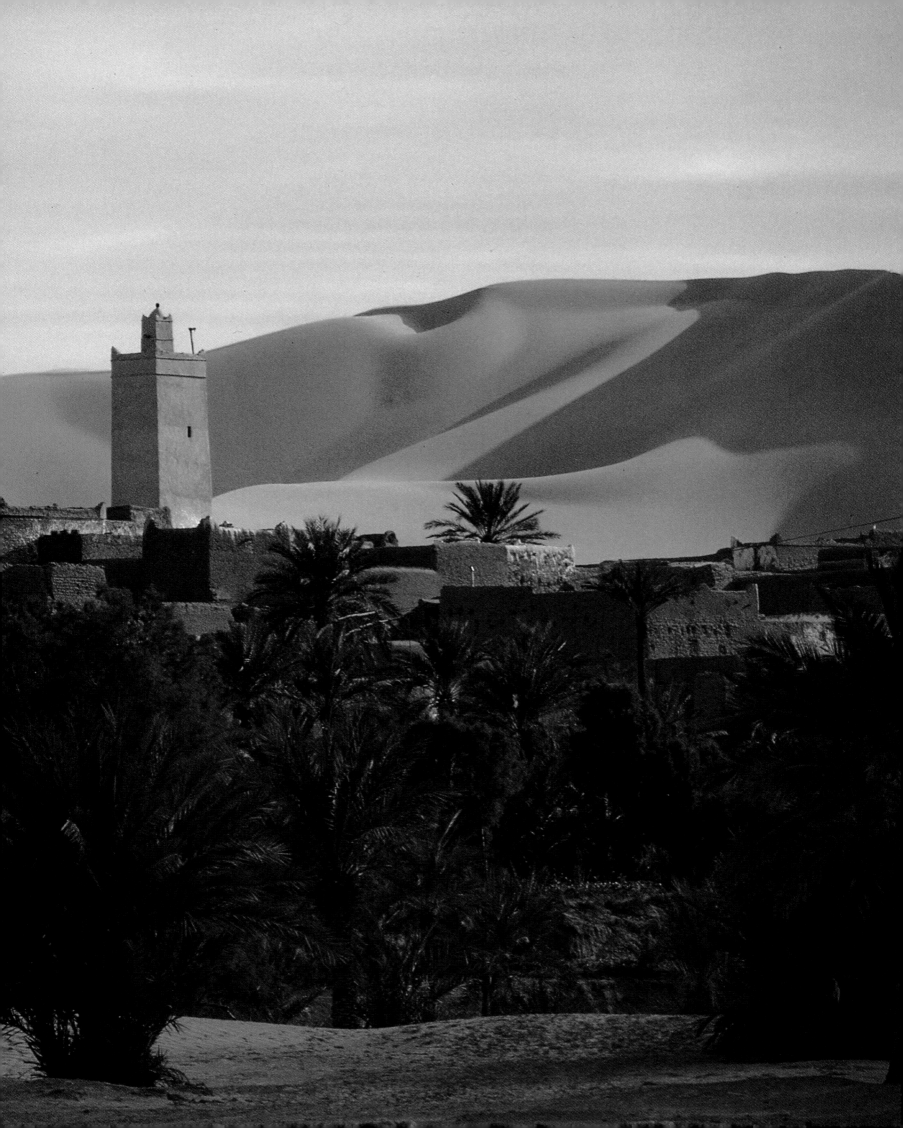

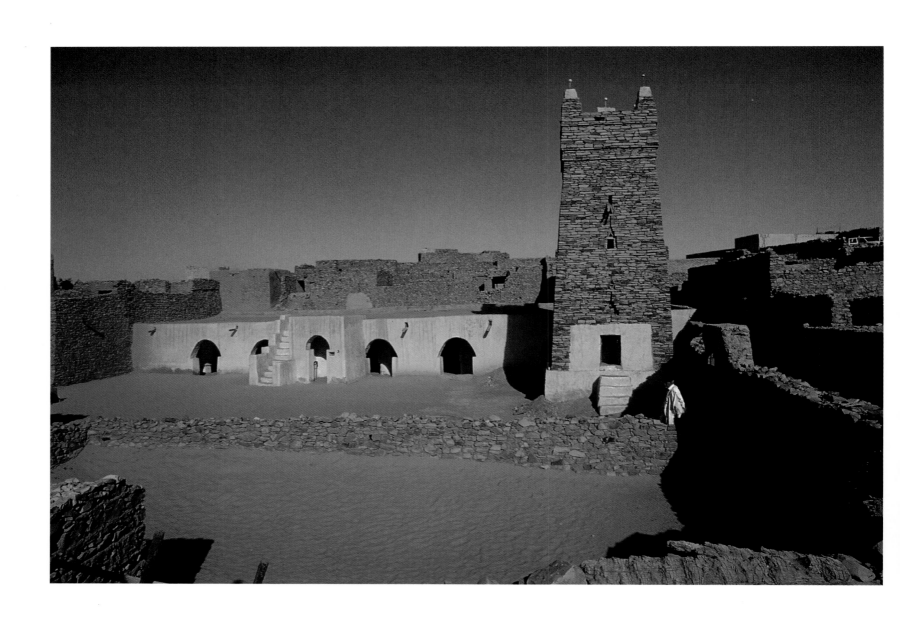

The Chinguetti mosque. The city of Chinguetti, believed to have been founded
in AD 660, is considered the seventh holy city of Islam.

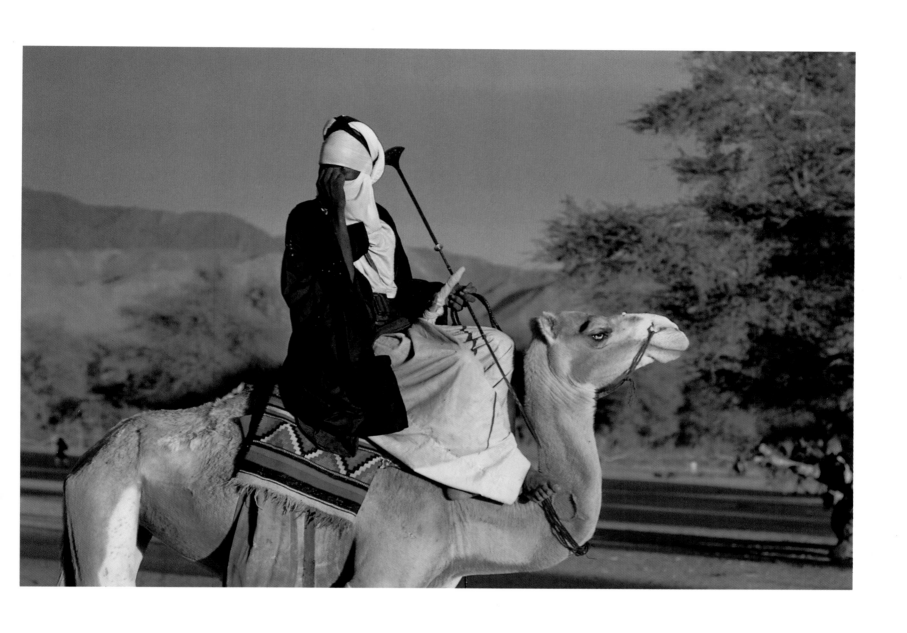

A Tuareg nomad from the Iferouâne region. The Aïr massif, Niger.

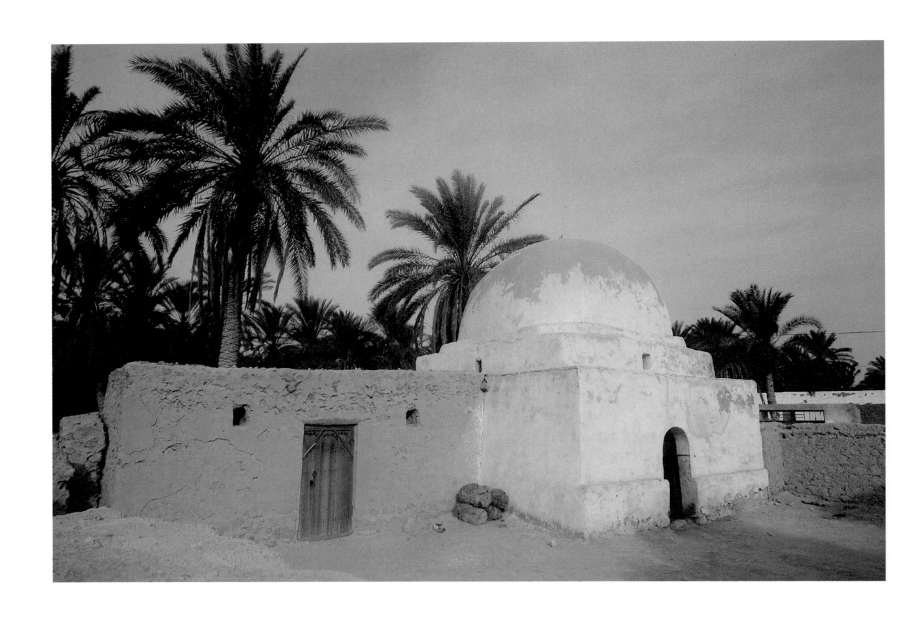

Above
Tomb of a Muslim saint. Southern Tunisia.

Opposite
A Hausa merchant in the city of Agadez, Niger.

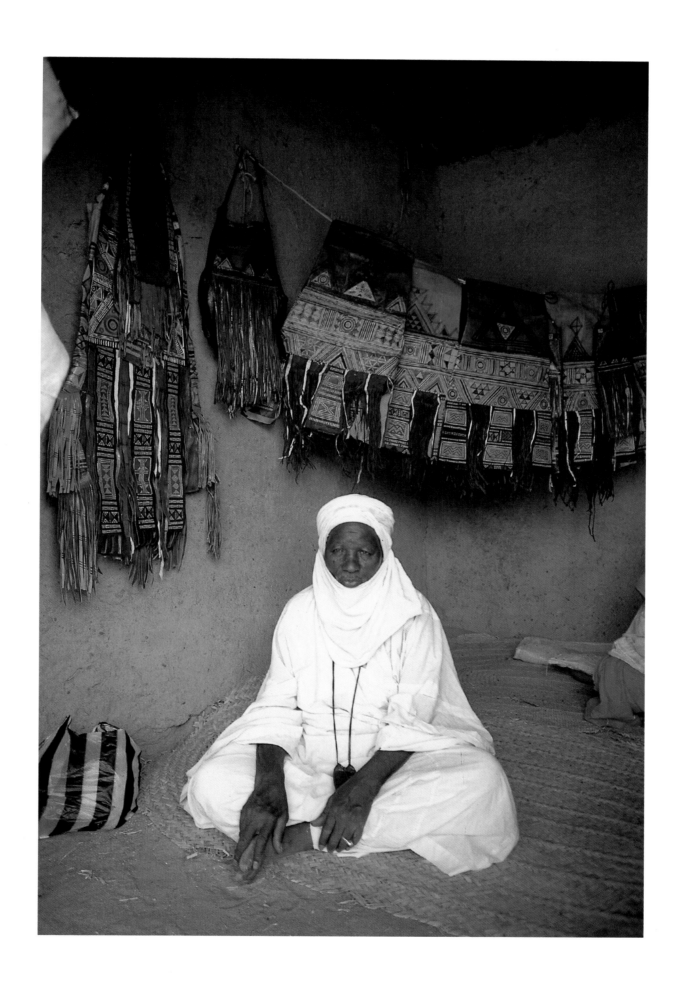

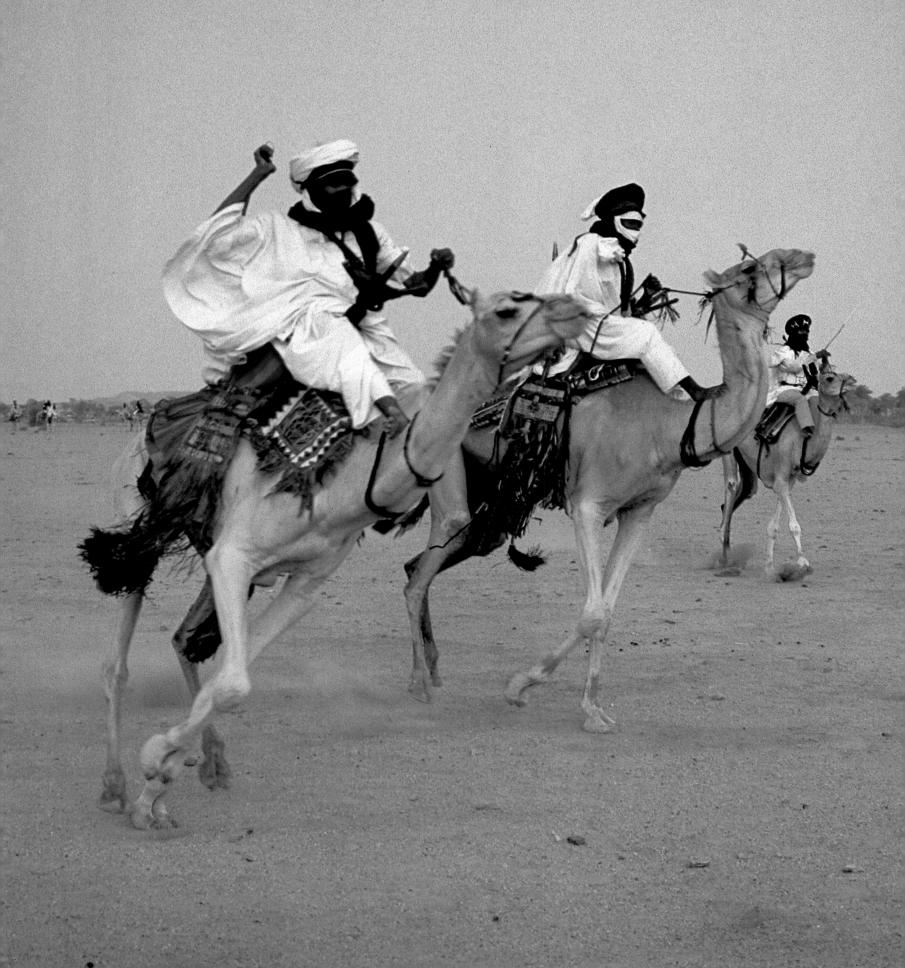

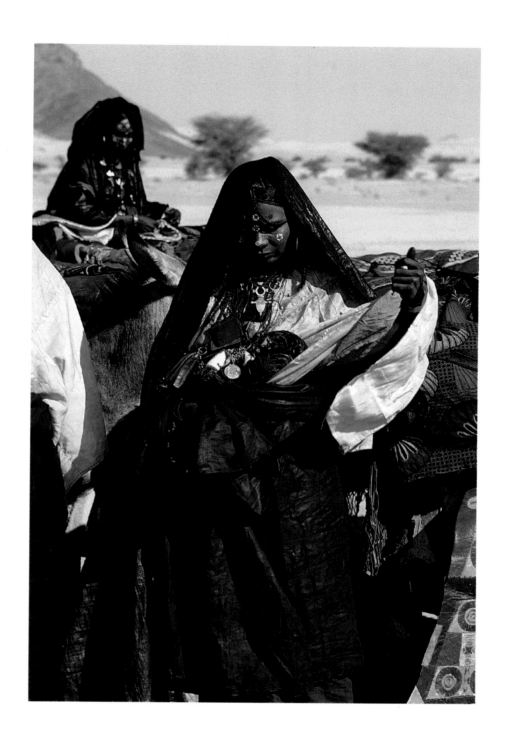

Above
Tuareg women at the Zagado wadi. The Aïr massif, Niger.

Opposite
Tuareg meharists. The I-n-Gall region, Niger.

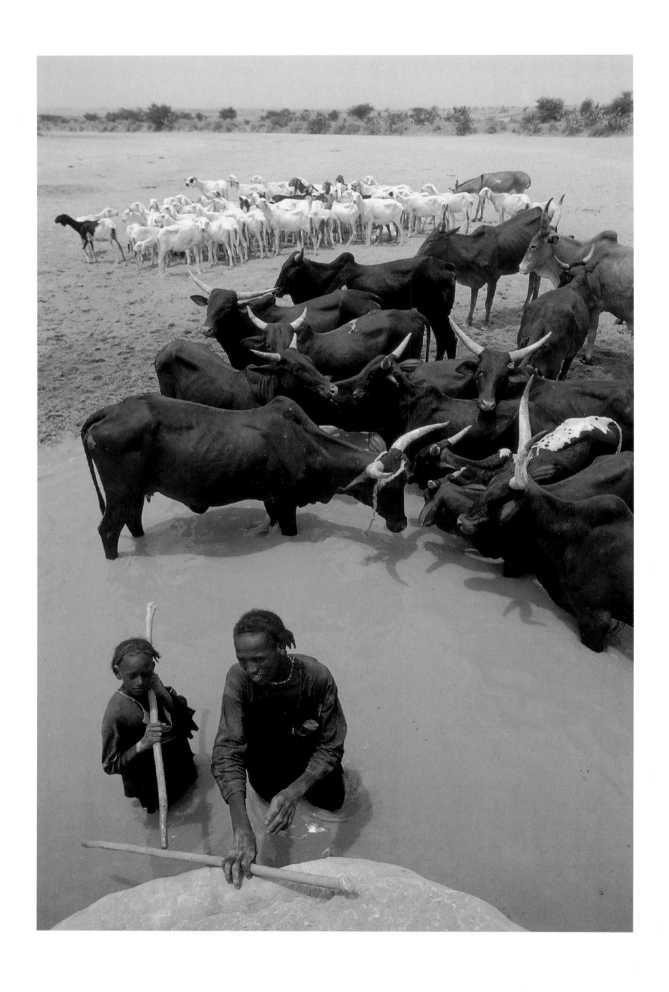

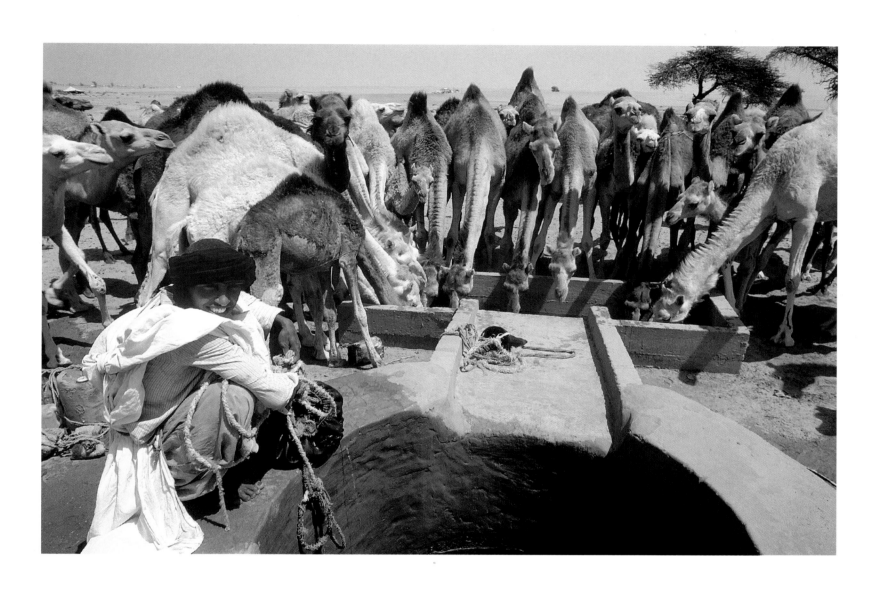

Above
A caravan at a well. Mauritania.

Opposite
Bororo Fulani with their herds. I-n-Gall, Niger.

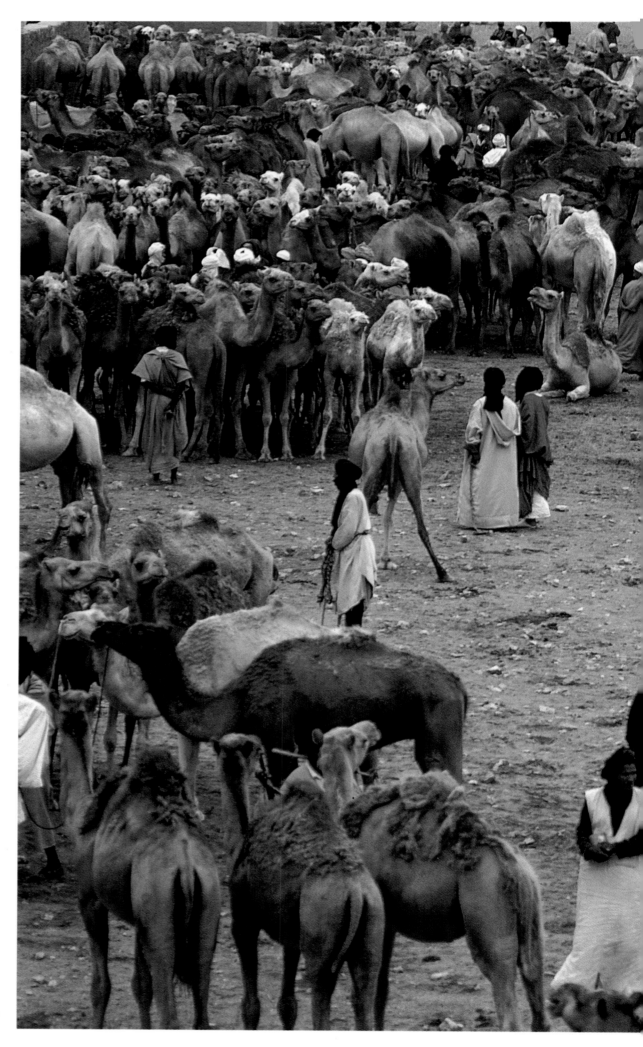

Goulimine camel market. Sahara,
Morocco.

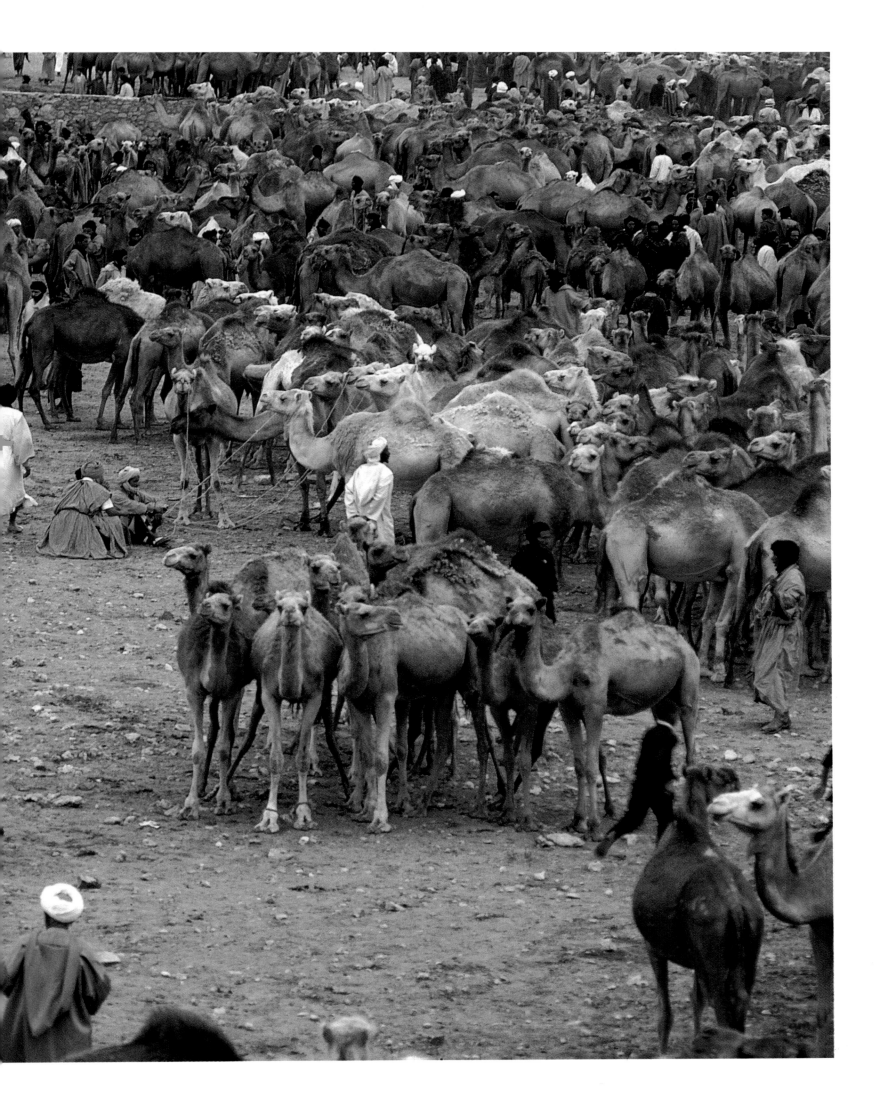

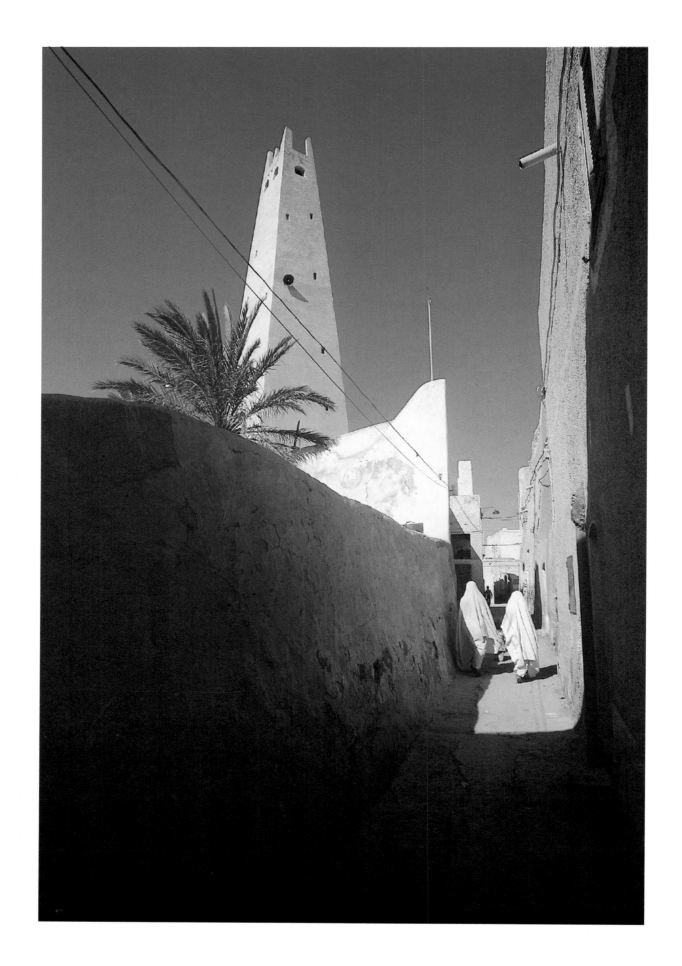

A street in Ghardaïa. M'Zab oasis, Algeria.

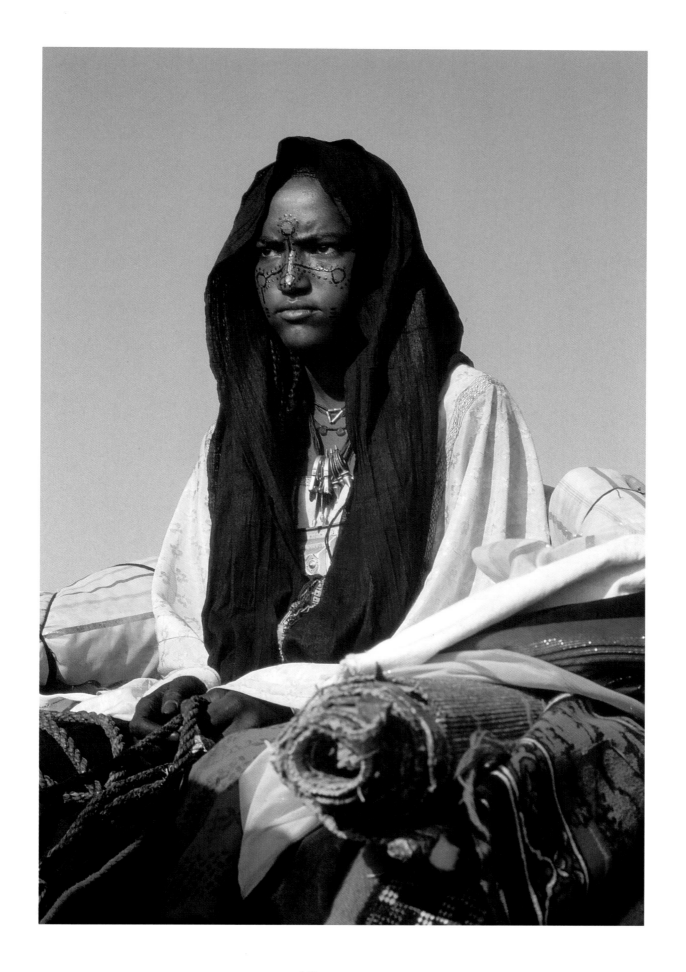

A Tuareg woman.

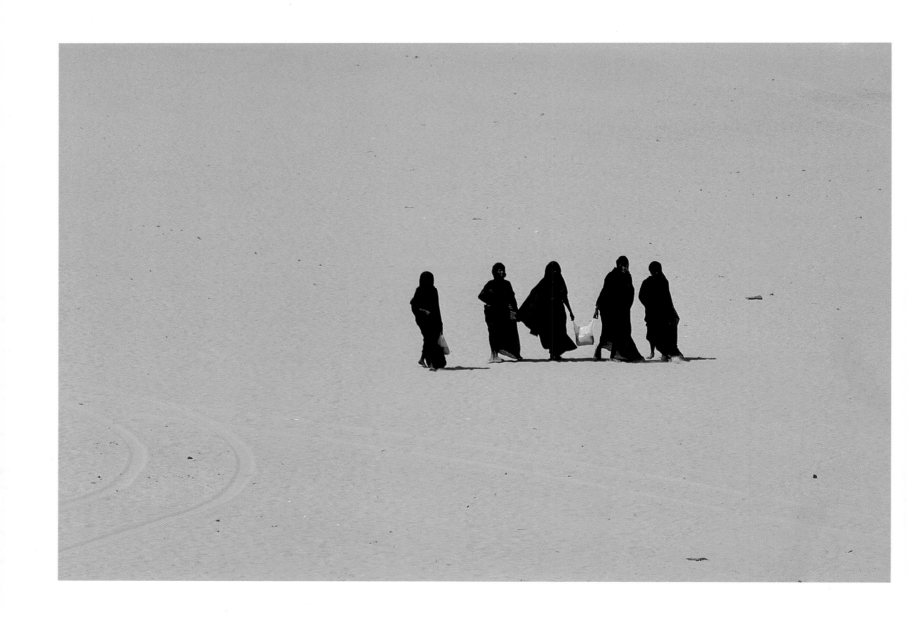

Moorish women. The Chinguetti oasis, Adrar, Mauritania.

Opposite
A Tuareg meharist.

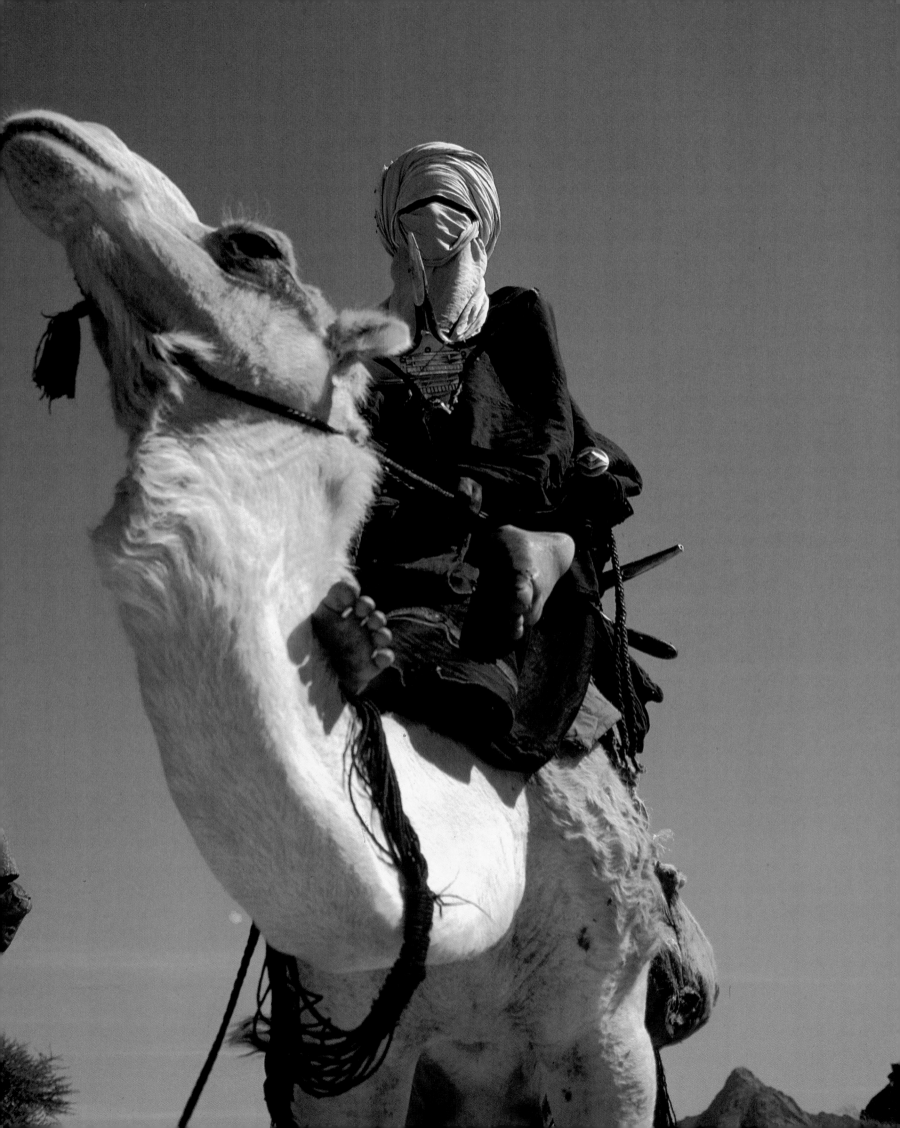

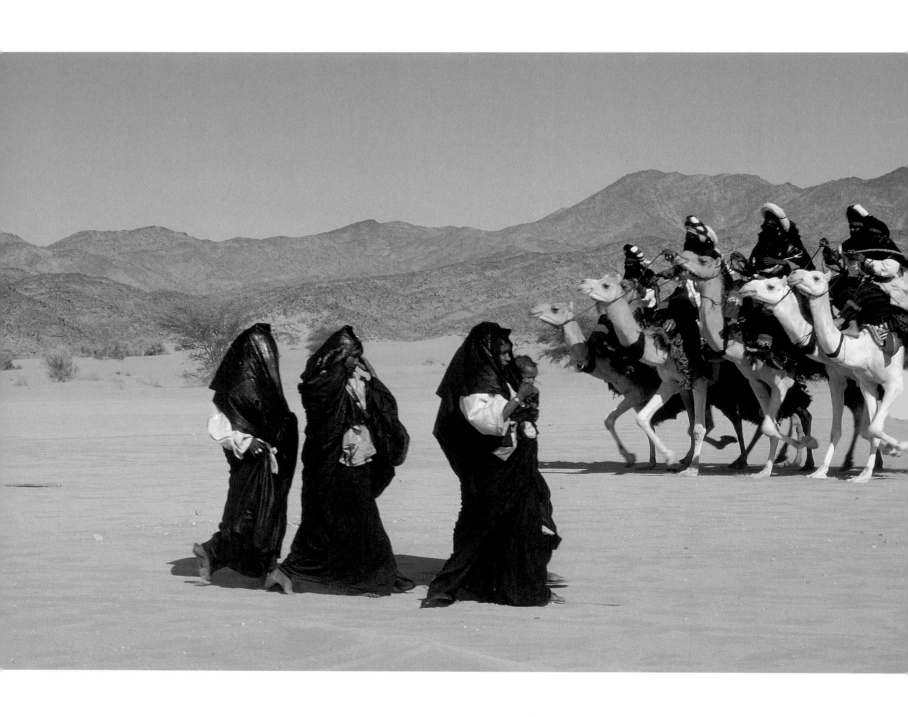

A camel race during a celebration among Tuareg of the
Kel Tadele tribe. The Kago region, northeastern Aïr, Niger.

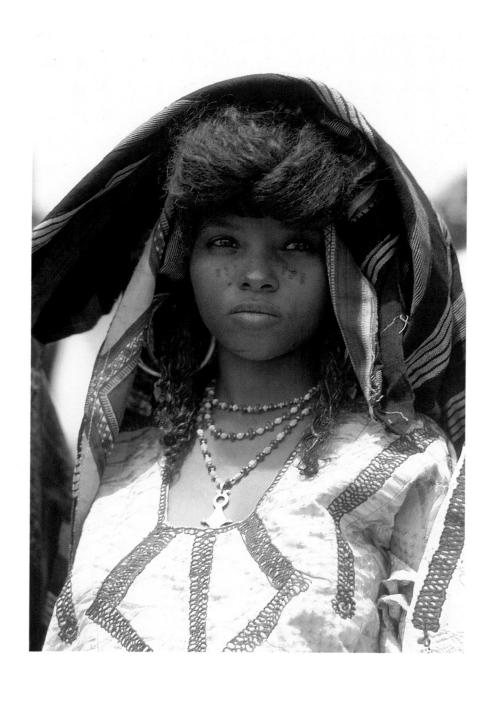

A Bororo Fulani woman during the *geerewol* celebrations. The I-n-Gall region, Niger.

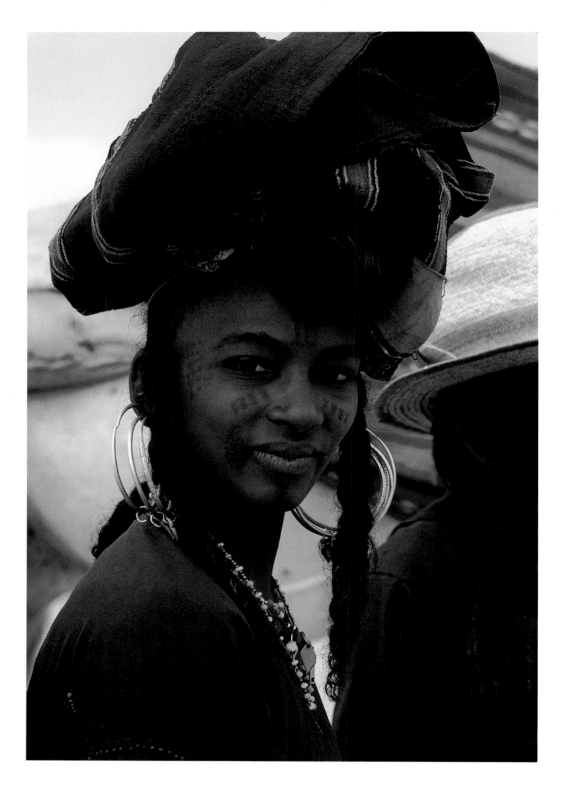

Above
A Bororo Fulani woman. The Abalak region, Niger.

Opposite
Salt pans at Teguidda-n-Tessoumt, northern Niger.

Overleaf
A Tuareg nomad of the Kel Ferouan tribe wearing an indigo turban of *alesho*,
a fabric coated with an indigo dye that rubs off on the skin. The Aïr mountains, Niger.

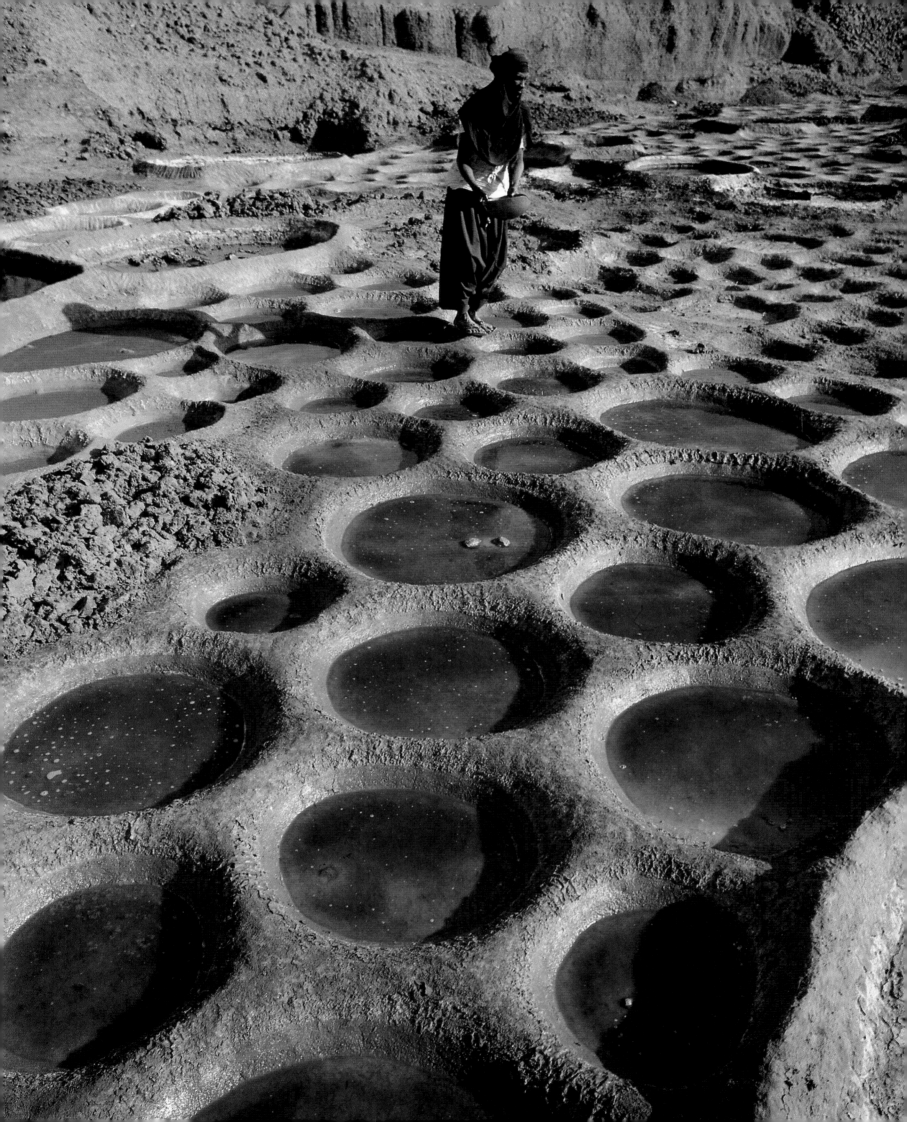

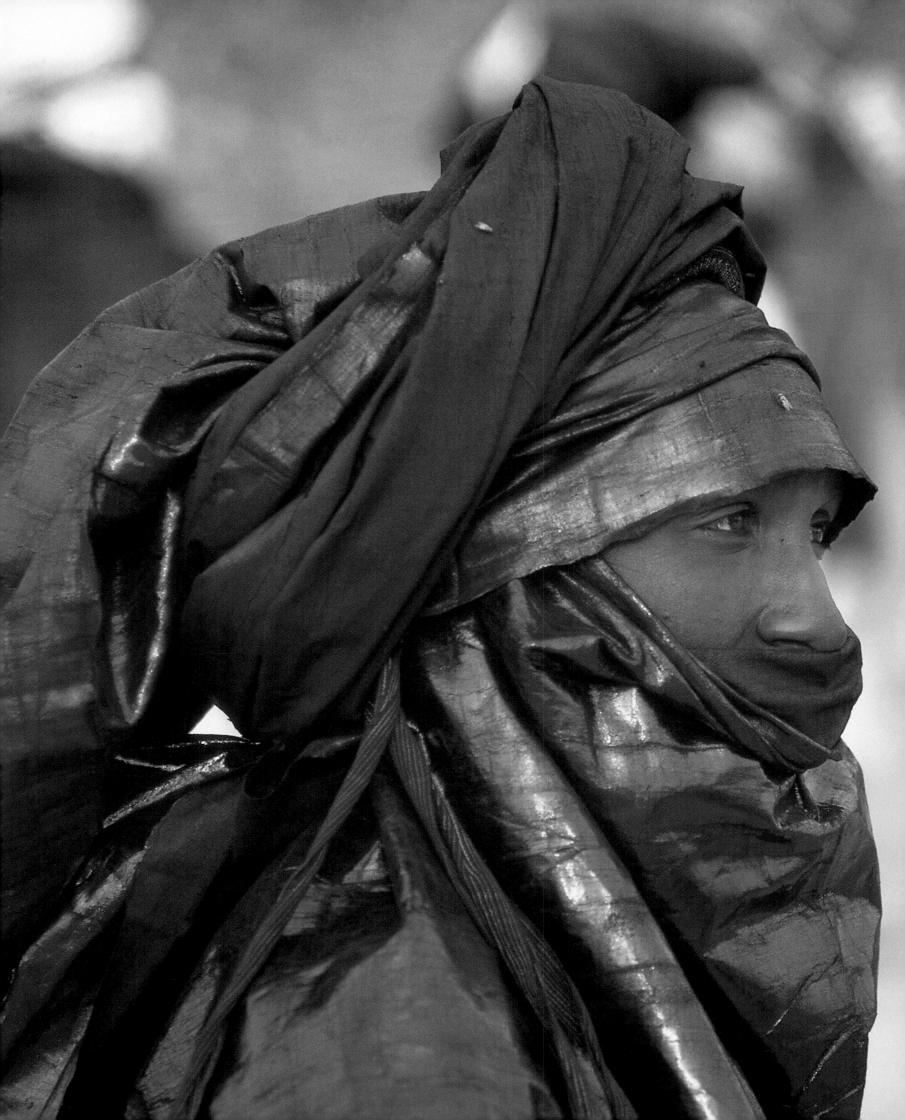

# VITAL SANDS

Hervé Derain

In early 1973 a friend asked if I would go to the Sahara and bring his broken-down Land Rover back to Paris. I accepted immediately. The Sorbonne had just closed until September, I was twenty-two, I was available, and the call of the wild was all the more irresistible because it had been one long year since my last escape—a 15,000-mile (25,000-km) round trip trek to Katmandu and back in a Citroën 2CV, and I was missing the wide-open spaces more and more.

Two days later, in the evening, after an endless series of stops, the old Air Algérie prop Convair that was carrying a handful of passengers flew us over the peaks of the Ahaggar and landed in Tamanrasset.

Despite the intense heat, I got to work right away, forever motivated toward great efficiency. My mission: to retrieve the car, get it repaired, and then depart as soon as possible. After three weeks spent hounding the Boubakar garage daily, waiting and negotiating to move the repairs along, I finally realized that Tamanrasset and Paris operated on different rhythms! "Tam," as it is familiarly known, still had only a few houses and one main street, which was deserted at midday but colorful with a blue and white crowd of Tuareg morning and evening. I went from the Boubakar garage to the Slimane café, then from the Ti Hinane hotel to the Père de Foucauld *bordj* and back again. I lamented the delays in silence. I made a few friends.

Finally, the car was ready, and without further ado I made a fast exit.

From the very first kilometers, the same magic happened then as it still does now, after twenty years: with every new outing into the Sahara, I feel myself suddenly become a free man . . . a free man!

The 434 miles (700 km) between Tam and In Salah in the dead of summer temporarily slaked my thirst for space and adventure. Streaming with sweat in a white-hot metal shell that rattled as if it were about to fall to pieces on the crests of a nightmarish road, I discovered, in the company of Boudjemâa Ben Mansour, my new friend and guide, the intense emotion experienced by everyone who encounters the desert for the first time: a kind of joy that nothing—not thirst, heat, fatigue, or physical discomfort—can mitigate, a pleasure both physical and mental from moving freely through an immense and beautiful space that is full of power and empty of signs of society. Nothing closing off the horizon, no billboards, no hotels, nothing; neither city, nor concrete, nor highway. A bare, yet enchanted paradise. . . .

As we headed north, I was fascinated to notice how the desert alternated between rock and dunes, yet always remained the same—forceful, captivating, welcoming, and threatening. I was charmed by the austere, pebbly harshness of the Tademaït plateau, one of the

hottest, most inhospitable places in the world. Slumbering in the heat, the oases between In Salah and Algiers streamed by as in a dream. I wasn't experiencing the Sahara's most beautiful regions, and it wasn't the best season to be venturing into this land, but the desert was already slipping me a love potion, silently infusing my soul with unparalleled pleasure.

Back in Paris, I was as yet unaware of how this initiation into the Sahara was going to change my life. When school resumed in October, after I had spent two months following splendid trails beneath the Afghan sun, my mind was made up. I dropped the Sorbonne and contemporary literature without a pang and left for Tamanrasset to train as a tour guide. Young People without Borders, a tourist association founded in 1968, had invited me to take over an expedition to the Sahara after a required training period. I signed up for a year, and what a wonderful year it was.

I had three Land Rovers at my disposal and, accompanied by Boudjemâa and groups sent from Paris, the luxury of ongoing exploration of the fabulous lands of the Ahaggar, the Tassili N'Ajjer, the Tassili N'Ahaggar, and the Aïr, as well as the Ténéré, which had made such a powerful impression on me. Is there anywhere in the world besides the Ténéré that gives such concrete meaning to the word "absolute?" Is there any other expanse on the planet so vast, that can in so short a span of time give a human being the chance to truly assess his place in the universe? The travelers whom I led in that period were not the first tourists to tour the highways and byways of the Algerian Great South or of Niger: a few trailblazing agencies, such as Croix du Sud out of Niamey, had led the way in the late 1960s. My groups, however, were pioneers in their own way as most of them were coming to the Sahara for the first time. They had chosen the desert for reasons they weren't always conscious of themselves, but that became clear during the course of the trip: "to escape civilization," "a retreat," "to find oneself," "to make a decision." Everyone came to the Sahara for his or her own desert crossing.

After some months, I knew one thing for sure. When we would start out—a dozen or so strangers—on one of my adored long crossings, sometimes for as long as a month and over thousands of miles, there was absolutely no doubt that these people would each find what they were looking for, regardless of the twists and turns of the trip. Although the comforts were rudimentary, no one dreamed of complaining. A trip to the Sahara is truly living as an art form—simplicity is essential. Those nights under the stars looking for the Southern Cross were, along with our dinners around the campfire, the most magical of moments. Boudjemâa would laugh aloud as he told astonishing tales of hunting cheetah, of horned vipers, and of battles worthy of the knights of yore. . . . The desert had an irresistible effect on everyone. The days went by, one sublime place after another, and a passion would light up in the eyes of some like so many stars.

Life flowed magnificently by. I enjoyed introducing my companions to the Temet dunes of the Aïr as much as the Admer erg on the edge of the Tassili N'Ajjer, or indeed, between groups, wandering around Djanet or Agadez before taking off for a week or two on camelback across the Ahaggar with a few Tuareg pals before the next group arrived. Pure happiness!

I had to go home eventually, however. But once back in Paris I was soon missing the Sahara. A year later, still seeking the right balance between work and passion, I founded the Terres d'Aventure travel agency with Daniel Popp, another desert-mad voyager, whom I had met a few months earlier through our friend Durou. We shared the same vision of a new kind of tourism: traveling on foot.

That was the beginning of new Saharan adventures and of our open-ended exercise in an exhilarating activity: the reconnaissance of new itineraries.

Because we were inspired as much by our common passion as by our need to be constantly rethinking our tours, it didn't take much to send us off on reconnaissance: a particular line on a map; a mountain with a mysterious reputation, like Mount Gréboun on the edge of the Ténéré; an intriguing account read in an old book on exploration; an erg with a magical name, such as the Kilian; a Tuareg friend's vivid description of some extraordinary place, discovered by chance, one day when he got lost; the rumored presence of dog-faced baboons on Mount Tamgak; and so on. Other times it was simply a desire to return to a place that we had only glimpsed during an earlier trip. A passion for the Sahara knows neither limit nor law. Once it's in you, it can lead you from erg to erg and from Mauritania to Chad—or draw you back to the same tassilis ten times. All that matters is one's passion for this beloved expanse, from each grain of sand to the next.

We did every kind of scouting, in January's transparent air and under May's crushing light, in the Aïr and the Ahaggar, the Tadrart and Kaouara, the Tassili or Mount Bagzane, the Tefedest and the Enedi. There were exhausting walks on the white, ocher, or red sand of wadis, and soothing camel rides along the dunes' voluptuous contours; entire afternoons in the shade of an acacia and stages by moonlight; experiences of solitude and unforgettable encounters. We scaled mountains, climbed down into canyons, and crossed black plateaus in silence; we experienced worried hours looking for a way through the hallucinatory labyrinth of a tassili, and emotional moments contemplating the enigma of cave paintings in some unknown grotto. Sometimes there were flashes of magic so intense it was as if time had stopped for a few seconds: we were left bewildered by the fleeting beauty of a graceful doe by the Arakao in Niger; by the touching vision of an addax in the middle of the Ténéré; and by the sudden leap of a wild sheep in El Ghessour canyon.

There were countless other experiences that made "just another day" in the Sahara unforgettable, such as our discovery of a river in a canyon at El Ghessour, and the ensuing swim down it, in incredible icy green waters. There was an April evening when, worn out after climbing boulders and scree on the slopes of Mount Gréboun for twelve hours, we finally stepped onto the plateau at the summit, only to make the astounding discovery of three or four *Oleo laperrini*—extremely rare, thousand-year-old olive trees. The magnificent sight of the Ténéré at sunset, from thirty-nine hundred feet (1,200 m) atop Mount Gréboun! A vision of the immutable. . . .

Yet over the years, the Sahara does change, imperceptibly. There are wonderful places that are overly visited. Others are polluted. Today Saharan tourism and travel have been interrupted by serious problems in Algeria and Niger. This lull has enabled the desert to become a desert once more, as the wind takes this opportunity to erase all traces of human passage; this would be a good time to consider the respect and protection due this extraordinary environment, more sensitive than it may seem to the repeated crossings of four-wheeled vehicles and the aluminum cans they inevitably leave behind. It is up to each of us to ensure that the desert does not go the way of vacant lots.

For many of us, the Sahara, with its millions of square miles of sweeping waves of sand, unlimited dunes, and nameless mountains, has become synonymous with Eden. A paradoxical Eden of stone and wind, a refuge that we need more and more, as cities increasingly nibble up the planet. We are justifiably concerned with scientific progress and the encroachment of

civilization and population. Emptiness reassures us, and the desert that once frightened us now becomes dear—dear and necessary. Necessary to our hearts, intoxicated with the absolute; necessary to our imaginations, dizzied by the idea of the exponential growth of human communities; necessary to our rushed city lives and our too-civilized bodies; and finally, necessary to that forgotten part of ourselves, the child or Little Prince, who comes to life again, playing in the desert with the dunes of sand and the stars in the sky.

HERVÉ DERAIN
*Co-founder and director*
*of the travel agency Terres d'Aventure*

# NOMAD HERDERS

*From Blind Fascination to Lucid Passion*

Edmond Bernus

For centuries, the nomads have aroused many passions but never indifference. Mainly, it is a mixture of admiration, hatred, and fear expressed by city dwellers and foreigners alike. Like many others, the Western city dweller in me was fascinated by the nomads, though initially it was based on the stereotypes I saw in the mass market. Once I met some nomads and lived among them in their camps, my fascination stayed with me. As the years passed, however, this vague feeling turned into a passionate interest in specific personalities and families. These people did not merge into an anonymous setting of dunes and palm trees—they lived in a familiar landscape that has since become a part of my universe. Now my interest and feelings about nomads are sustained by real-life experiences, which are wholly different from the stereotypes that influenced me at the start.

My fascination was initially based on the notion that nomads live unconstrained by time and space, that they are free of the obligations that weigh most people down: the scramble between home and office, the unrelenting schedule that eases up only briefly to allow short vacations—vacations during which, ironically, some of *us* become temporary nomads, carting camping and hiking equipment through valleys and into the mountains.

My first discovery was that the nomads' perceived "freedom" does not consist of moving just anywhere at whim. The nomads are worshipful of the region in which they live and in which their history is inscribed: if they leave the desert, it is only because very powerful pressures compelled them. Their annual movements are regular, and their itineraries repetitive: they are homebodies in their own right, and their nomadism should not be perceived as mere wandering.

These nomads, who live by their herds, depend upon an unpredictable climate, which may dispense generous rains one year, only to withhold them the next. Worse, there are successions of dry years and wet years, following one another like the seven "fatfleshed" and seven "leanfleshed" cows of Pharaoh's dream (Genesis 41:18–19). Water and forage, indispensable to humans and animals, are renewed each year in an ever-changing scenario; from one year to the next, they can have the green pastures of an earthly paradise or the scorched torment of no grass, dead trees, and dried-up ponds. According to their mental annual calendar, these will be referred to as "the year of plenty" or "the year of hunger" or sometimes worse: "of drought and death." I soon ceased to think of nomadism—human and animal—as a paradise set apart from the pollution and overcrowding of the industrial world. As I looked more closely at the Saharan past, I noticed that the years "of thirst," "of cattle plague," "of the

grasshoppers," or "of the rodents" outnumbered the bountiful or even uneventful years. The nomads suddenly became to me the people who, as well as facing all natural hazards, deal with the dangers of being perceived as an archaic humanity only recently emerged from the Stone Age, one that has to be integrated into the modern—and necessarily settled—world.

After that, the nature of my fascination changed. It became one of constant amazement at seeing a society that manages to live, with its herds, in such a difficult environment. These herders are one with nature and know how to use nature by domesticating it, by finding in it most of the resources they need not just for survival but for a certain quality of life. At the same time, this fragile desert environment gives the impression that it can be mastered only by adapting to it, not by trying to transform it to external norms. The only way to live there is to follow its rhythm, manage its space and time with great flexibility. You can't control nature here, but you can use it, if you know how to obey it.

## A WORLD WITHOUT WALLS

When I visited the nomadic herders, especially the Tuareg, the road I traveled from south to north left the often-enclosed areas of villages and fields to enter a world of vast horizons. The traces of human presence in the landscape become increasingly unobtrusive, almost disappearing, so that all that remains visible are scattered herds, the signs of animals converging on a well, occasional tents, their ocher vellum merging into nature. Whenever I enter this region, I get the powerful impression that I am going into an open landscape, with no obvious boundaries or borders. If there are frontiers, recognized territories, they are not marked, nor do they shut communities into cramped, compartmentalized spaces.

After years of barely adequate rainfall, the nomads reached an all-time low in 1984. The herds had no forage, and in order to save the majority of them, the nomads were obliged at the end of the summer to abandon their usual routes and head south into farm country, where the vegetation was more abundant. There the nomads felt jammed into a walled, closed world where the herds couldn't move freely. Their animals represented a threat to the as yet unharvested fields, an attraction for lurking thieves, and an instrument for extorting millet or straw. The nomads thought of nothing but returning to their lands of vast horizons.

*Girls of our land,*
*who tint their faces with henna . . .*
*I am going toward I-n-Tamat and I-n-Tadant,*
*And setting up my camp there.*
*Not a single garden growing calabashes.*
*I don't see a single field*

*The she-camels graze freely,*
*The donkeys aren't hobbled.*
*We have reached our beloved country.*
*My prayer is finished,*
*My song complete.*
(Bernus, 1991, pp. 129–30)

This poem is by a Tuareg who, with her family and herds, was driven from her land in the autumn of 1984 by the relentless drought. In this place, where the nomads must squeeze themselves between villages and fields, she dreams of returning to the land where the herds can graze without fear, barriers, or hostility.

## A DIFFERENT KIND OF FREEDOM

I then discovered that the freedom that seemed to me to be as integral to the nomads' life as water to a plant did indeed exist, but in a more elusive, subtle way than I had at first con-

ceived. If so many men and women were attached to this manner of life, it was because they perceived this freedom as being within a cluster of heavy constraints.

The nomads live in movable camps that gather together a variable number of tents, which are usually grouped around the tent of a patriarch. Indeed, if a particular person is known as an authority on community customs or for expertise in religious matters, that person will attract the others to set up their tents on the edges of the camp. The most common camp model is that of an elderly man whose tent is surrounded by those of his children, other relatives, and servants, depending on the ever-changing bonds of family. Should a disagreement arise, separation will occur without hesitation, all the more so since the camp grows and scatters over the course of the seasons, depending upon the available grazing resources. The family members group together to manage their herds; when the pasturage is inadequate, or there is a disagreement, each household takes its animals back, keeping them by their own tents or grouping them with those of other relatives and friends. In a village, when you leave the land your father allotted you or you abandon the family's large field, it is almost always an irreversible act. Among the nomads, leaving a camp or dividing up a herd may be part of a flexible management of the journey or may result from disputes that demand distance. This distance, whether temporary or permanent, allows for the possibility of return.

During the collective movements of the rainy season, each family can change its route—since the general direction is dictated by the available water and pasturage—to travel with the tents of friends, or to avoid a family with whom it is in disagreement.

This, then, is the freedom of the nomad: the ability to connect and separate, to meet and avoid one another, without it being a hostile act; the freedom to always leave behind a door that is all the more open because it doesn't physically exist.

## LESSONS IN SOLIDARITY

"And Lot also, which went with Abram, had flocks, and herd, and tents" (Genesis 13:5). From Old Testament times to the present, there have been nomad herders. And all through the centuries this lifestyle has always had its dangers. Job had seven sons and three daughters and owned immense herds: "seven thousand sheep, and three thousand camels, and five hundred yoke of oxen, and five hundred she asses, and a very great household" (Job 1:3). But in an instant, "Sabeans. . . . The fire of God. . . . Chaldeans. . . . [A] great wind from the wilderness" (Job 1:15–19) destroyed and massacred Job's family, servants, and herds, until he remained naked and alone. These many misfortunes converging on one person provide an accurate summary of the dangers nomad herders still risk today, just as in the Old Testament. The harsh climate—mainly droughts—causes herds to starve to death, and people to leave for the cities, while a lack of security, which in the old days meant raiding parties, today portends revolt and repression.

To guard against these perils, the nomads wove bonds of solidarity that still allow them to correct inequities, the rich helping the poor. The Tuareg lend camels or milk cows to a relative or neighbor in difficulty; the parties then agree on the term of the loan: usually one or more lactations. Among the Fulani, one friend lends another a heifer: a number of calves, established ahead of time, stay with the borrower, who thereby rebuilds the lost herd. Each herding culture sets certain rules for living that not only allow the destitute to be cared for but form bonds between people that are embodied in the animal that is lent. The cow that is acquired in this way is the favorite, because she is the cow of friendship. "She requires a great deal of attention.

You must stroke her. You must regularly pick the ticks off her. You have to get her used to answering to her name, and when she does comes to you, you must stroke her all over" (Maliki, 1984: 59). This enforced solidarity is inscribed within a code that results from an upbringing that renders all those who follow the "Fulani way" (Laya, 1984) interdependent. Among the Tuareg, to be well mannered is to respect others and especially to accept one's place, whether it be a function of age, sex, or social status; to a young man, this means tightening his veil in the presence of an elderly person, showing nothing but his eyes through a narrow opening.

These codified behaviors are the product of a diversified society that is often frozen within compartmentalized hierarchies. The Tuareg proverb "The tail stays where it is, it always comes after the feet" means that everyone must stay in the place into which he or she was born. Another proverb, "The fingers all come out of a single palm, but they are not all the same length," means that there are differences among people, though they come from a common stock. These relationships of solidarity are manifested in the specific context of a society in which no one can ignore the rules.

## A PASSION FOR A WORLD REPRIEVED?

Our fascination challenges us. I speak for myself: Isn't this passion for a world that is in the process of disappearing, for a people that is merely reprieved? The nomads epitomize the ability to exploit a particularly hostile, arid environment. They have succeeded by their remarkable understanding of it, which allows them to make decisions on the basis of changing circumstances. Their sense of direction derives from a keen gaze, constant observation, and hyperalert senses. The nomads' life is also a sum of the knowledge that they have accumulated about natural resources: vegetable, mineral, and animal. It is, too, their ancient relationships to animals that they know, love, choose, select, name, and mark, and whose genealogy they can often relate. The loss of their herds is not only a loss of capital; it is often a loss of identity.

Pastoral nomadism implies a certain relationship between a people and its herds, but it is also—in fact, especially—the possibility of choice: choice of partners, of routes, of culture. New questions asked, adaptability to new pressures, and the potential to move are guarantees of survival. At the same time, these choices have become more and more limited, and today the nomads have pledged their future and are modifying their behavior in response to an ascendancy of various constraints. It is this loss of choice that threatens the nomads' values and genius; when they become anonymous paid watchmen, they risk forgetting the pastoral techniques that are the foundation of their civilization.

A passion for the lifestyle of the nomads should not be taken lightly. Pastoral nomadism is not cut off from the rest of the world: it is connected to both rural and urban areas, to the markets, and to national and international trade; it cannot survive amid poverty and hunger. The passion for nomads must become something more than nostalgic, passive fascination. We must try to see how the nomads themselves can, in a world subject to the laws of the marketplace and shifting currents, maintain and give new life to their imperiled civilization.

EDMOND BERNUS
*Ethnologist, Geographer*
*Research Director at ORSTOM*

Works cited:
Bernus, Edmond. *Touaregs: Chronique de l'Azawak*. Paris: Plume, 1991.
Laya, Dioulé. *La Voie peule: Solidarité et bienséances sahéliennes*. Paris: Nubia, 1984.
Maliki, Ancelo B. *Bonheur et souffrance chez les Peuls nomades*. Textes et civilizations (series). Paris: Edicef, 1984.

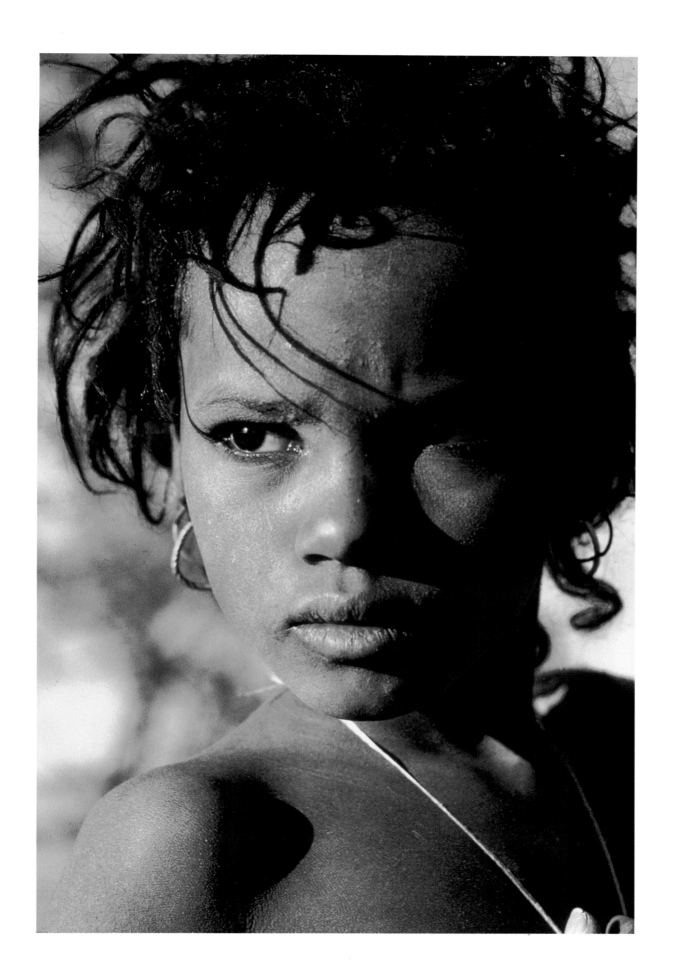

A Fulani boy. The Abalak region, Niger.

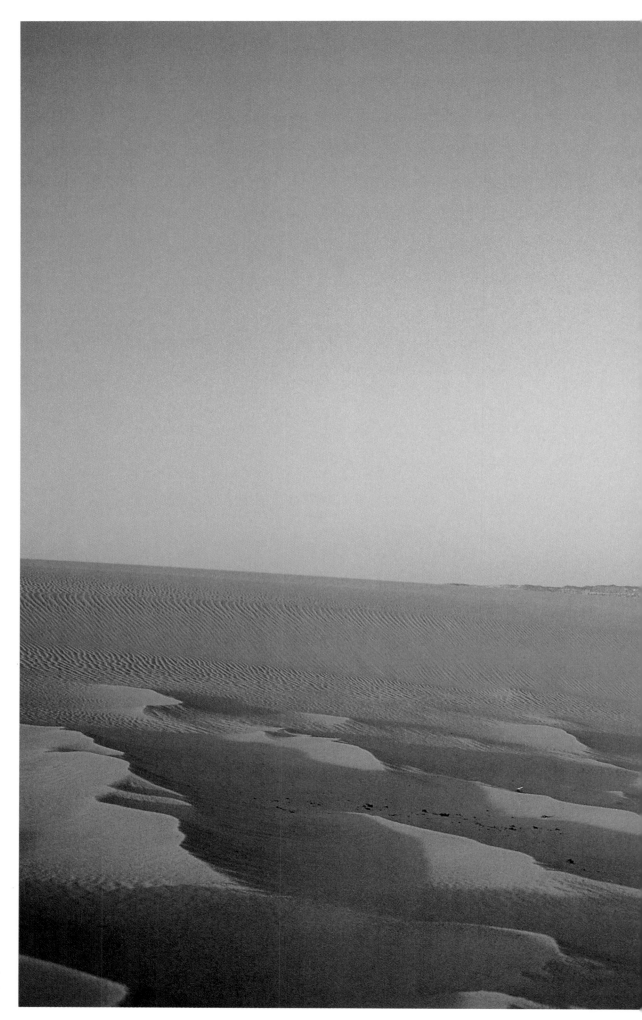

A Toubou woman carrying palm branches. The Kawar oasis, Niger.

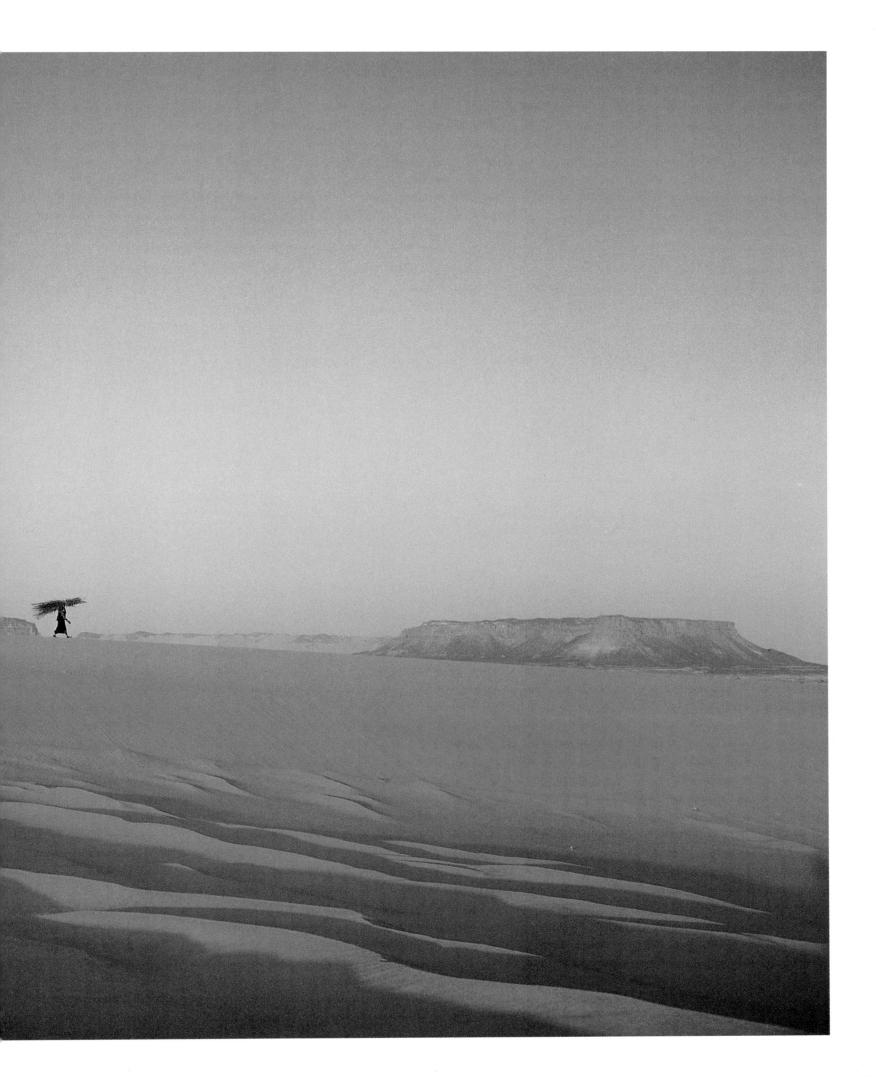

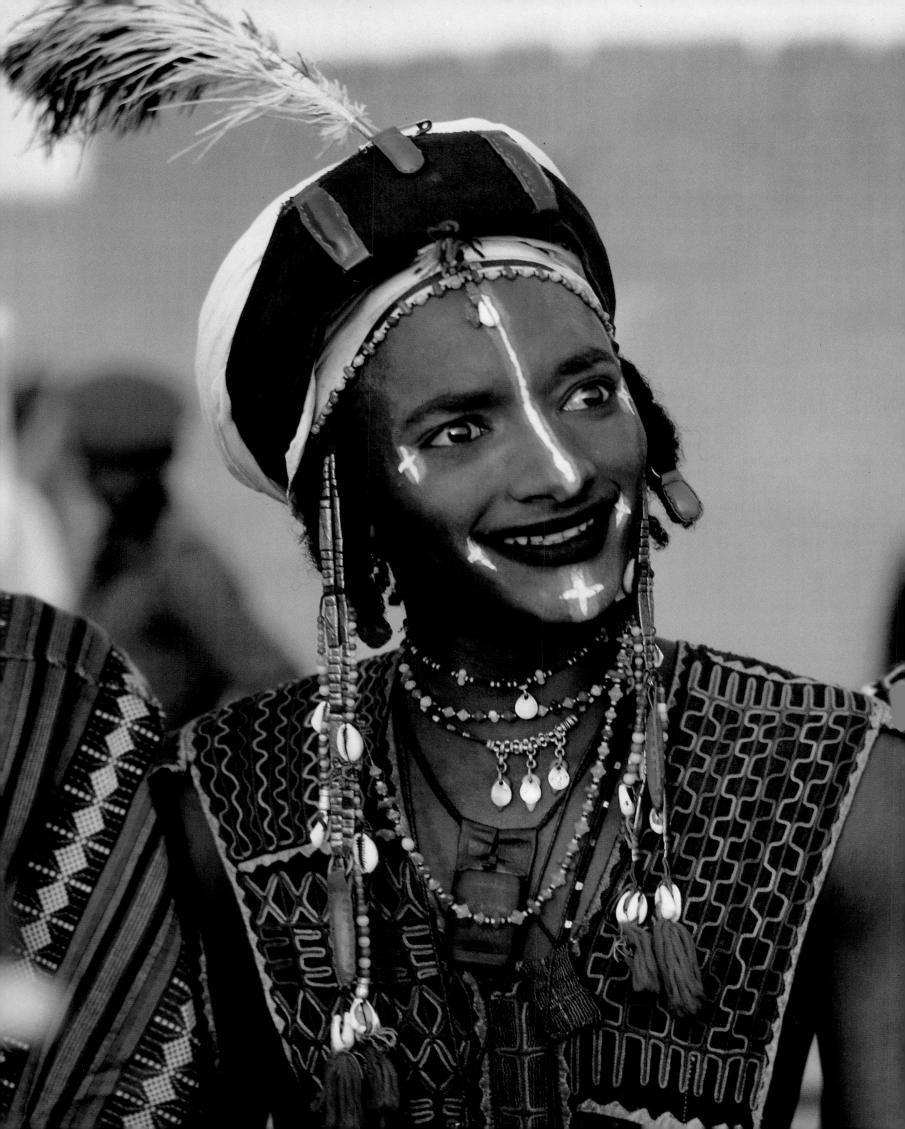

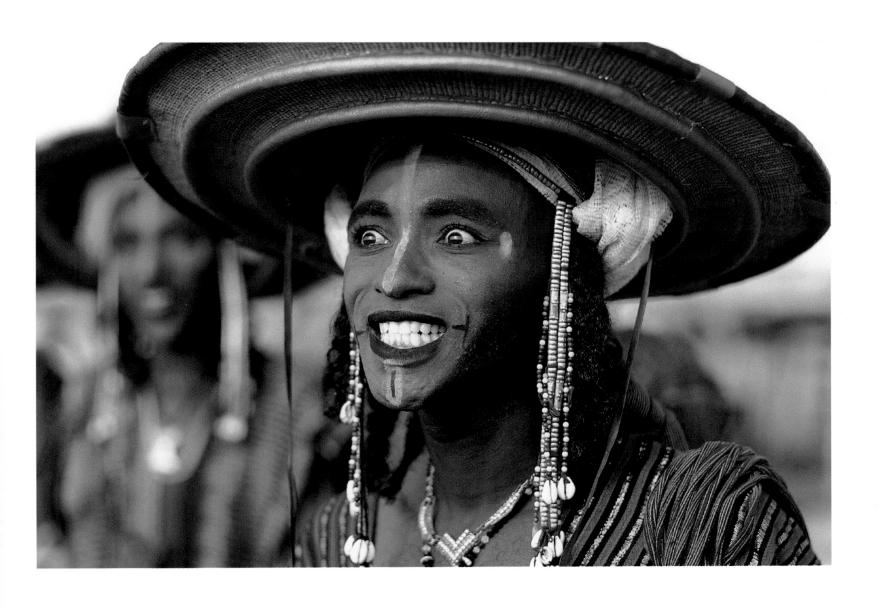

Above and opposite
Men of the Bororo Fulani tribe in northern Niger
made up for the *yaaké* dance, or beauty contest,
during the gatherings of the *geerewol* festival. I-n-Gall, Niger.

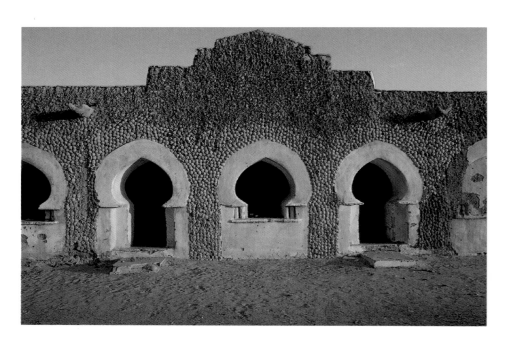

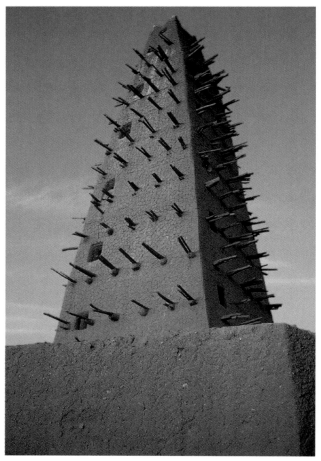

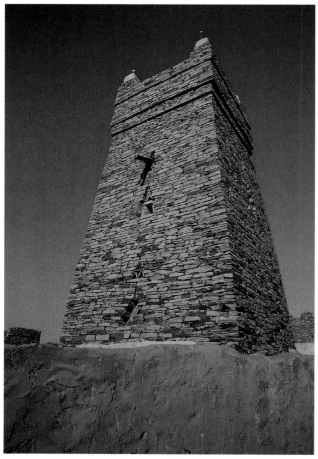

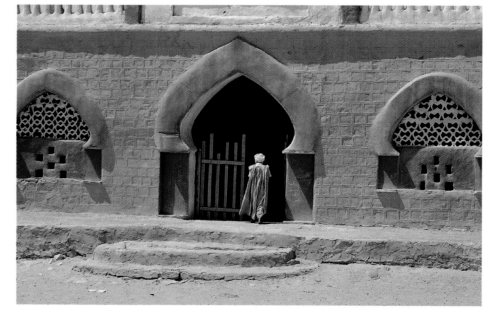

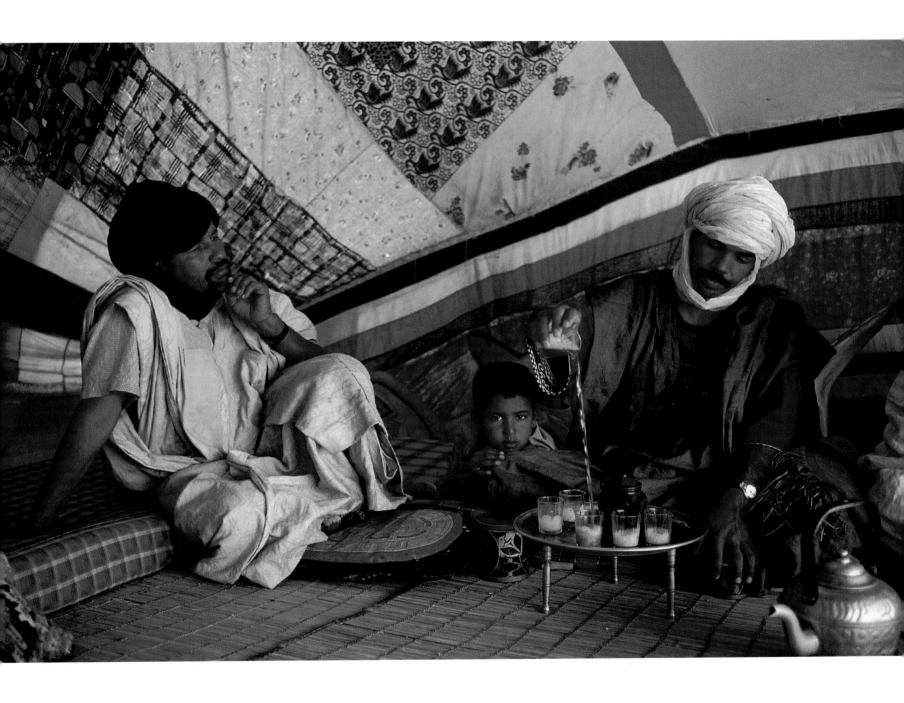

Above
A tea ceremony in the tent of a Moorish nomad of the Chinguetti region, Mauritania.

Opposite
Top, left. Mud architecture in an ancient building of the Chinguetti oasis, Mauritania.
Top, right. The minaret of the Agadez mosque, Niger.
Bottom, left. The minaret of the Chinguetti mosque, Mauritania.
Bottom, right. Mauritanian architecture.

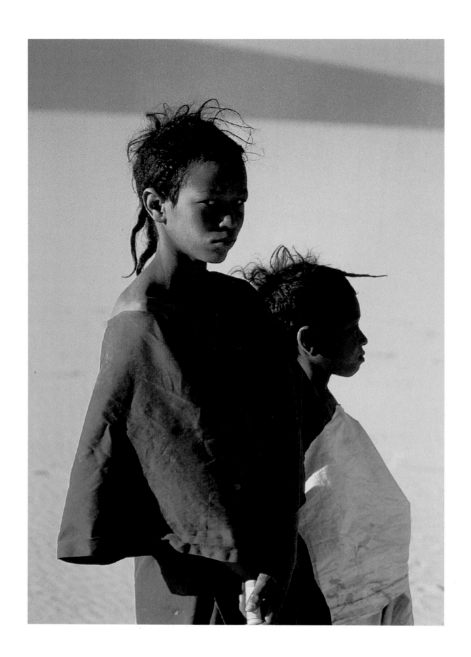

Tuareg boys. A mountain in the Aïr, Niger.

Opposite
Tuareg meharists. The Agadez region, Niger.

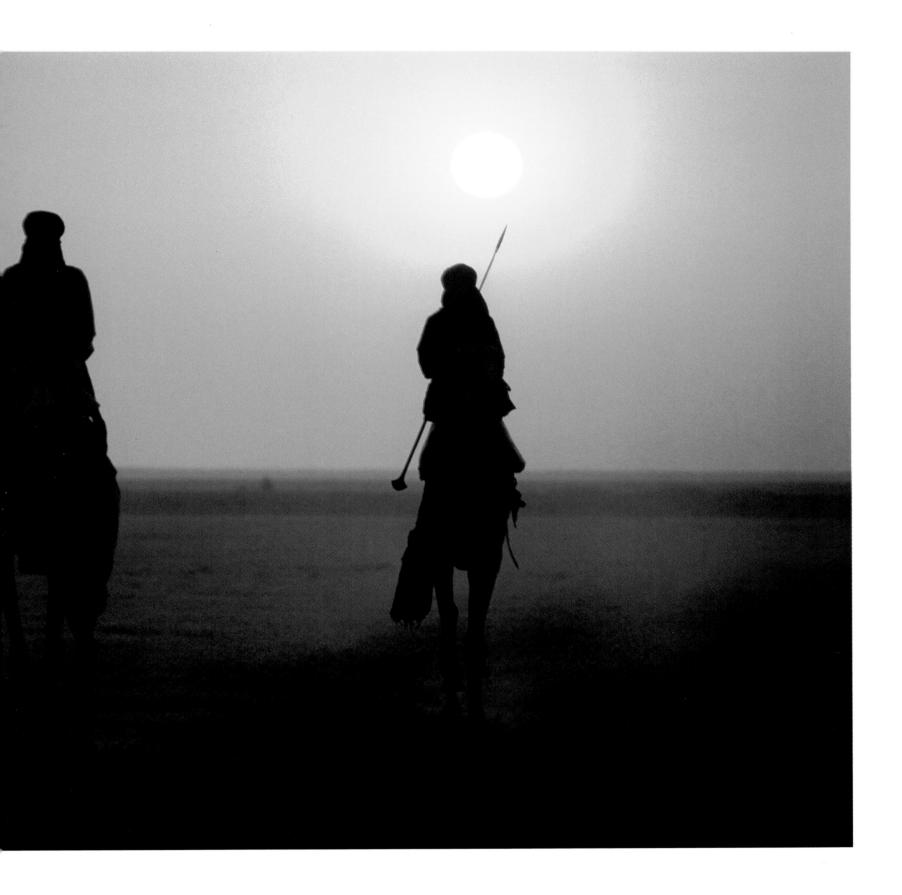

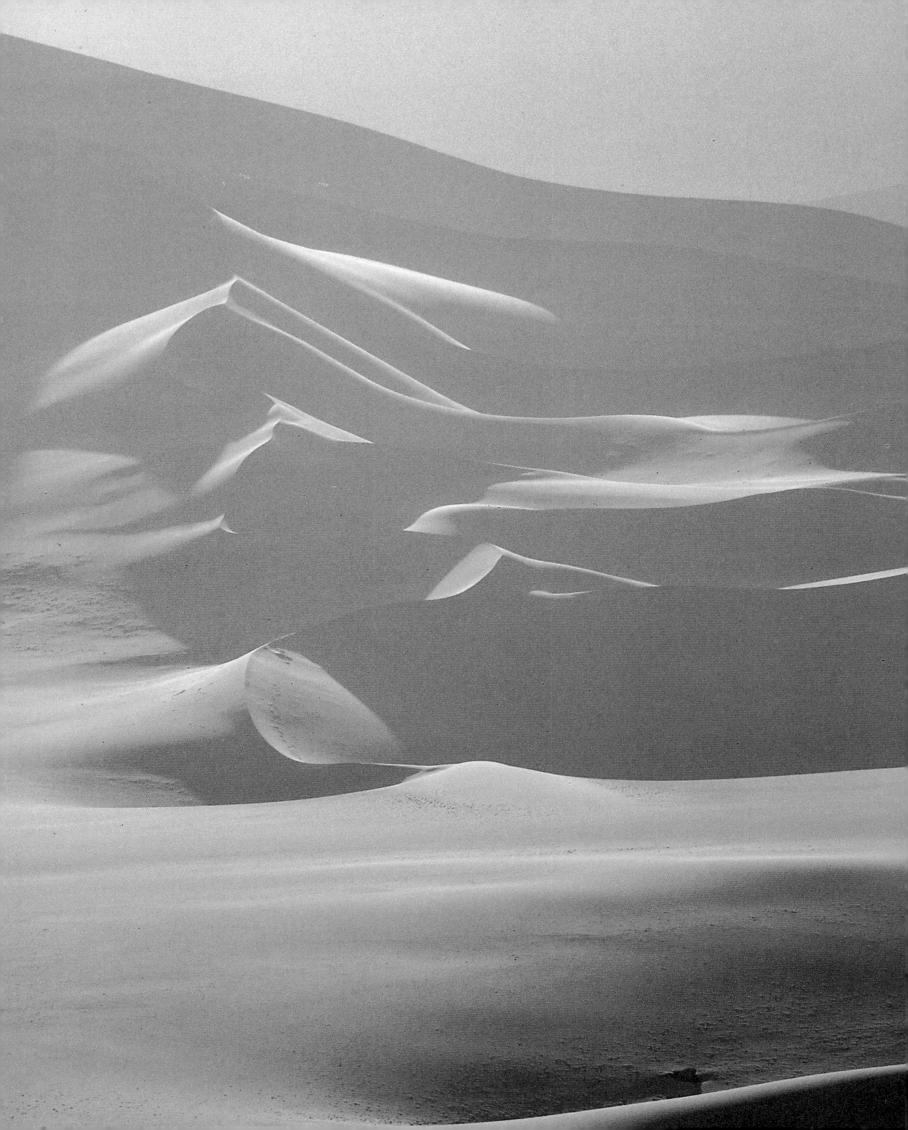

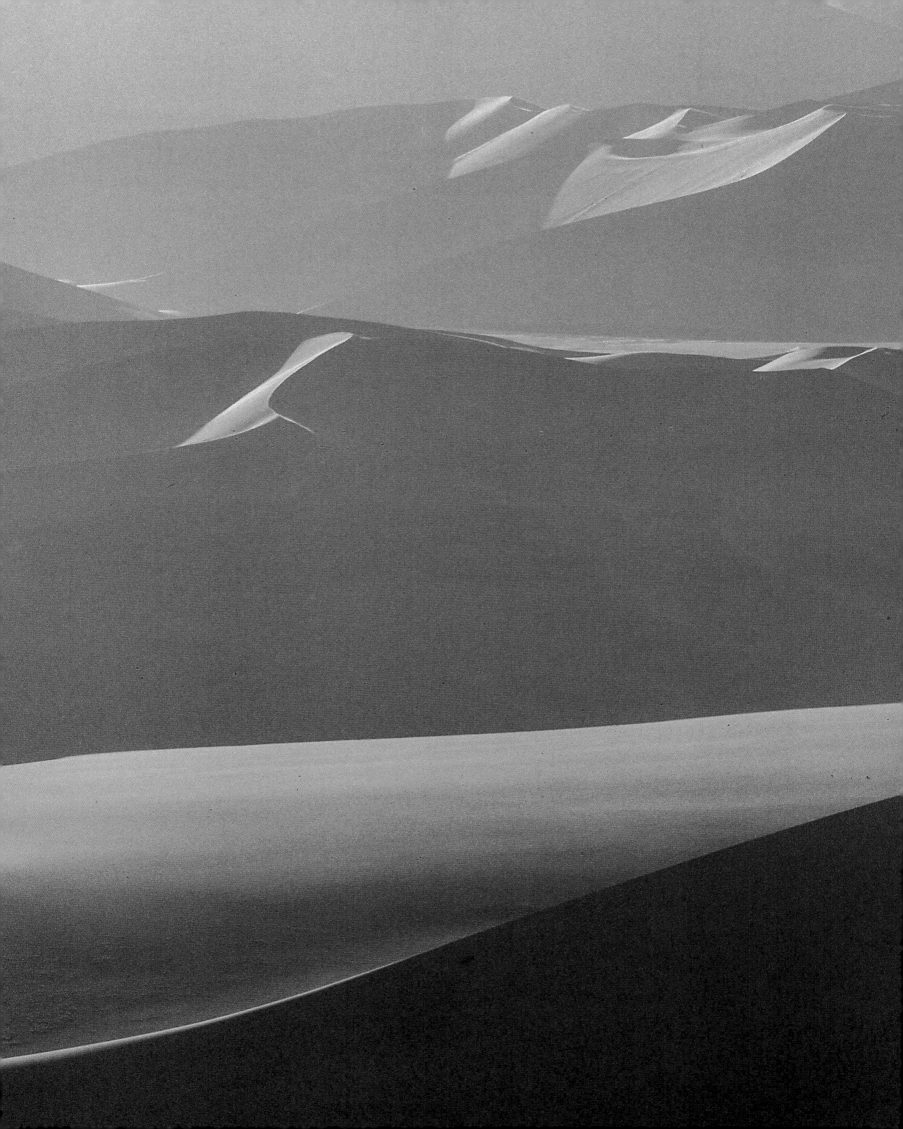

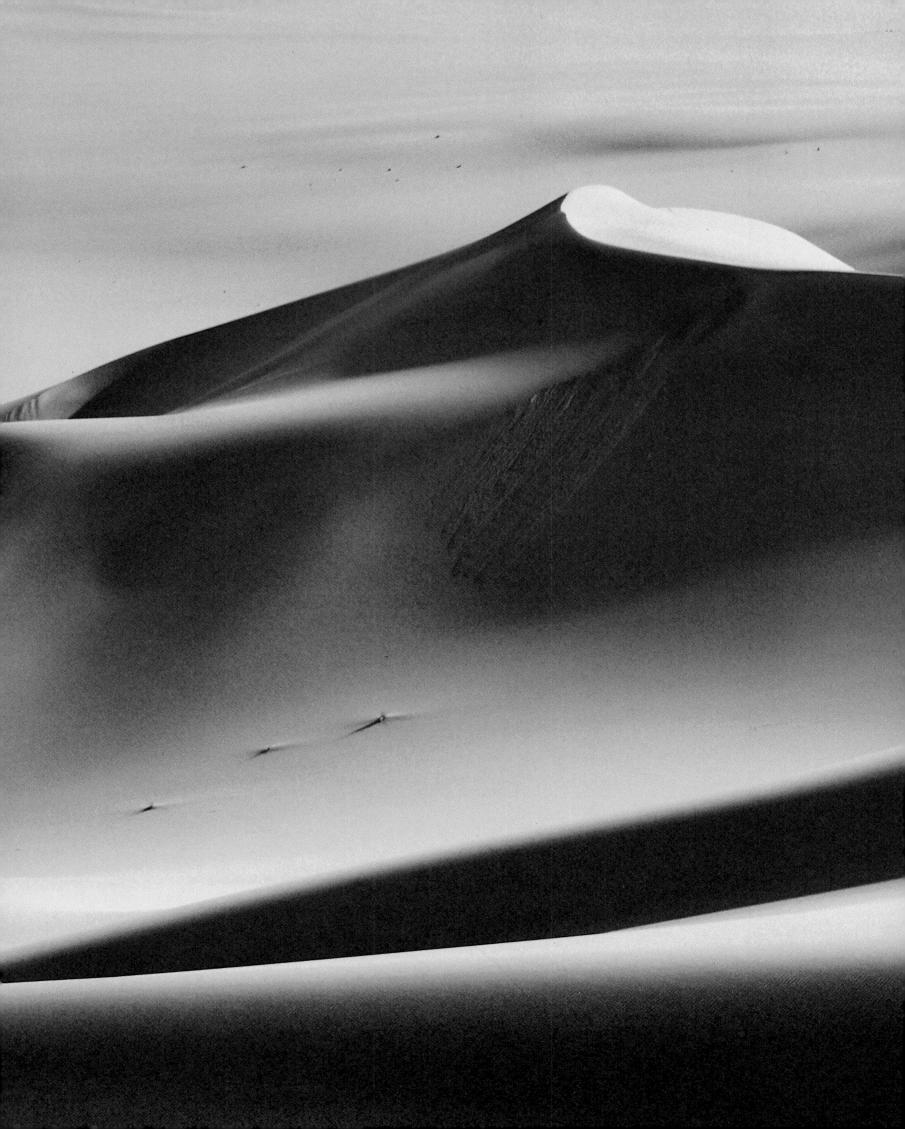

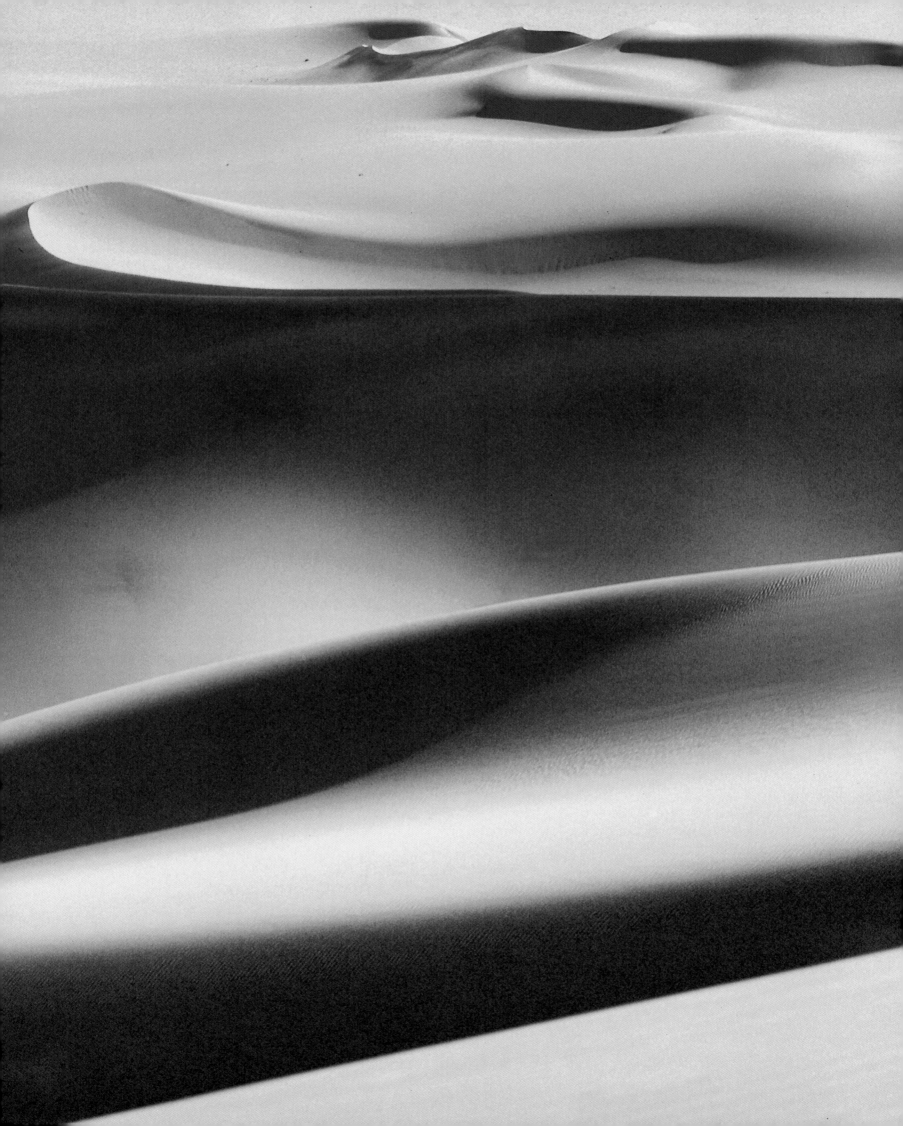

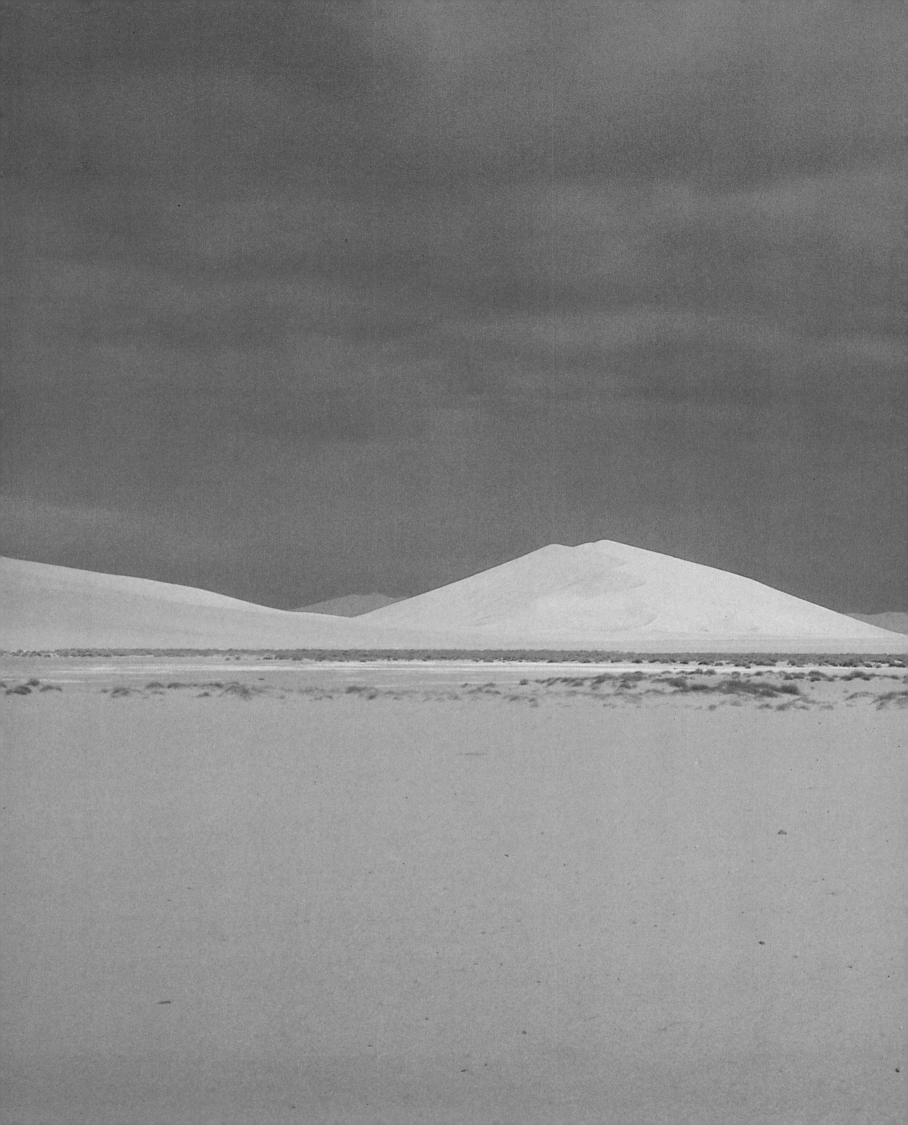

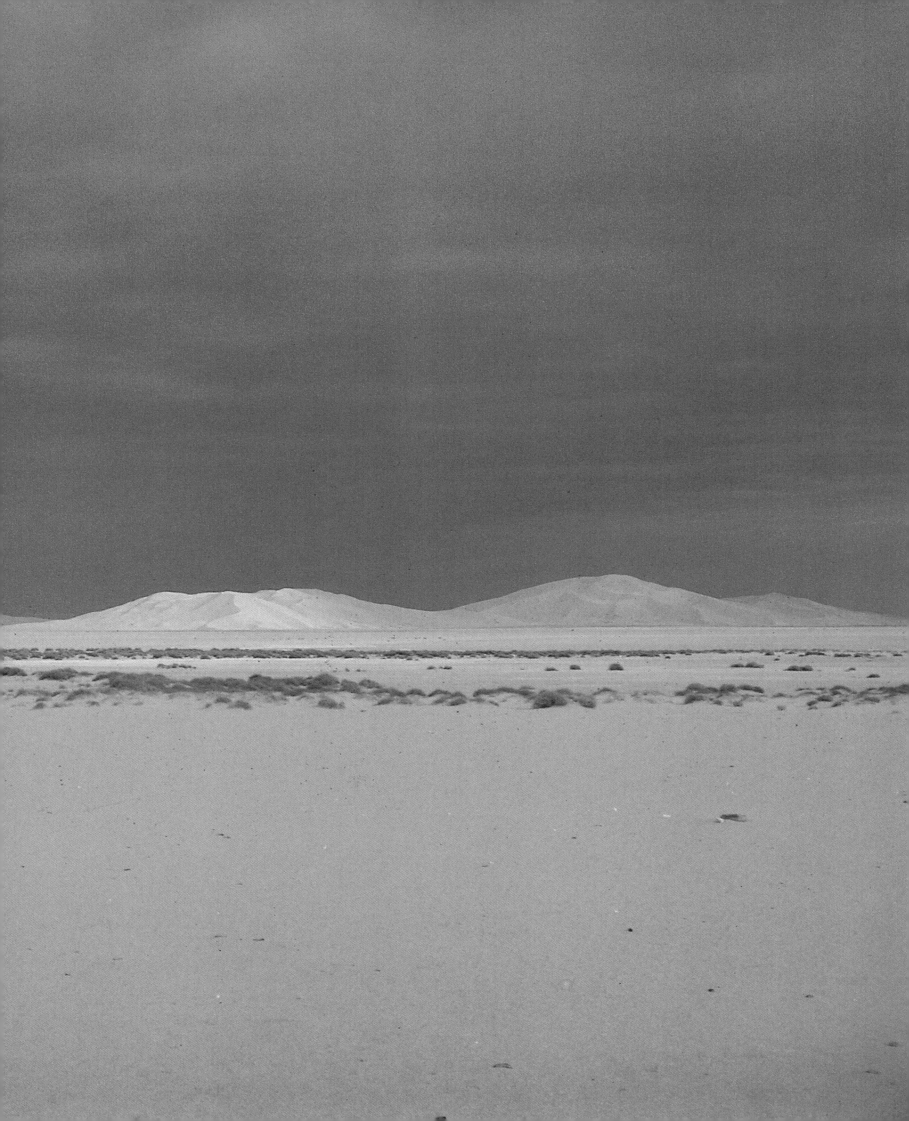

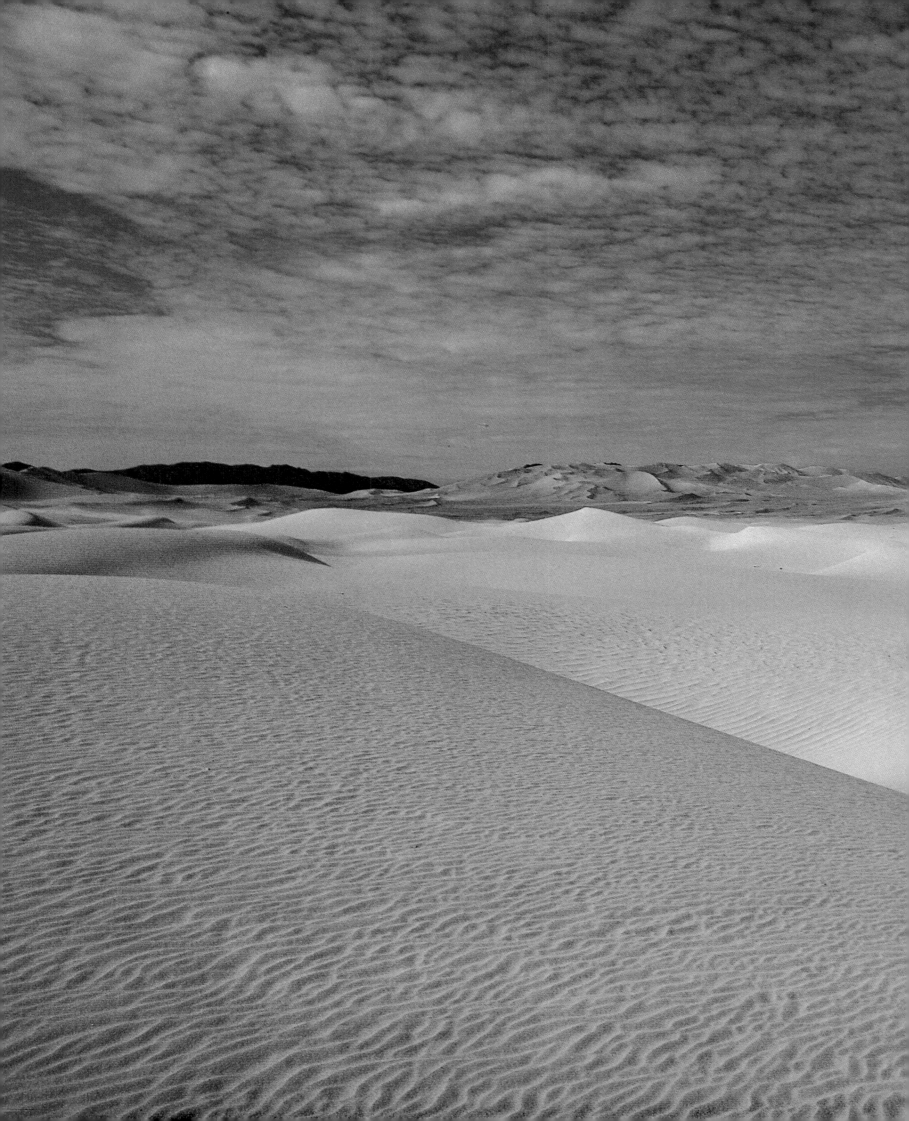

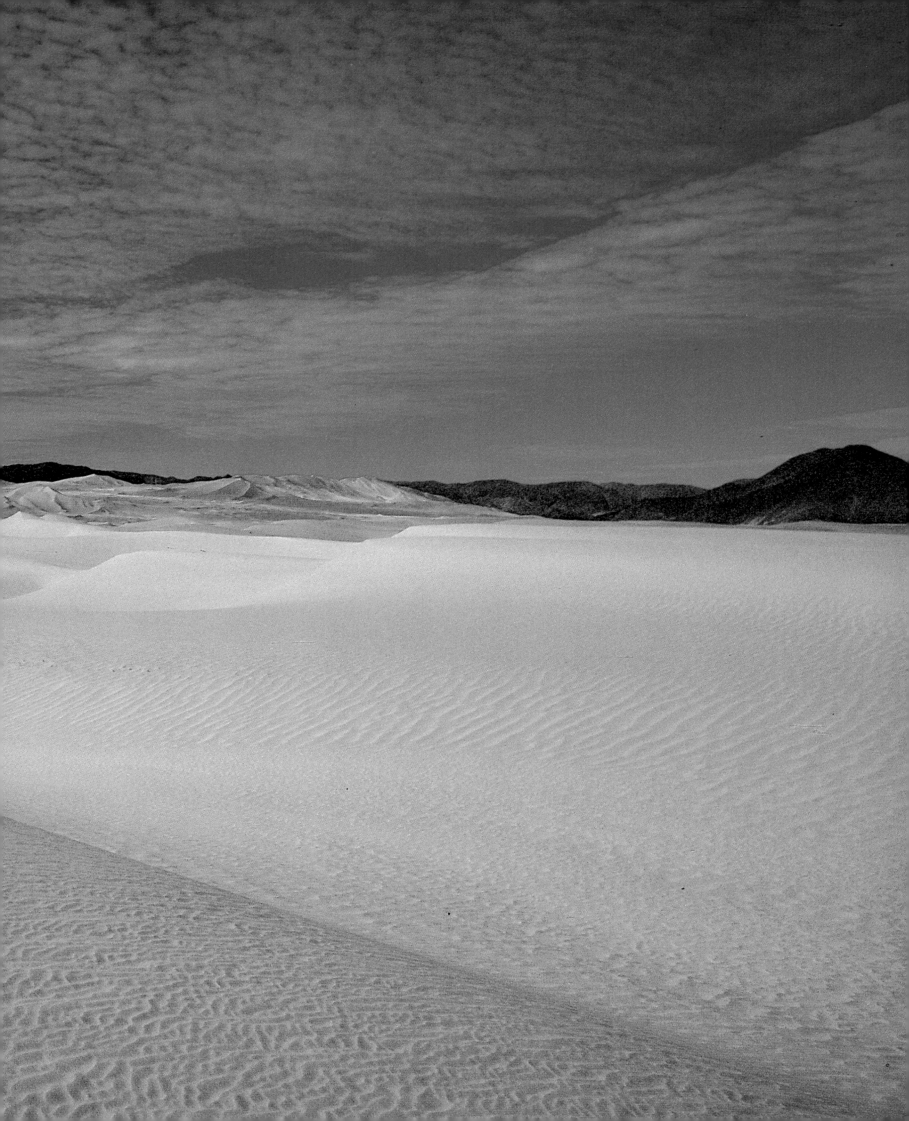

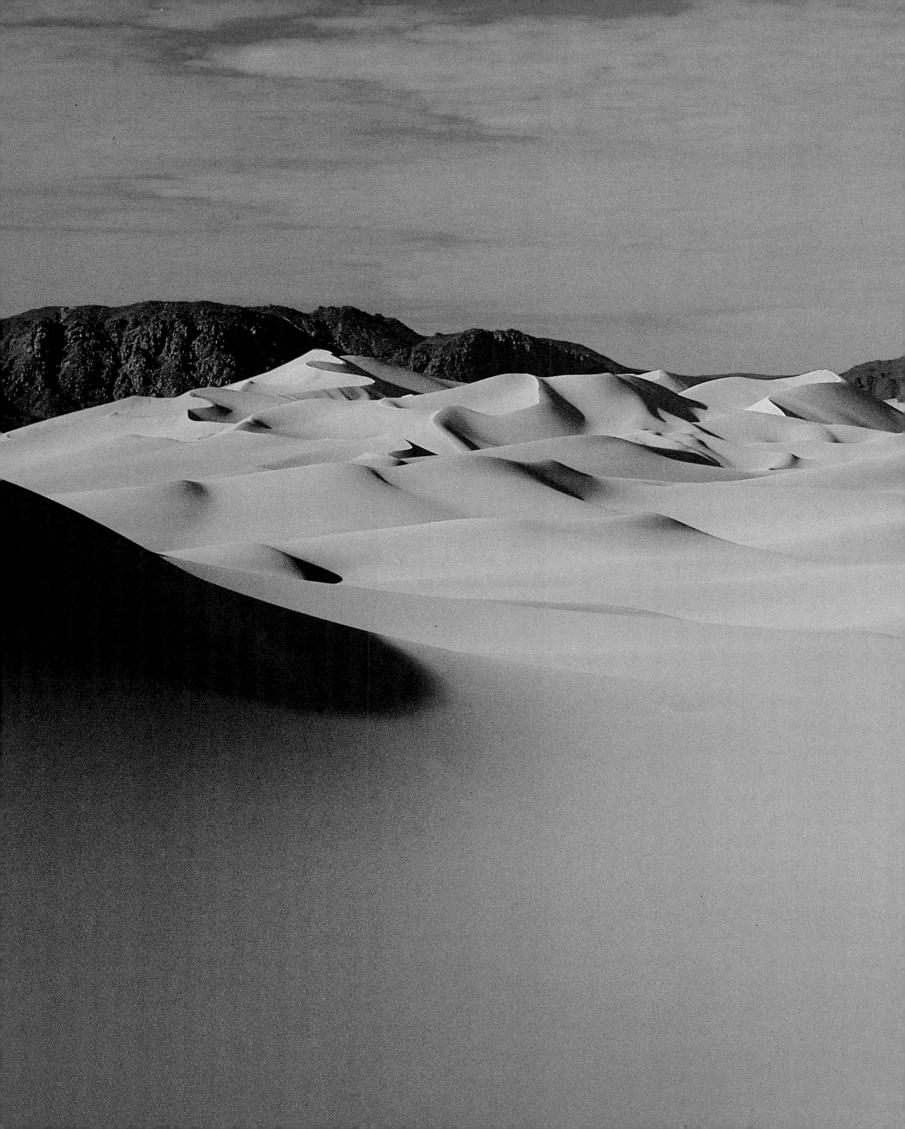

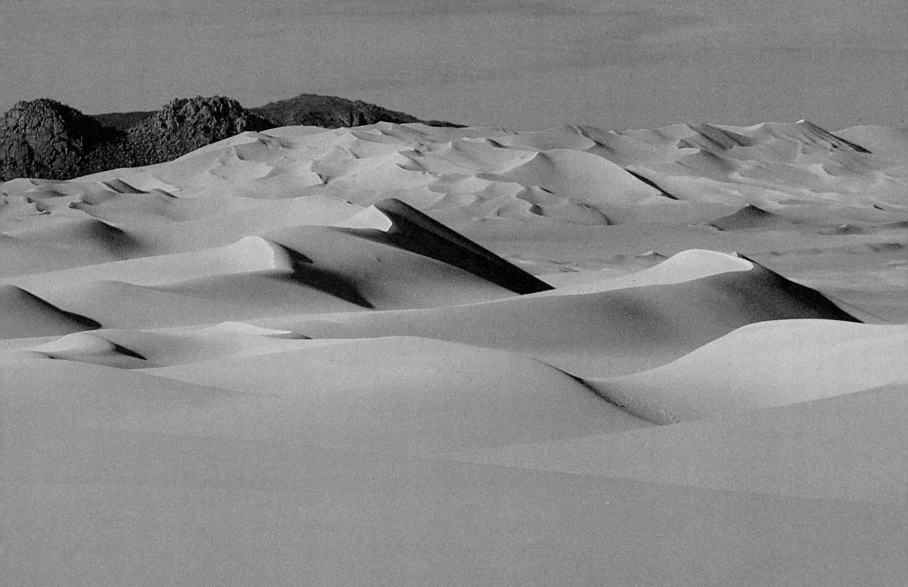

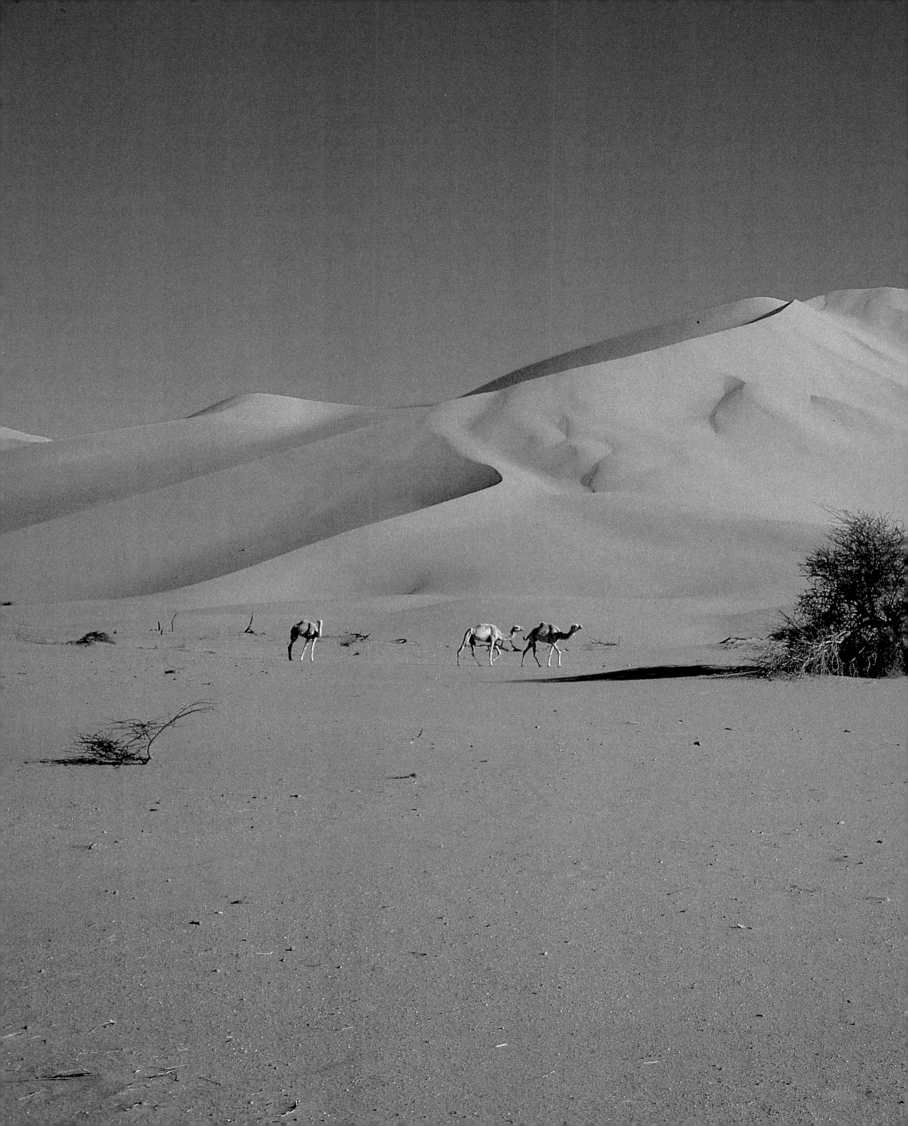

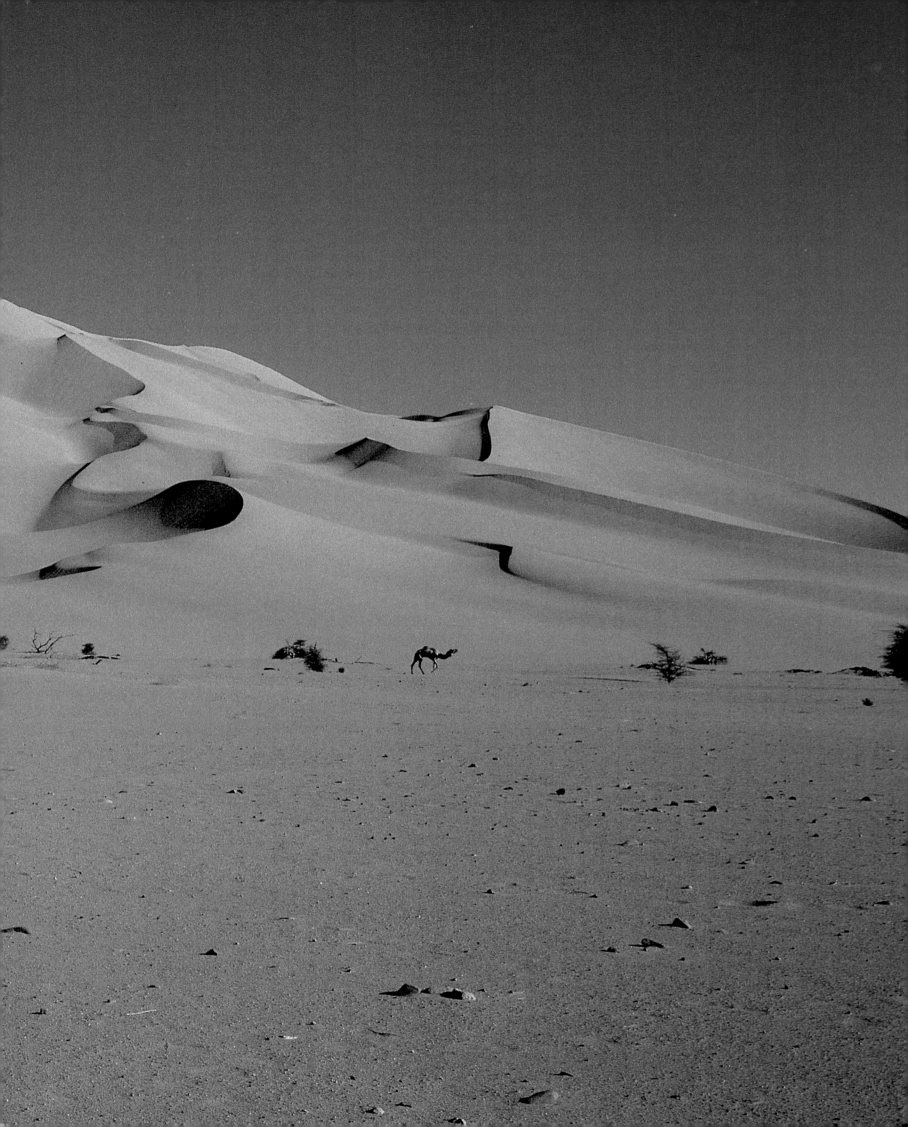

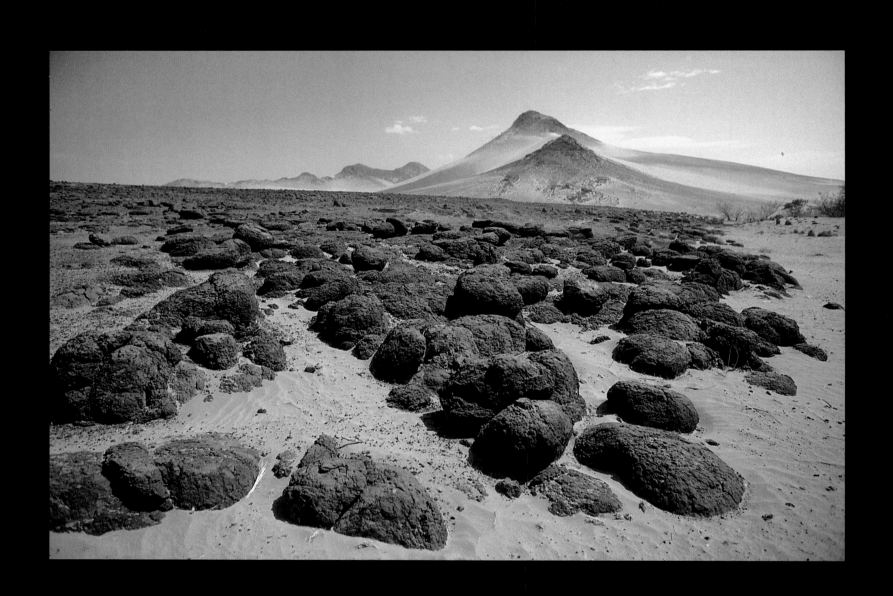

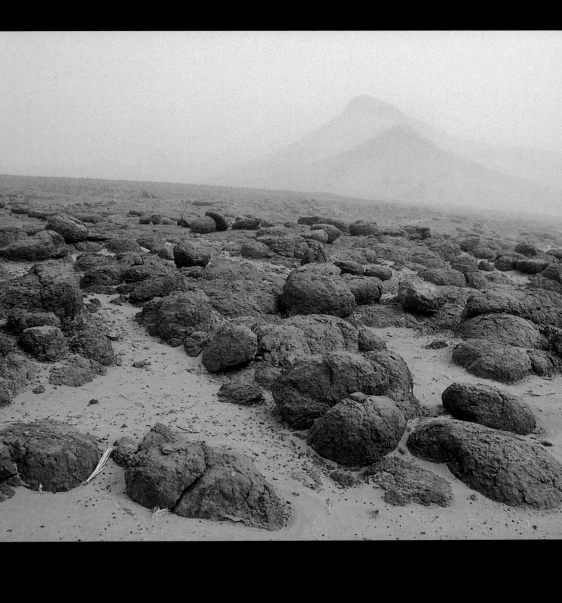

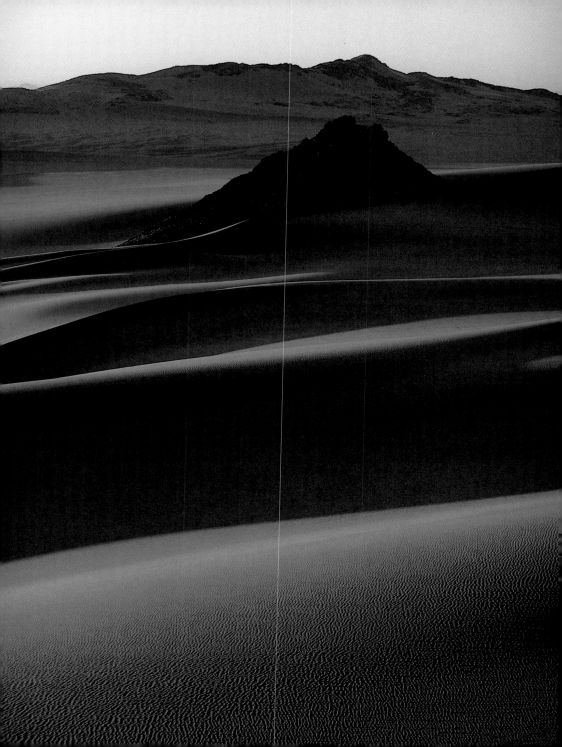

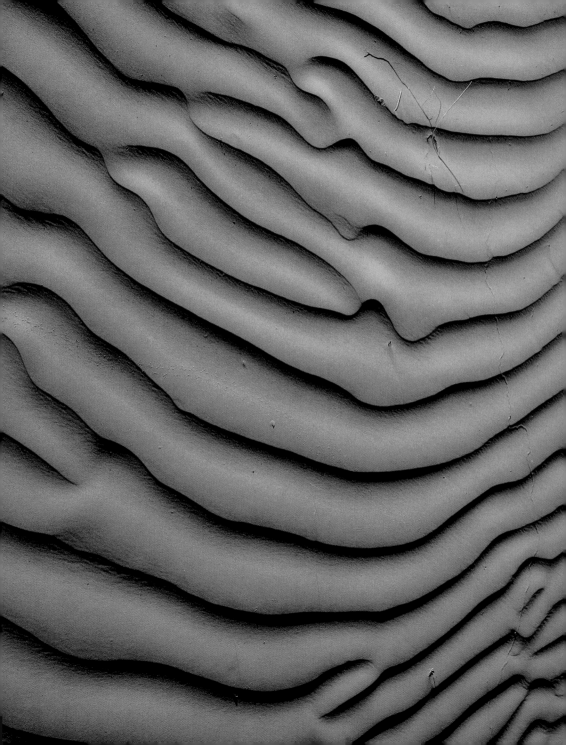

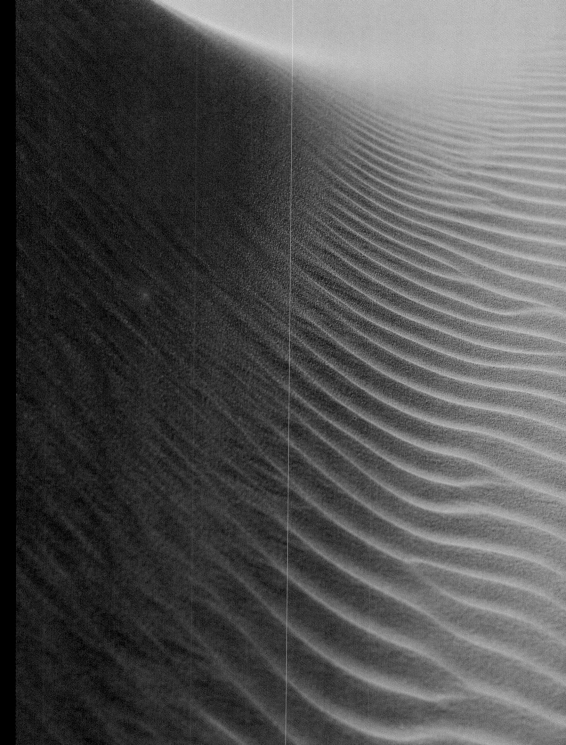

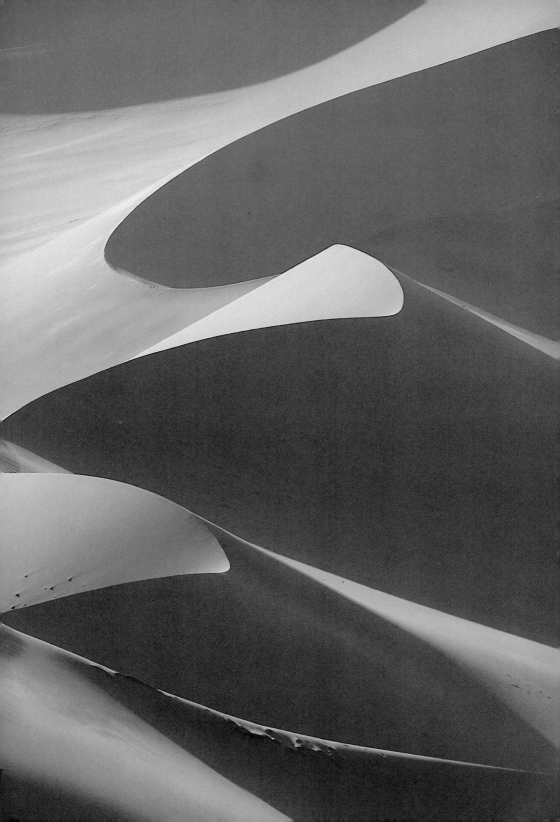

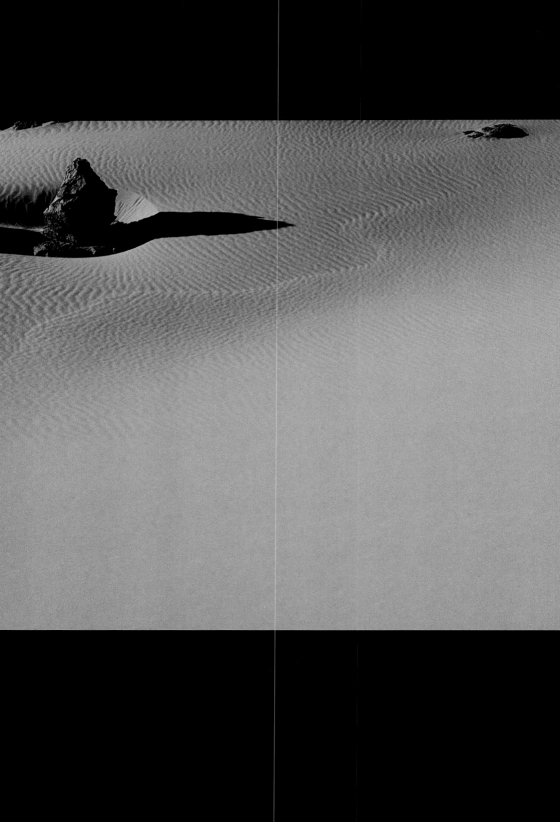

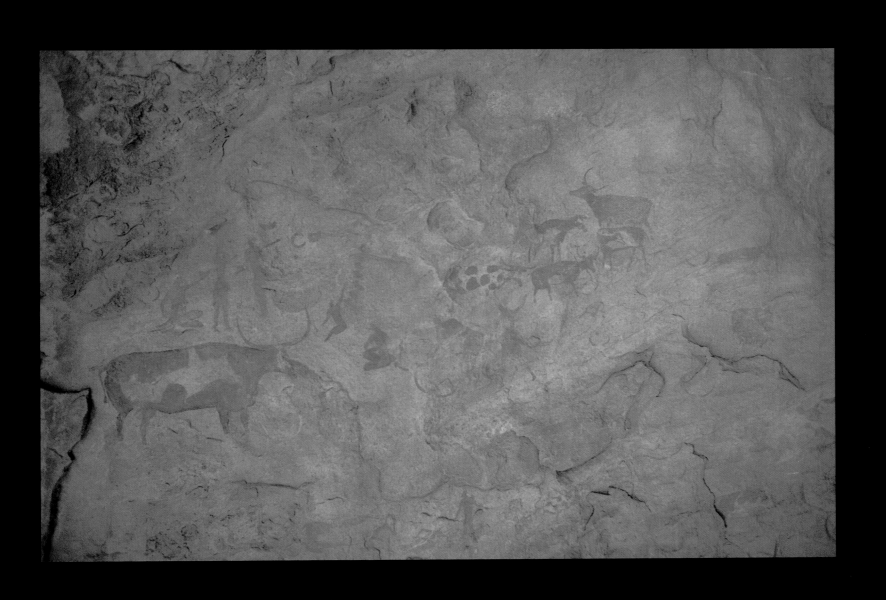

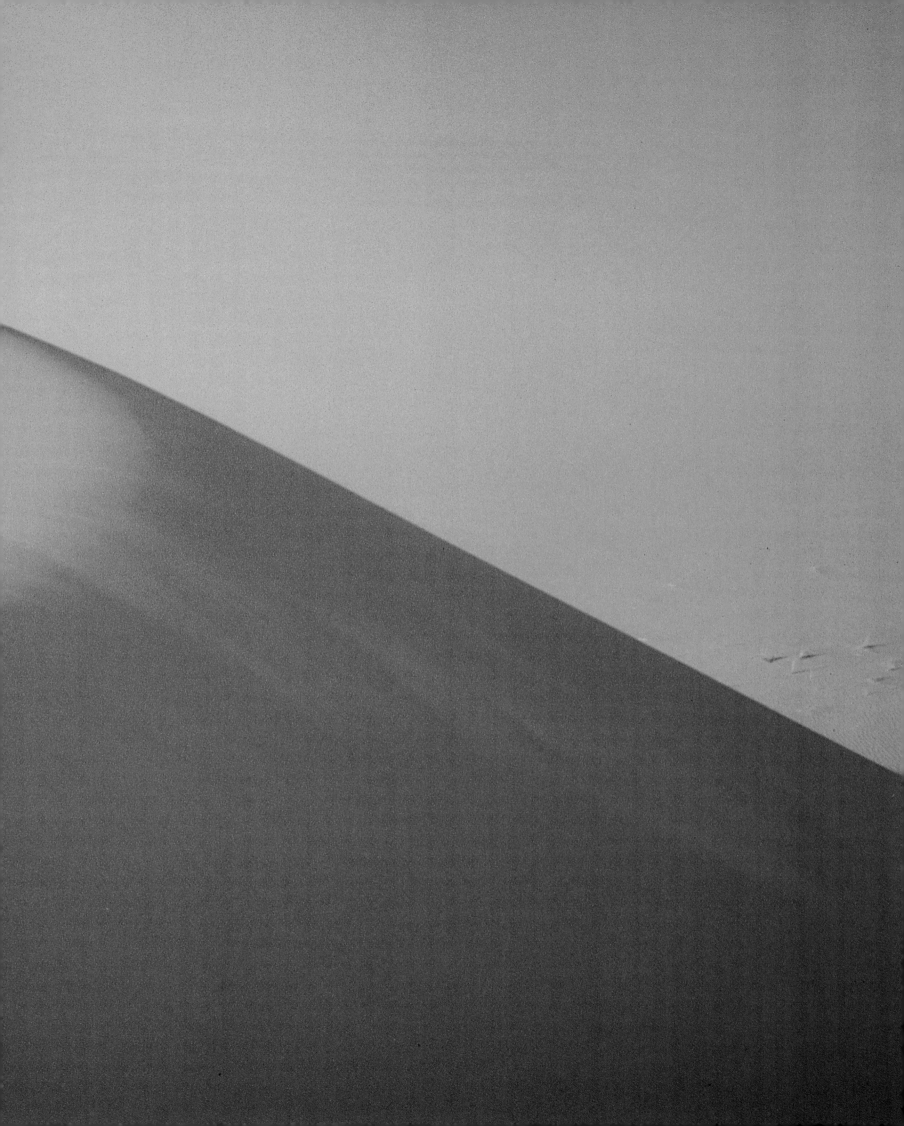

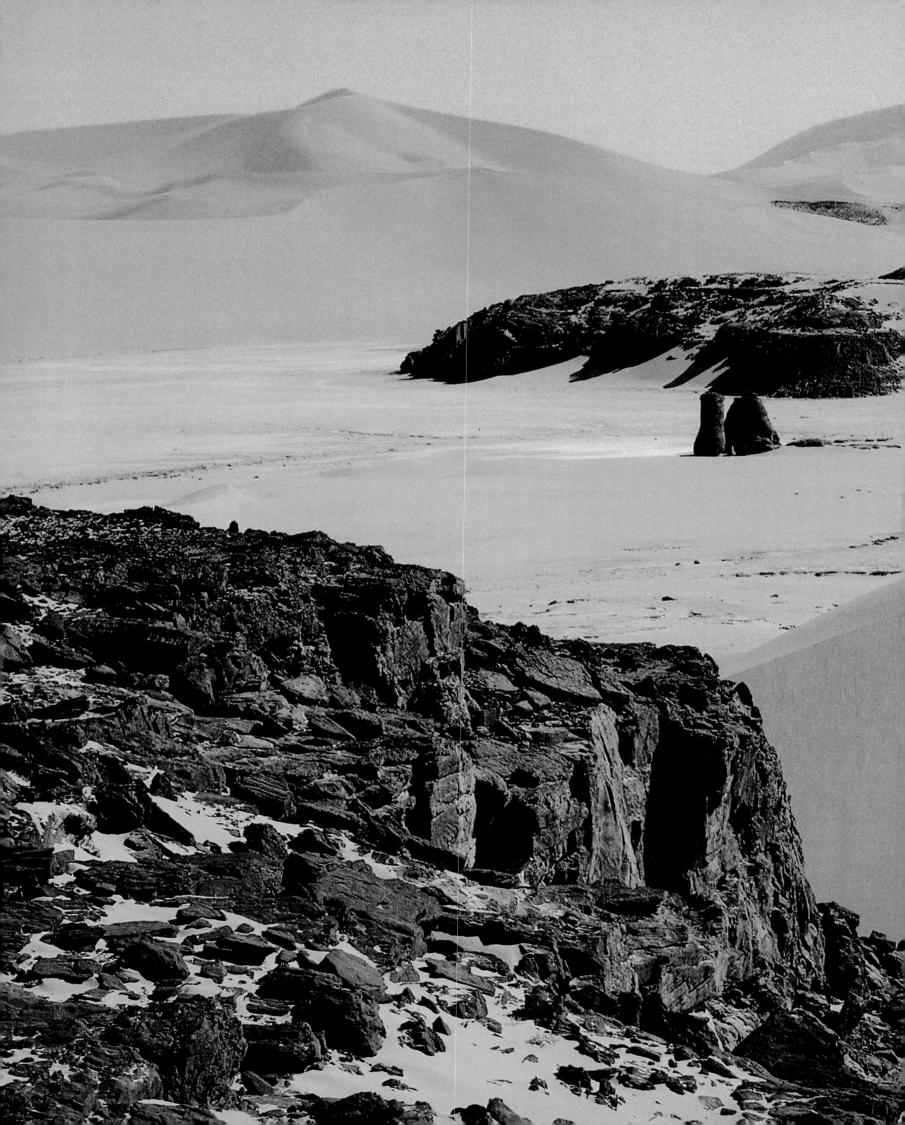

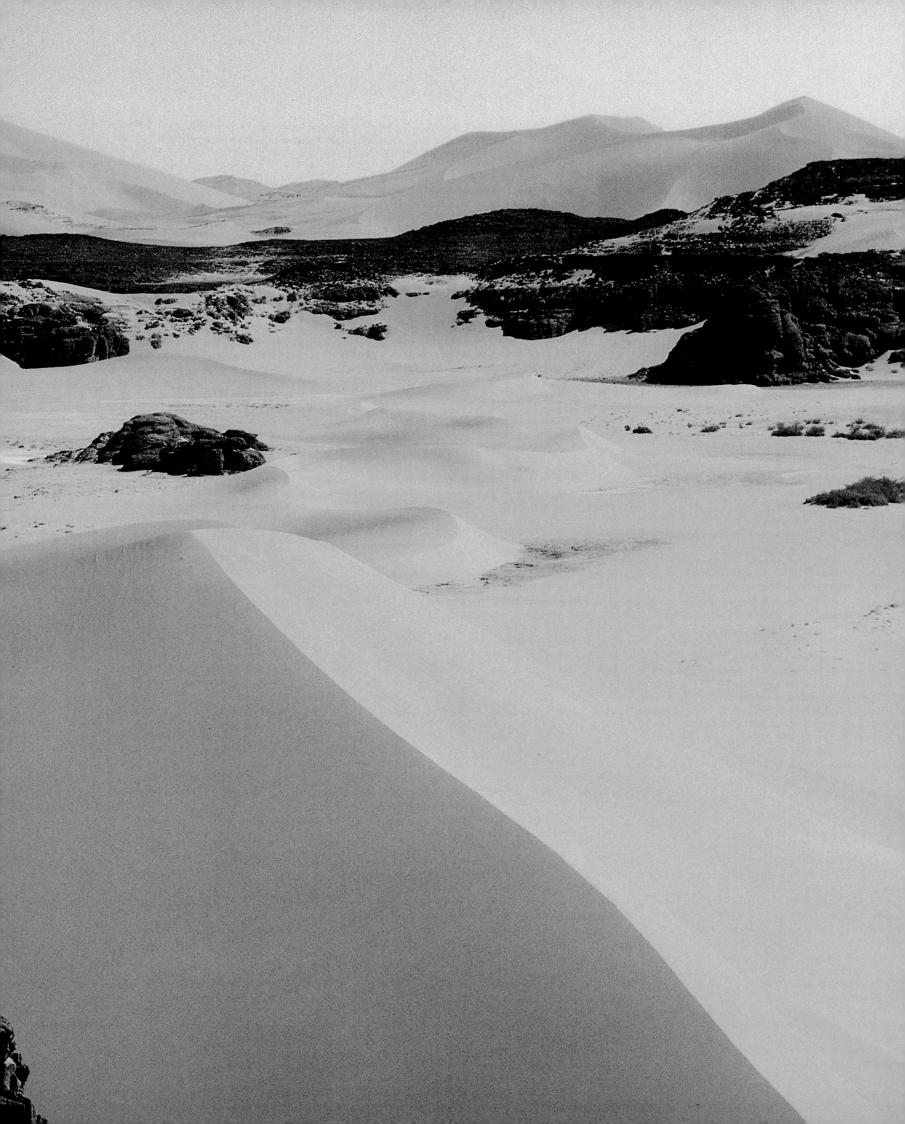

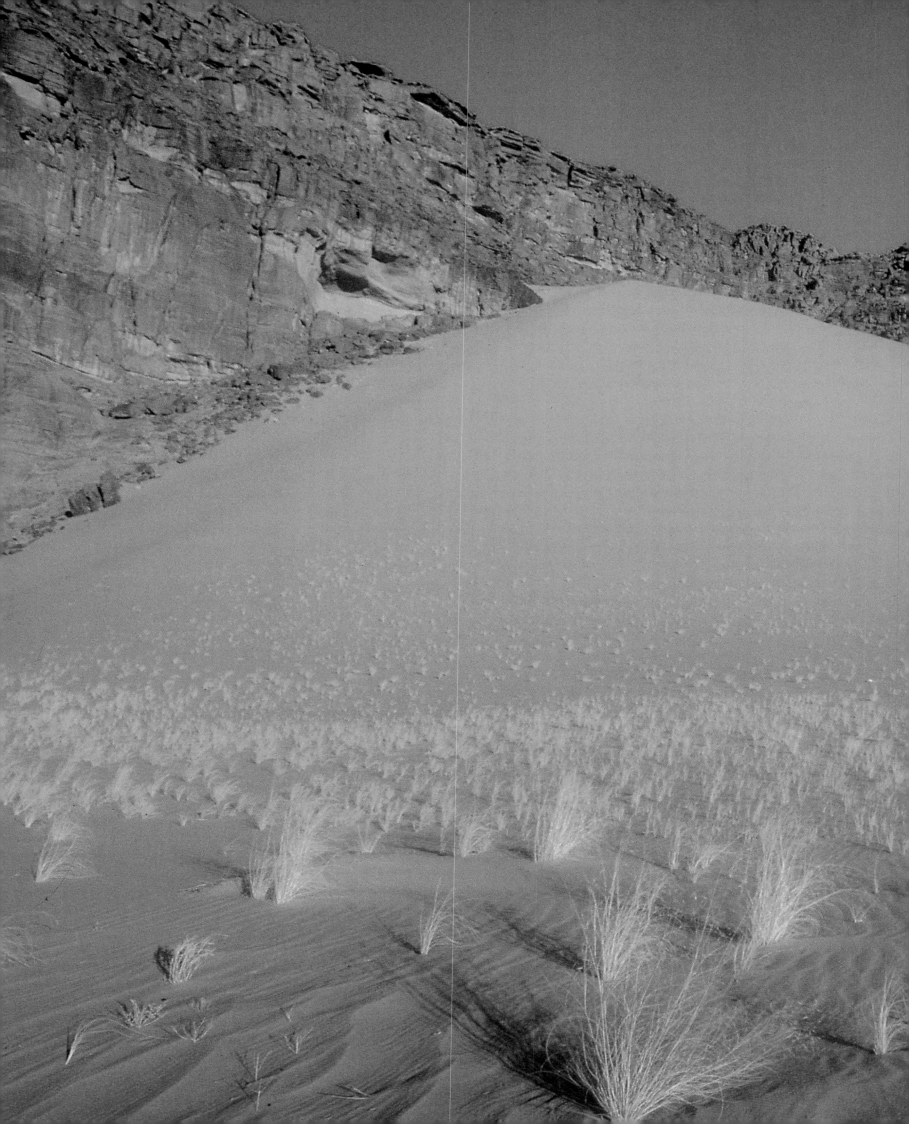

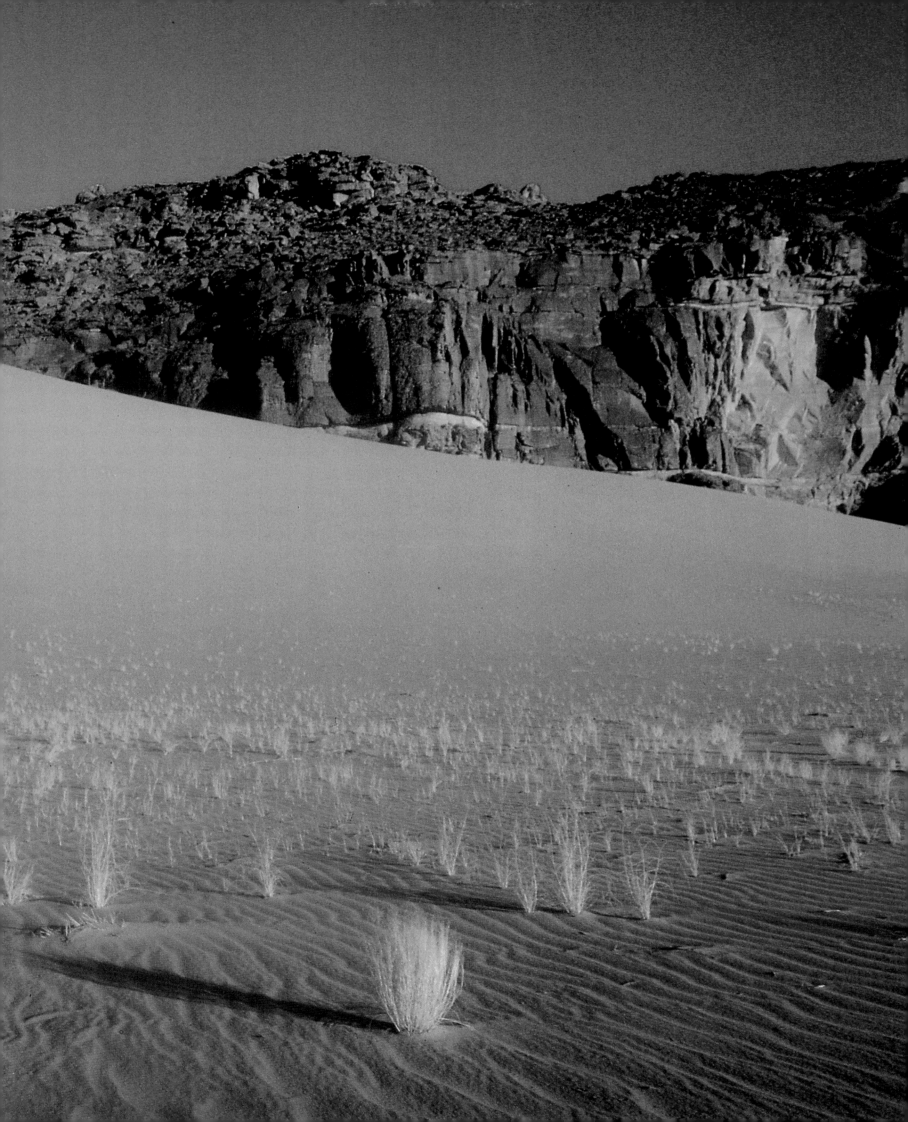

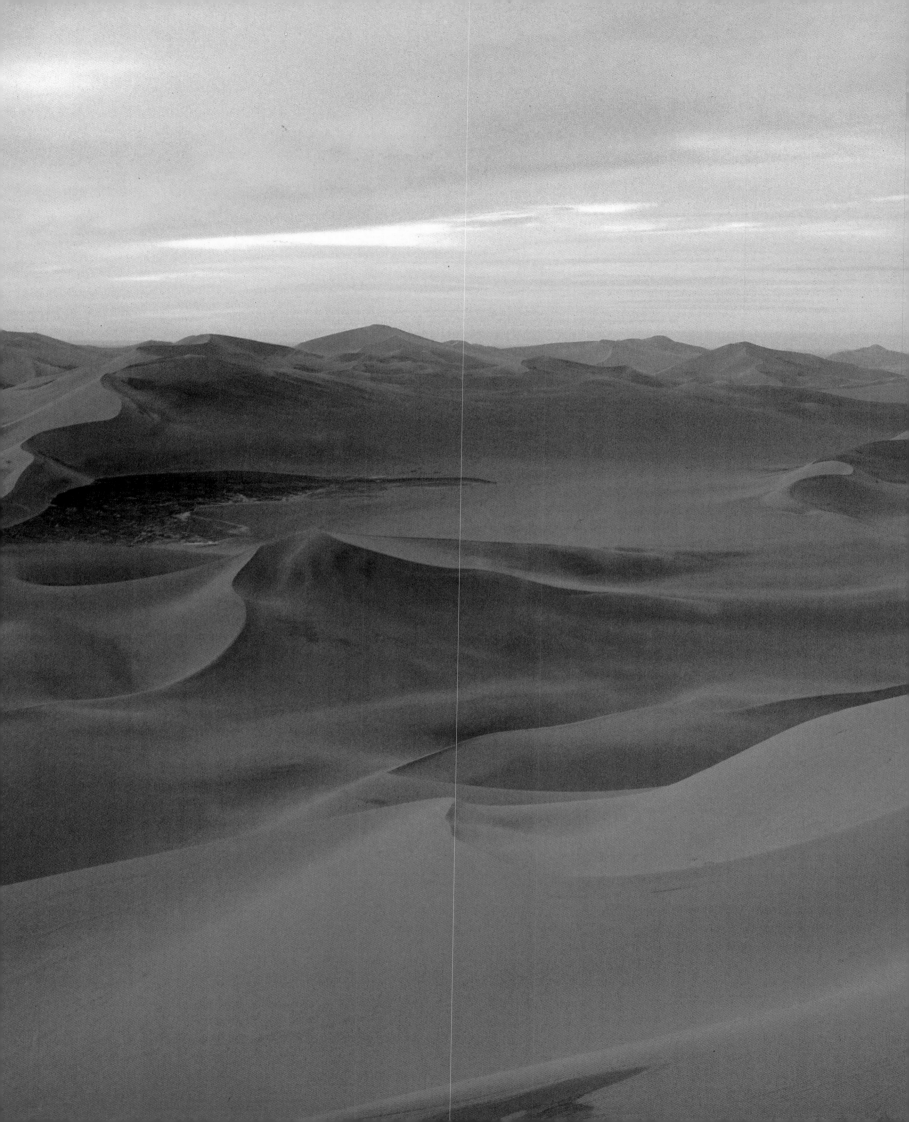

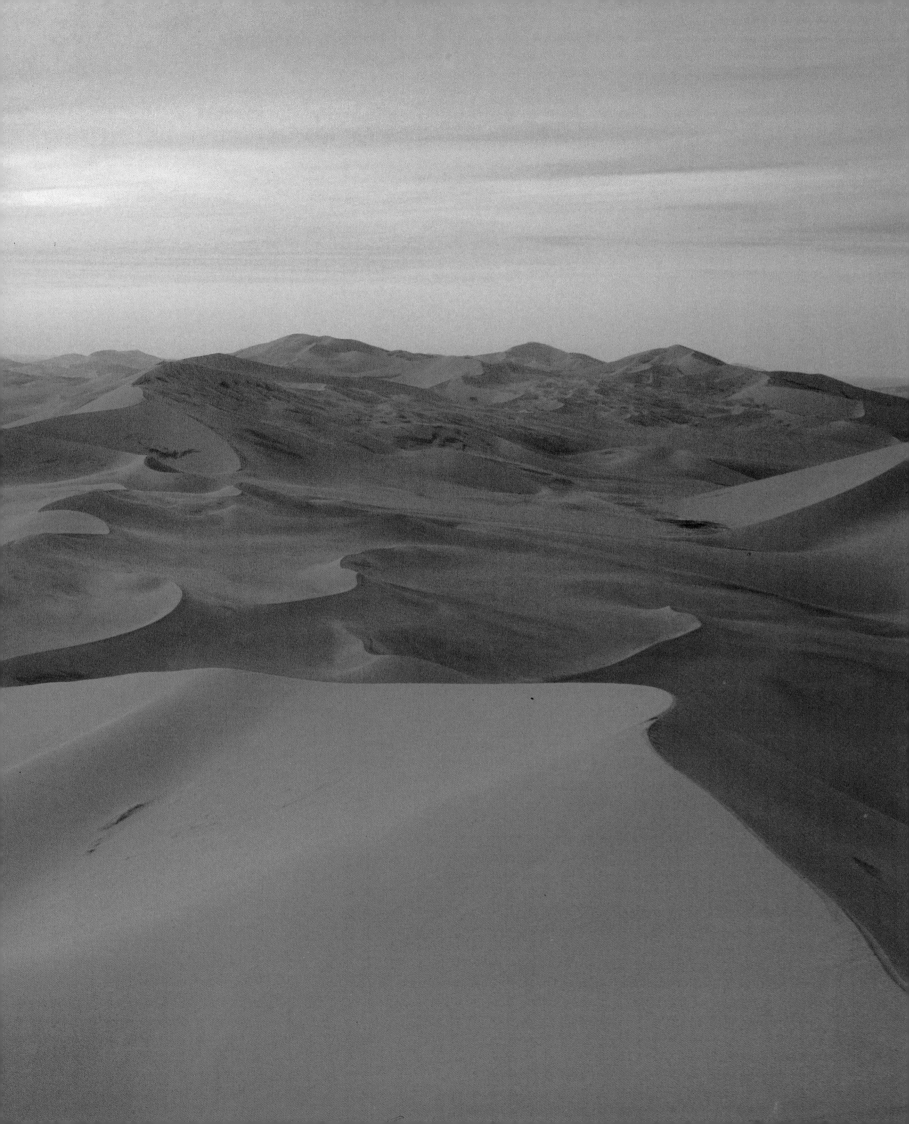

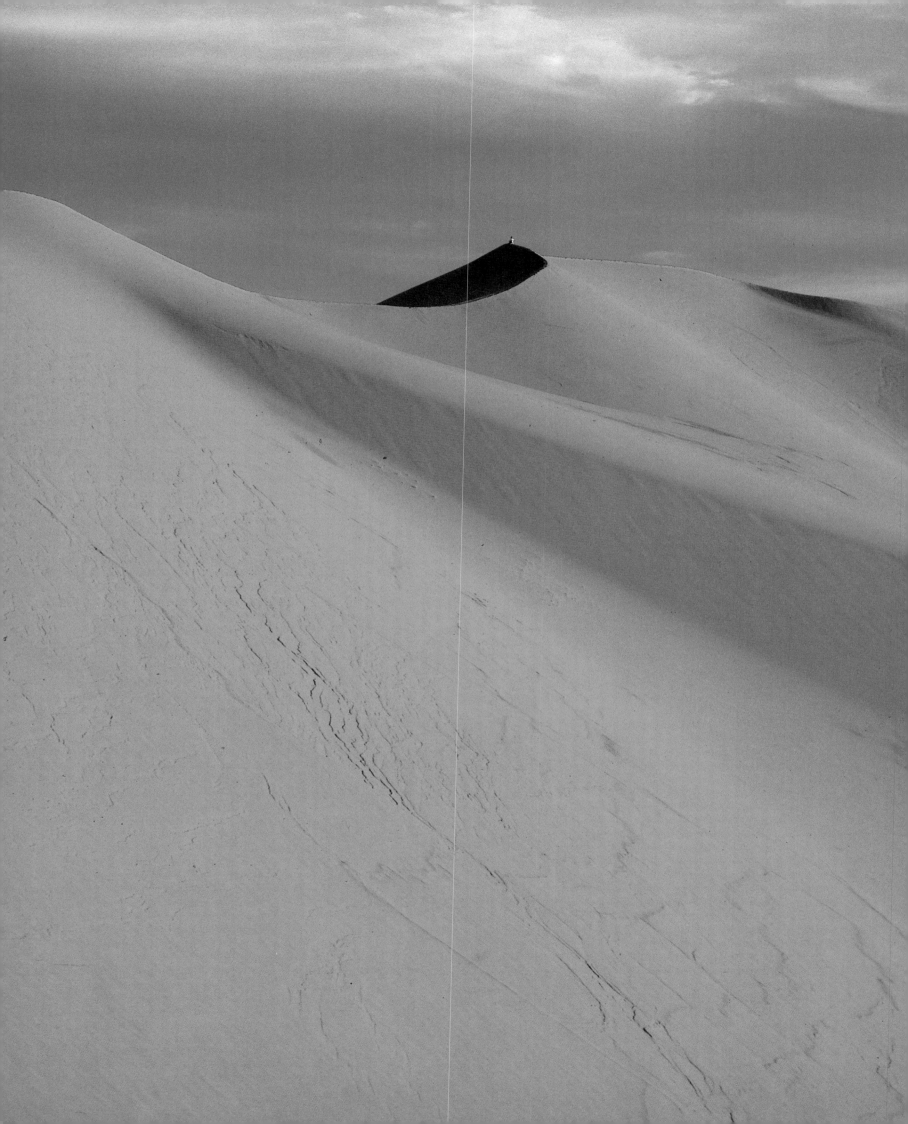

# FROM *FORT GARDEL* TO *FORT SAGANNE . . .* AND BACK AGAIN

Louis Gardel

Jules Roy is the one who made me want to write *Fort Saganne*—or rather who told me to write it—one evening when we were dining in the commandery of monks deep in the Morvan, where he was living some fifteen years ago. I was telling him about a novel I had in mind: the story of an aging lady who suffers from migraines. He interrupted me with one of his warm, mocking laughs.

"Gardel, between the old lady and her migraines, you'll bore the hell out of everybody. You should write the story of your grandfather in the Sahara."

I knew almost nothing about this grandfather, who had died in 1916 at twenty-eight, before his son, my father, was even born.

My imagination had a few points of reference that I had gleaned here and there, but with no real certainty. Gabriel Gardel had traveled in the desert with Father Charles de Foucauld; he had amputated one of his soldiers with only what he had on hand; he had escaped a siege with fixed bayonets. I also knew that there was a fort named for him in the Sahara. I believed that it was in that fort where he had been surrounded by hostile tribes, and there where the desperate, bloody, and glorious charge had taken place.

I began writing the book at Jules Roy's suggestion as soon as I got back to my room. I tried to picture, in the Morvan night, the setting of that Saharan fort, about which I knew nothing, of which I had never even seen a photograph. At the same time, I attempted to put myself in the place of that man, my grandfather, who, with nothing to lose, had decided to plunge into the enemy bayonet first. What had he been thinking? What had he felt? What is it like to avoid being struck down and to strike others, point blank, chest to chest? Would I have been capable of such courage, such savagery? Was I even capable of reconstructing within myself the thoughts, emotions, and sensations of somebody who had been capable of this, someone who had physically done these things? I sat at my table, pen in hand, attempting to conjure the visceral tone and weight of those minutes out of the realm of pure imagination.

Later on, to support the fiction, I consulted piles of books and articles on the lives of French officers in the Sahara between 1900 and 1914. From them I learned that the bayonet charge took place not at Fort Gardel but at a place called Esseyne, which is today in the

Tripolitan territory. I read Gabriel Gardel's report on the battle. It is dryly written. I kept it in the book, almost word for word, motivated not by respect but by the certainty that I could do no better. Nevertheless, the very act of folding it into fiction transformed it from a factual account to literary fantasy.

Later still—in my ongoing search for documentation—I visited the fort named for my grandfather, between Djanet and Tamanrasset. Until then, the book in progress had been titled, in my head, *Fort Gardel*.

The instant I laid eyes on those half-collapsed earth walls, around which two unfortunate Algerian agronomists, exiled from Oran, were vainly attempting crop experiments, it was clear to me that I had to find another title. As it was, this fort, with a name that was mine to share, had no place on the cover of the novel. After much trial and error, the result was *Fort Saganne*. The title brought me back to familiar territory, that of the imaginary. I didn't make this choice; it imposed itself. Hence the serenity with which I met the attacks and controversy aroused by *Fort Saganne*, especially on the part of the Saharans. It is in the nature of publishing that the book aroused their hostility and that they considered its author a traitor. To write fiction is to betray. Not truth—at the end of the day, it is fiction that tells the truth—but reality. There's no escaping it. As we know, reality goes beyond fiction or, more precisely, catches up with it.

When *Fort Saganne* was turned into a film, shot in Mauritania, the Algerian authorities refused to make their territory available to the crew. A fort was built from scratch near Chinguetti to serve as the setting for my characters' adventures.

*Fort Saganne* took shape on film, just as Gabriel Gardel, who in my hands had become the fictional Charles Saganne, was incarnated with the features of the actor Gérard Depardieu. Yet these were still only images: we remained in the realm of the imagination.

Someone recently showed me the Michelin map of Mauritania: the film set, or what's left of it, is there, officially labeled Fort Saganne. And so the loop is closed.

Which loop, though? I don't know exactly. It is something to ponder.

The Sahara is certainly a bewildering place.

LOUIS GARDEL
*Writer*

# "FOR THE TUAREG, THE DESERT IS THE REFLECTION OF THE SOUL."

MOHAMED AOUTCHIKI CRISKA

The desert is a world of disproportion, shaping humans and their emotions in its image. It is an environment of extreme demands. The desert's inhabitants have an unlimited generosity of spirit matched only by the endless horizon, the infinite patience of a never-ending road, and the pure dignity of a people built as solid as a mountain.

I was born in this desert some two hundred miles (300 km) north of Agadez, in the Aïr massif. I belong to the Kel Tedelé, who live in the Talak plain. Later I entered the civil service and went to live in town. But I can never stay in a house for very long, and in reality I spend more time on the road in the desert and in the mountains than at home.

The attachment of the Tuaregs to the desert is nourished in part by their love for others. Every Tuareg feels a kind of kinship with everyone who crosses his or her path; this love for the other is, in fact, a condition of survival in the desert. Every person is available to another, is always prepared to help. Without this love for the other, this profound respect for all living things—human, plant, or animal—it would be impossible to survive. What fuels the passion of the Tuareg for their desert, what reinforces it, is the endless freedom they receive in return. This freedom is, in a way, their reward.

We live in a hard and hostile environment; the desert demands a great deal of endurance, but it gives accordingly. This freedom is our finest gift. This and the love for one another to some degree makes poets of all the Tuareg. For they are all free, and all loving.

Our culture derives from this passion. It is a culture made up of refinement and austerity, delicacy and depth. The desert is also a secret world, requiring a long initiation. The key to this initiation is patience and observation. It is the Tuareg women who are the keepers of this culture, for it is they who will transmit it and teach it to their children.

I was a child of the desert, raised in this world of deep attachment to others. Tuareg children learn very quickly that the love of their people consists of absences, separations, and reunions. It is the bond of love in the nomadic life. A Tuareg proverb says that we must "move our tents apart to bring our hearts together."

The Tuareg are reticent. They will not tell you so directly, but if you take away their desert, you take away a part of them. When they lose a part of their culture, it is as if they were losing their arms or their legs.

I always keep deep in my heart the vision of those immense, splendid spaces, the quality of light on the dunes, and the reflection of those blue marble mountains in the azure sky. These are the images that I hold deep in my heart when I am away from the desert. But I do not forget the other side of that setting. I always remember the great droughts.

There are other images, too, of rags caught on sticks, the only traces of encampments abandoned by families whom extreme poverty has stripped bare. I have seen these proud men, my brothers, clustered around food distribution centers. Obliged, like beggars, to receive food ladled out to them by strangers, strangers who could not even guess the extent to which these nomads were forsaking their dignity as men. Droughts, then wars reduced these people to begging. Today a great many of them, rejoining what is left of their families, have gone to the outskirts of the big cities of West Africa: Abidjan, Dakar, Niamey, and Bamako. Far from their desert, they are subject to another law of survival. They beg or live as refugees in camps in Mauritania and Algeria. I hope they always keep the desert deep in their hearts, for the passion that the nomads feel for their desert is also, I believe, the reflection of what is divine in human beings. The desert is like a mirror, and everyone can carry it deep within. For the Tuareg, the desert is the reflection of the soul.

MOHAMED AOUTCHIKI CRISKA
*Nigerian Tuareg naturalist*

# "ONE ALWAYS TRAVELS AHEAD OF ONESELF"

*—Tuareg proverb*

IBRAHIM LITNY

I have traveled. I now live far from my home. I have lived in Paris for almost six years, but I know that the desert still possesses me. The desert is a part of me, it is in me. I belong to it. I was born out there, in the desert of northern Mali, and I will carry it with me forever.

The desert is, above all, a system of references. It is the world in which I lived, and where I learned to live. It is the environment that conditioned the way I was raised and the way in which, today, I think about things.

People who are born and bred on a mountaintop never lose the habit of bending their necks to look at what's around them. People born and bred in the desert never lose the habit of looking very far ahead.

The desert is also my identity, my place, my home. When I go back to the desert, I feel that I'm going home. That is when I regain my perspective, when I reassess the meaning of things, when I feel I am in my natural element. On the other hand, when I am in Europe, whether in Paris or elsewhere, I am obliged to adjust my desires and needs, to conform to behaviors, values, and language that are not natural to me. A Tuareg proverb says, "Sing the song of the birds of the country where you find yourself." So I've learned to sing the song of the birds of Paris, but I will always have a vital need to immerse myself back into my native environment, a regular need to hear the birds of my own country. Only those who live in the desert know that the black-and-white *moula-moula* is the messenger bird, the bird that brings happiness. In the desert, as a Tuareg child, I learned very early how to speak *moula-moula*. And, like other nomad children, I learned to be flexible, to adapt; I learned patience, tolerance, and the golden rule of hospitality.

When you describe the desert, try not to use words like "exotic" or "supernatural." The desert is just one environment among many. It's just a piece of the planet, a piece of land that should be described simply, with all its beauty and ugliness, its good and bad.

At the end of the sand is a mountain, and then more sand. It is nature to the extreme.

And yet the desert bears a gift called freedom. It is the desert's greatest beauty, this environment of pure freedom. I only became truly aware of this gift when I left the Sahara for the first time. In my native land, one is free to come and go as one pleases and to settle where one wishes. But when one lives in such a harsh climate, sometimes in utter destitution, it is easy to overlook this freedom—the Sahara's greatest treasure. One must leave and then come back

to really see it. Or else experience the perspective of foreigners, the travelers and tourists who come to trek through the sand for adventure. When I first encountered these visitors to our desert, I thought they were crazy. They had everything at home, in their wealthy countries; what could they possibly be looking for in our lands, where there's nothing? Now I know that they come to experience this same sense of freedom that I now never take for granted.

Tuareg children are taught early on about the contradictions of the desert: freedom and destitution. They are taught the essentials, the gestures of survival; the gestures of water, well, and rope; the gestures of food, how to kill an animal and how to prepare it. They learn that every action has its value and use: hunting, herding, living in tents, traveling with the herds, the caravans. These gestures are celebrated, sung, and taught. They give rise to the stories, proverbs, and adages that form the basis of Tuareg culture. So the children are introduced to all the gestures of survival in this arid world. They aren't taught that the desert is beautiful or that the desert is big; they are not taught to love and respect it—such things are innate. They are told the stories of encampments, battles of the past, caravans that lost their way, and camels killed to save those from dying of thirst. They are shown tracks on the sand, those of a gazelle that managed to elude a hunter or of the goat that became separated from the herd and will have to be found before nightfall.

These tales and these daily lessons, the lessons of survival, are repeated for Tuareg children, in a way gradually "feeding" them the desert. Soon the desert possesses them, becomes a part of their souls. That was my life before I moved to France.

All that is changing, however. More and more of the Tuareg are going to live in the cities. They travel less and less. They no longer follow the herds. They draw salaries. And we can't oppose these changes, because one of our teachings, one of the foundations of our culture, is precisely to know how to adapt. And yet, at this crucial period in our history, it is of primary importance that we gauge what we may assimilate from other cultures, and what is essential that we preserve. We must determine today what we must never lose, what we must never find acceptable to lose.

IBRAHIM LITNY
*Malian Tuareg*
*Author of*
*"Systèmes éducatifs et sociétés touarègues"*
*("Tuareg educational systems and societies"), a dissertation*

*Oh! that the desert were my dwelling place,*
*With one fair spirit for my minister,*
*That I might all forget the human race,*
*And, hating no one, love but only her!*

Lord Byron

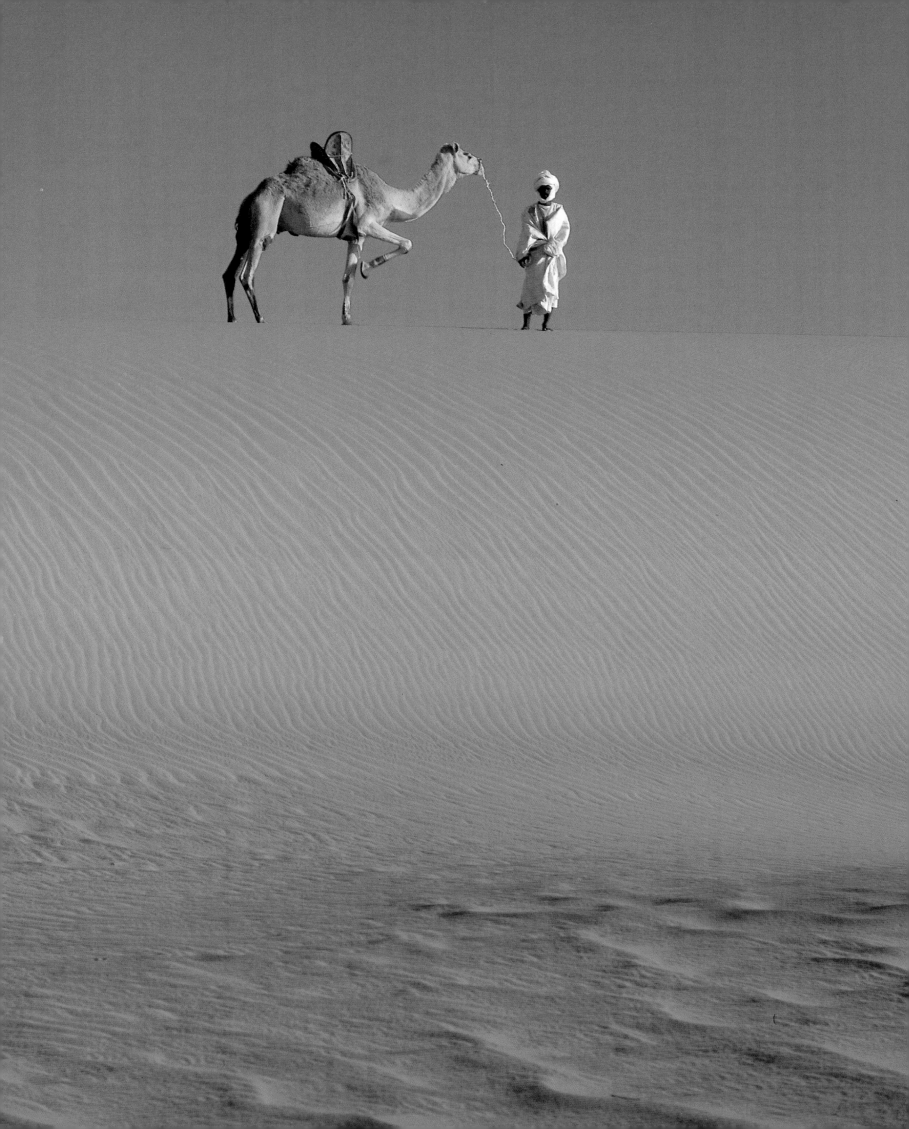

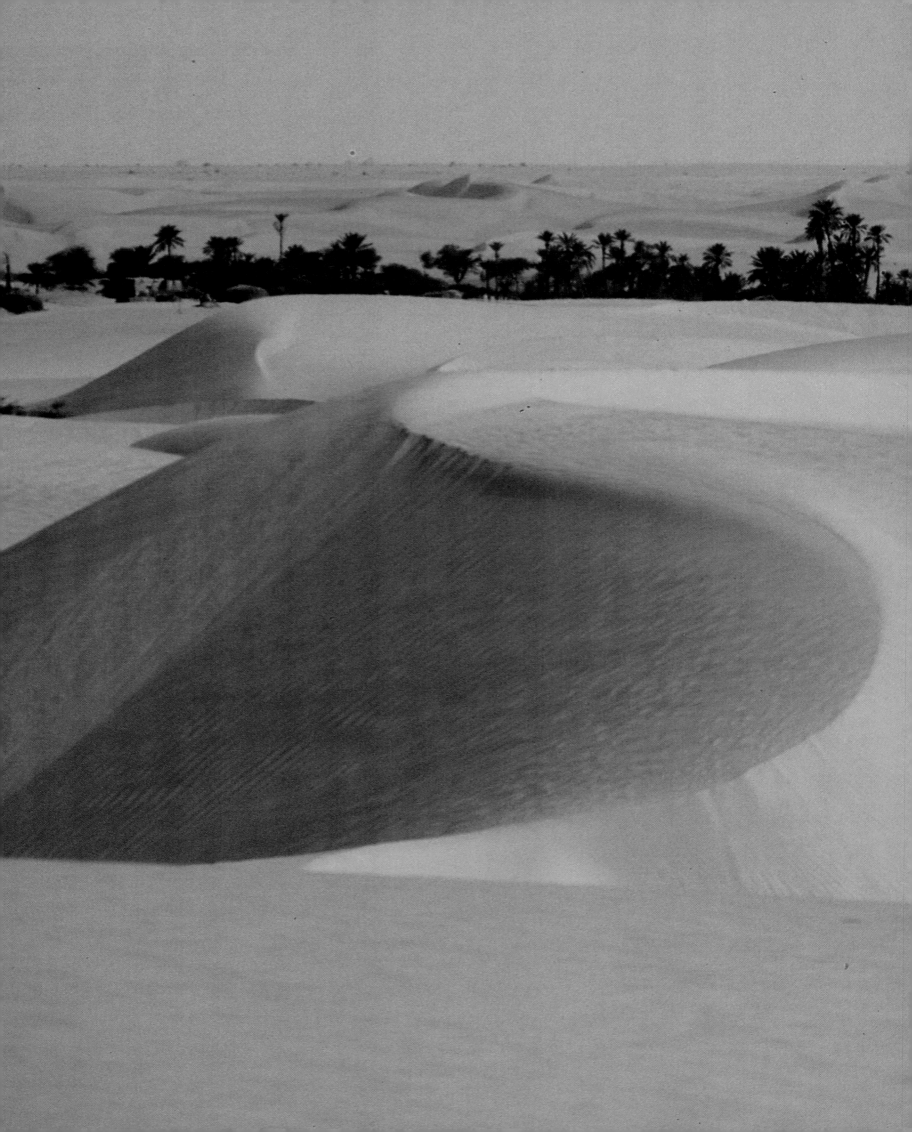

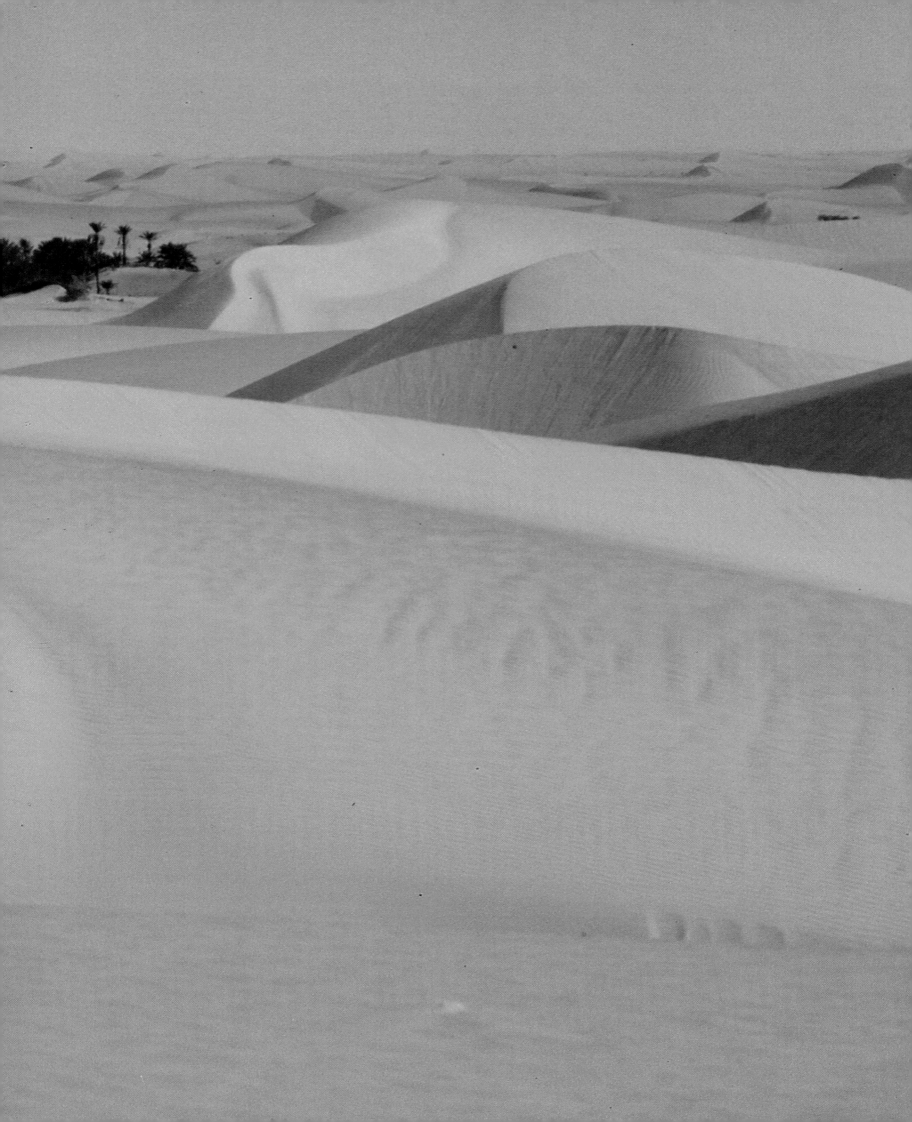

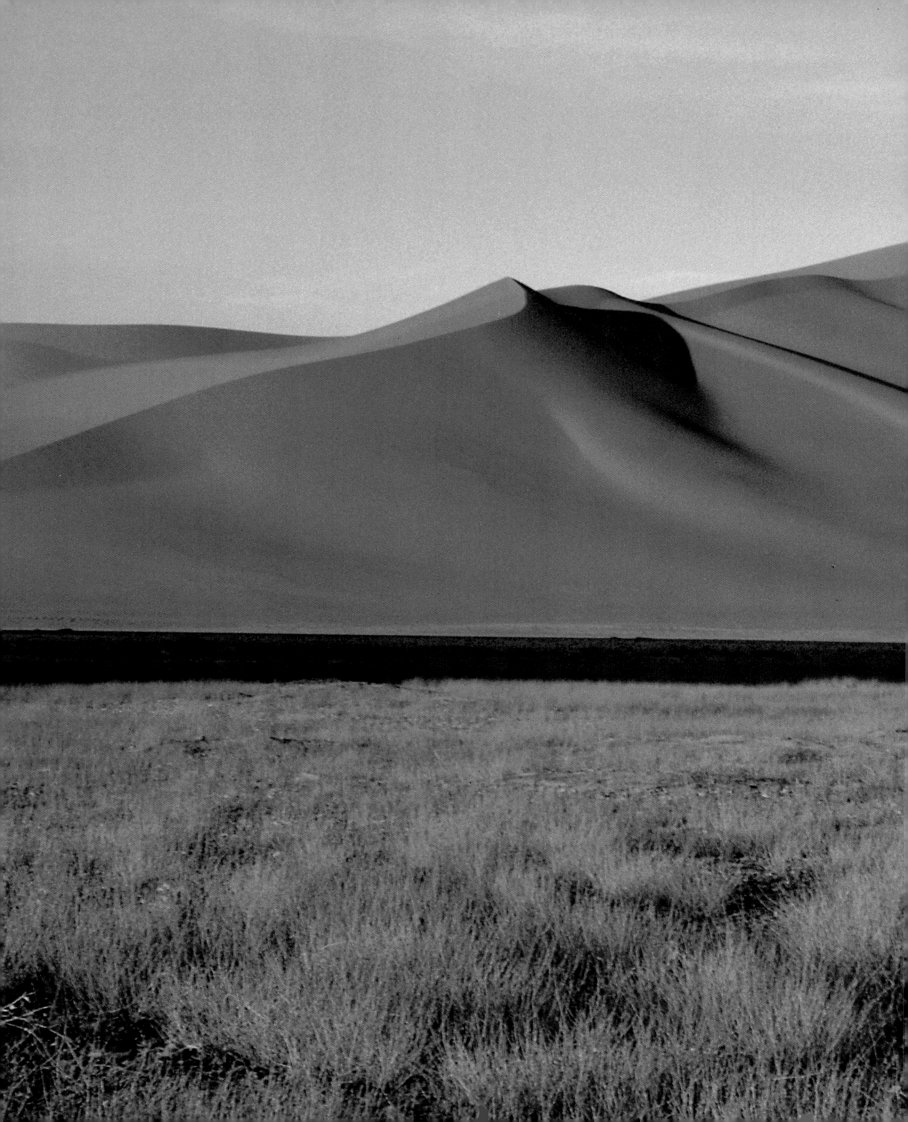

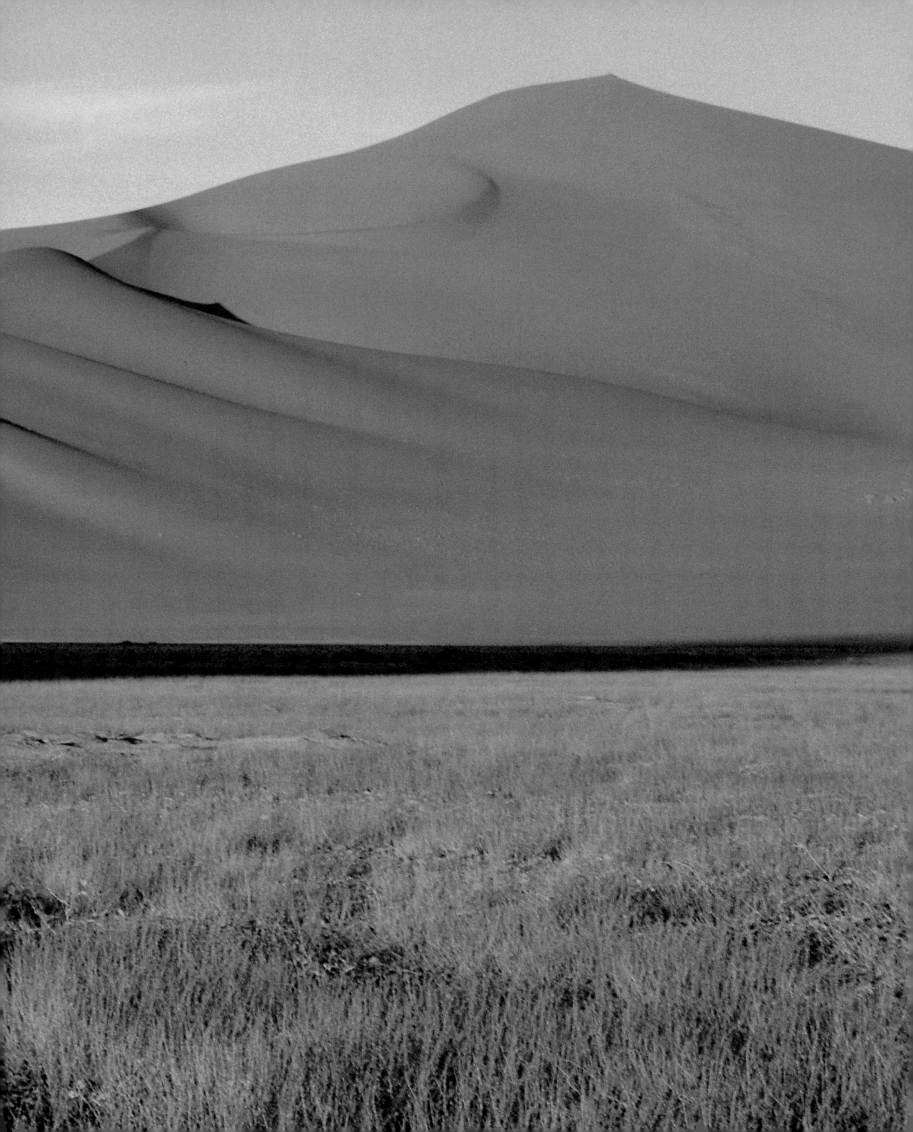

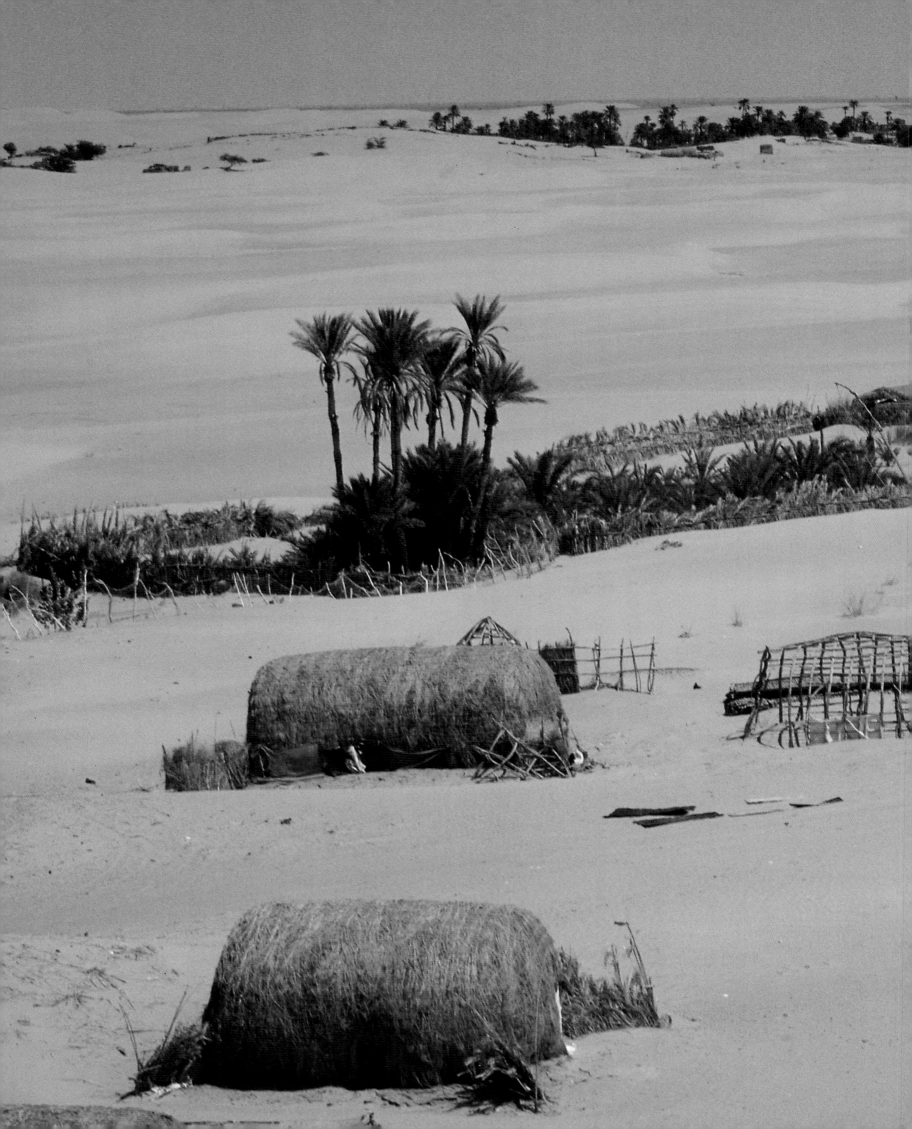

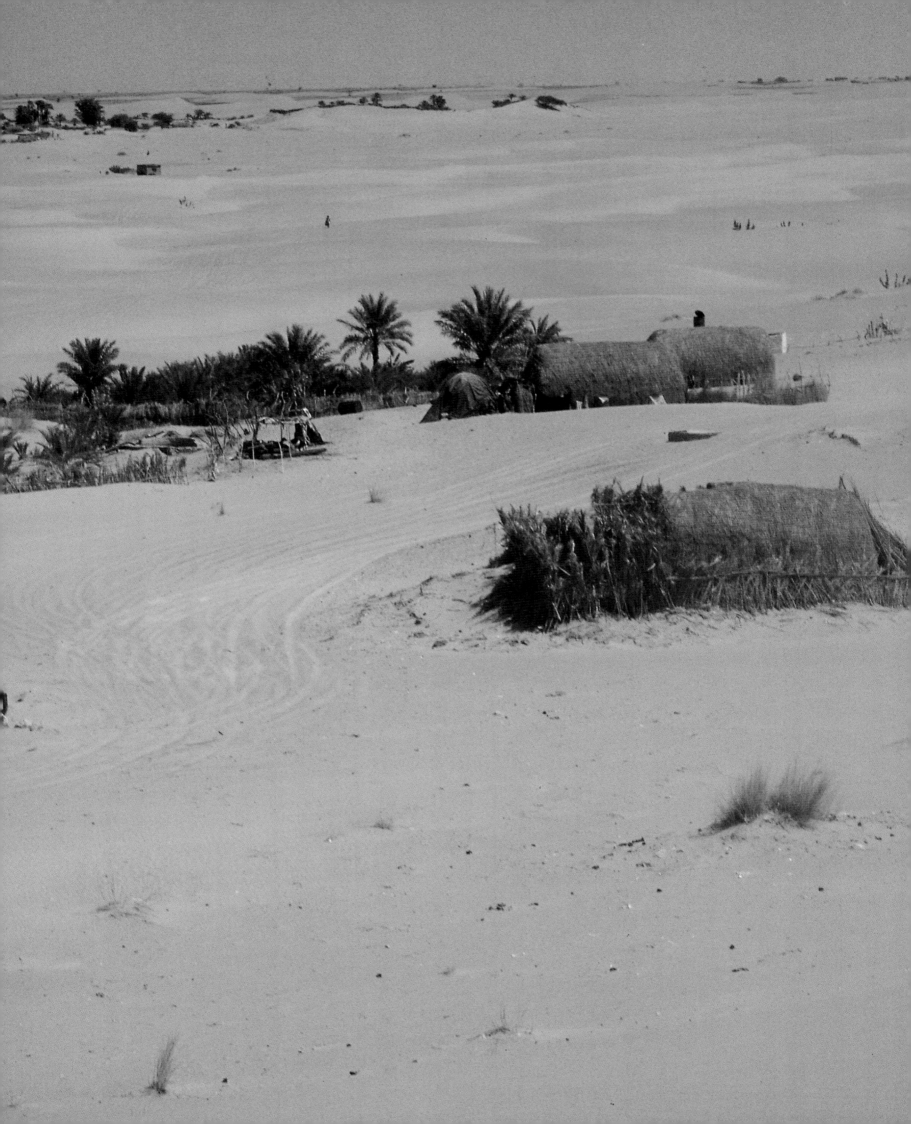

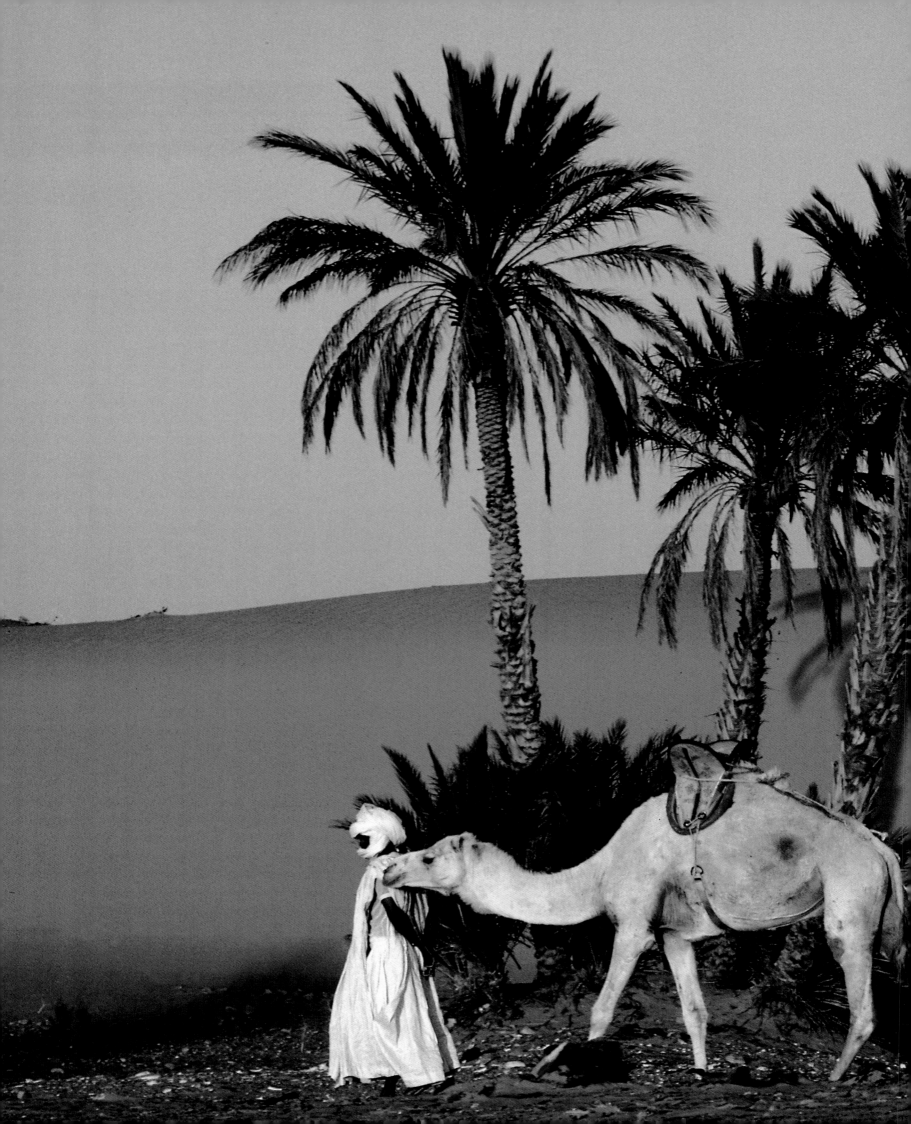

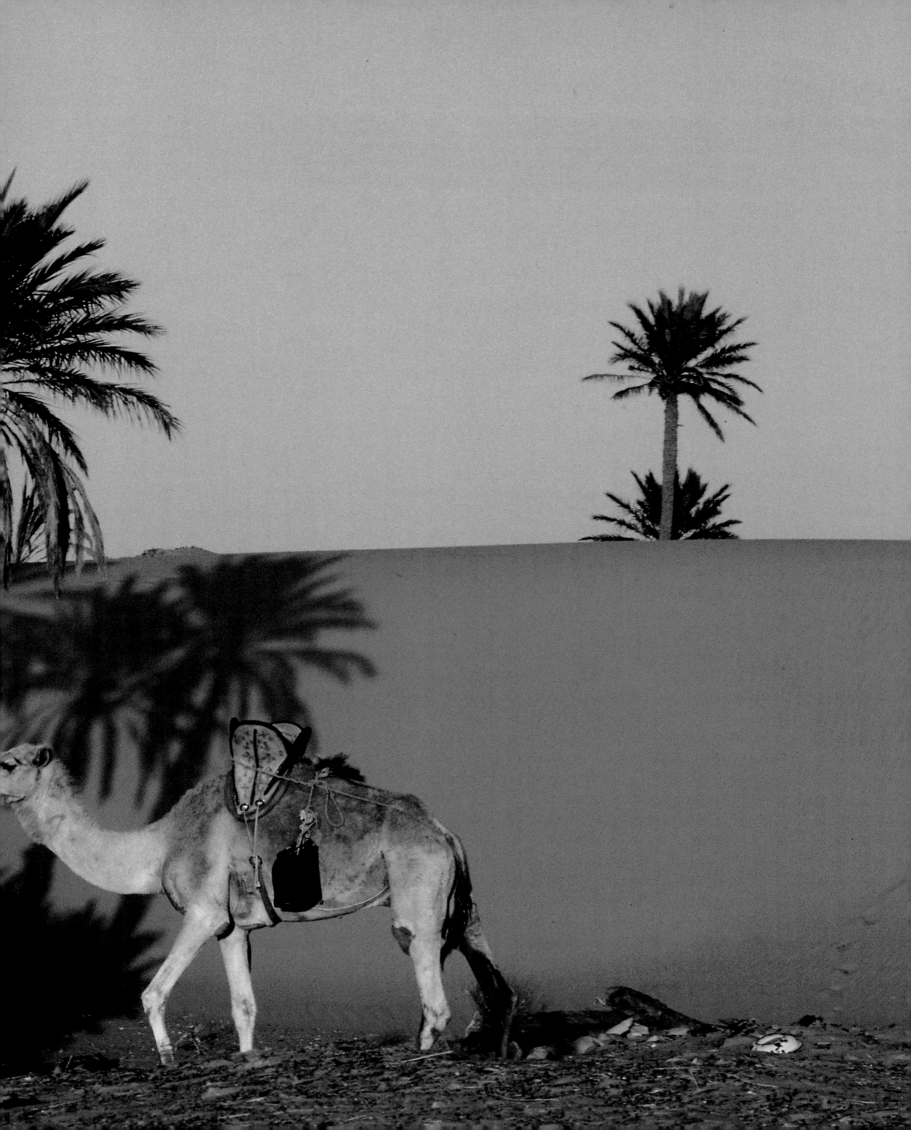

Project Manager, English-language edition: Ellen Nidy
Editor, English-language edition: Matthew Giles
Design Coordinator, English-language edition: Tina Thompson

Library of Congress Cataloging-in-Publication Data

Durou, Jean-Marc.
    [Sahara. English]
    Sahara : the forbidding sands / Jean-Marc Durou ; preface by Mano
        Dayak ; [essays by] Theodore Monod . . . [et al.].
        p.    cm.
    ISBN 0–8109–4187–2
    1. Sahara—Description and travel. 2. Sahara—Pictorial works.
        I. Monod, Theodore, 1902— II. Title.

DT333.D8313 2000
966—dc21

00–38084

Printed and bound in France

Harry N. Abrams, Inc.
100 Fifth Avenue
New York, N.Y. 10011
www.abramsbooks.com

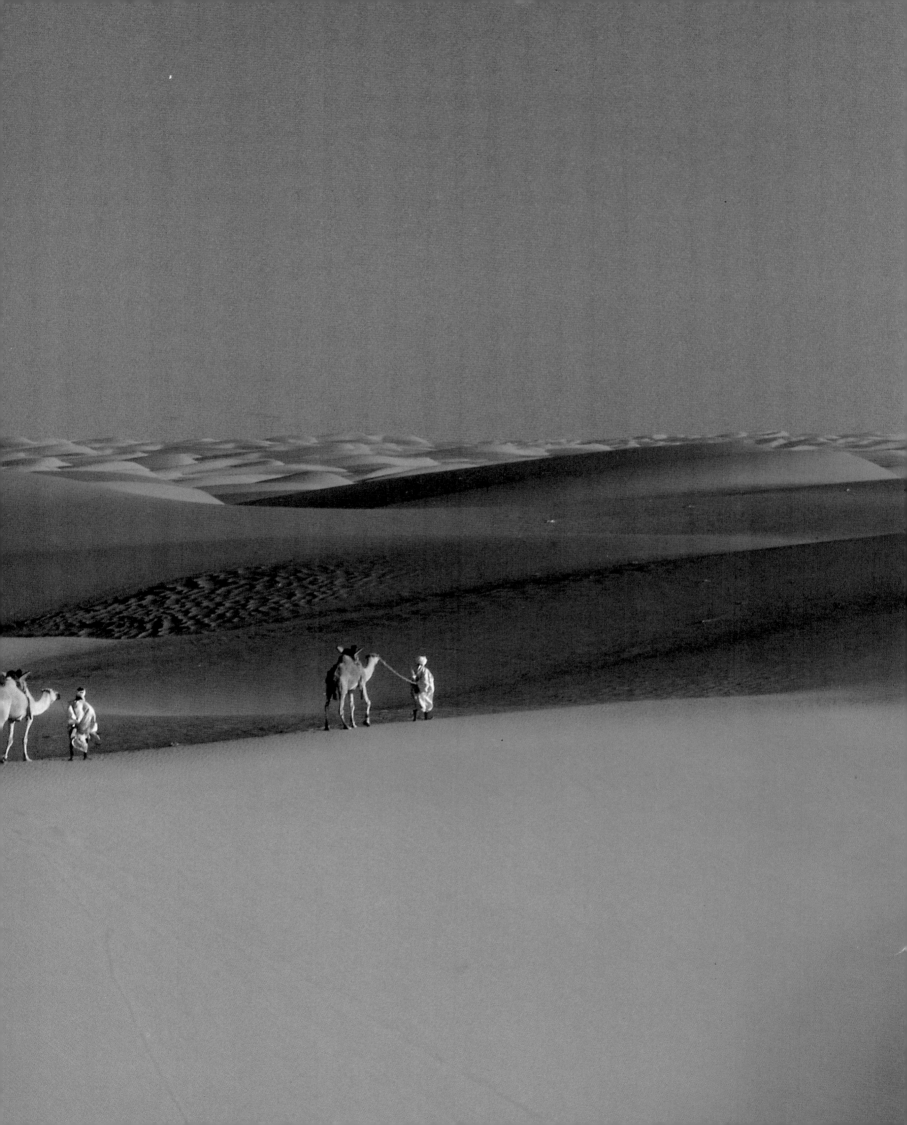

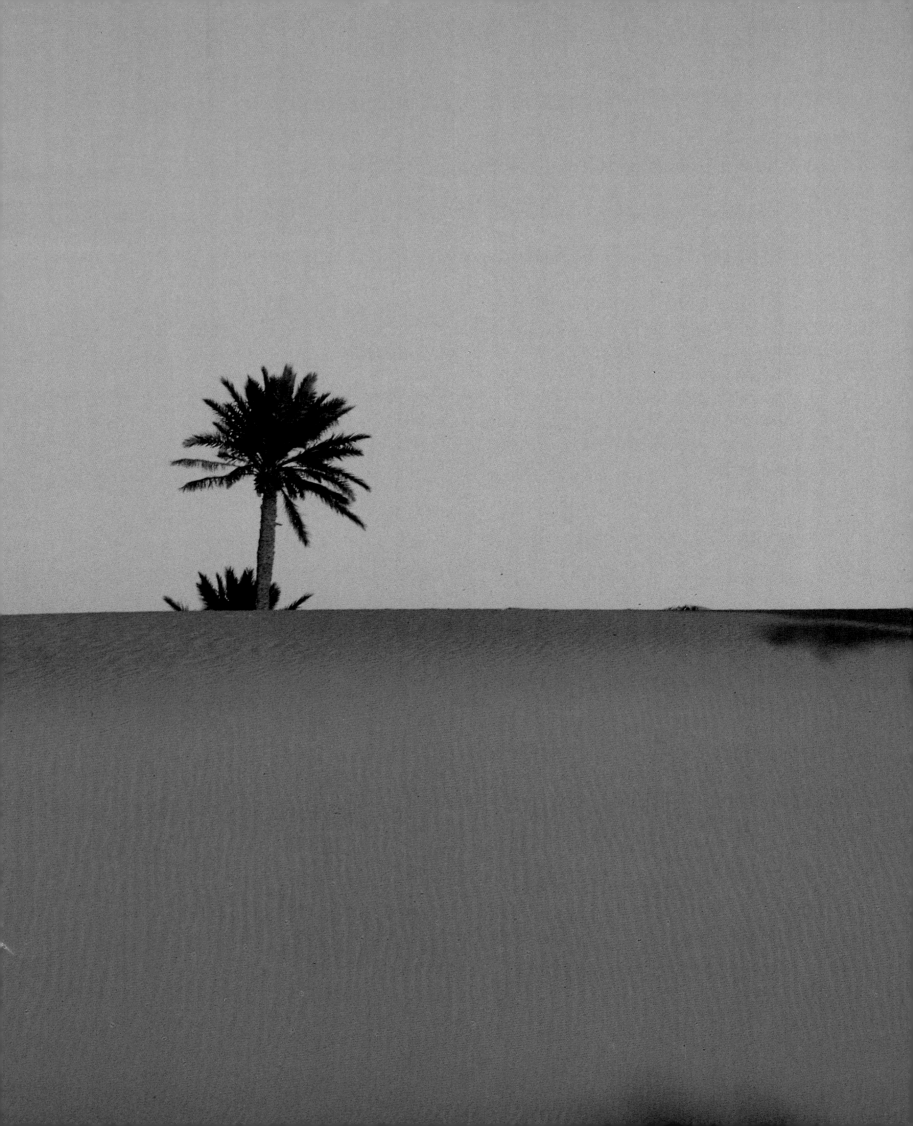